James Arthur O'Connor

PRESENTED IN MEMORY OF

ANGELA GREENE

"BOYNE VIEW", NORTH ROAD

DROGHEDA

A GIFT FROM HER HUSBAND AUSTIN & CHILDREN

A.D. 2000

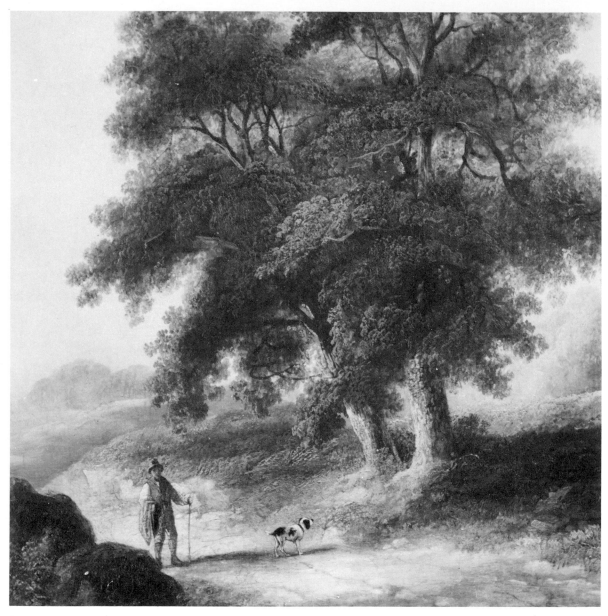

Detail of *Homeward Bound*, (Cat. No. 63)

James Arthur O'Connor

John Hutchinson

The National Gallery of Ireland

Published by the National Gallery of Ireland on the occasion of the Exhibition
James Arthur O'Connor

THE NATIONAL GALLERY OF IRELAND
November–December 1985

THE ULSTER MUSEUM, BELFAST
February–March 1986

CRAWFORD MUNICIPAL ART GALLERY, CORK
March–April 1986

British Library Cataloguing in Publication Data

Hutchinson, John
 James Arthur O'Connor
 1. O'Connor, James Arthur—Exhibition
 I. Title II. National Gallery of Ireland
 III. Ulster Museum
 IV. Crawford Municipal Art Gallery

ISBN 0-903162-28-8

Edited by Joanna Mitchel, Barbara Goff and Adrian Le Harivel
Photography by Michael Olohan
Design, origination and print production by Printset and Design Ltd., Dublin
Printed in Ireland by The Ormond Printing Co. Ltd., Dublin

COVER: detail of *A Thunderstorm: The Frightened Wagoner* (cat. no. 73)
FRONTISPIECE: detail of *Homeward Bound* (cat. no. 63)

CONTENTS

'O'Connor was a man of simple, quiet, unsophisticated feelings, alive to the simple charms of nature, and awake to her slightest impulses. He was deeply impressed by her sublimity and grandeur, and artificially cultivated, demesne scenery was not to his taste. The deep and darkly wooded glen, the grey, weather-bleached, massive rock, crowned with the stunted oak or sparkling holly, hanging o'er the rushing waters, or the moss-covered trunk of gnarled oak, draped with clinging ivy, standing as though he guarded the narrow mountain pass, where the jaded traveller is seen, wending his way towards the distant column of deep blue smoke — here lay his strength.'

'M', Dublin Monthly Magazine, April 1842.

Chronology of James Arthur O'Connor's Life

1792	Born at no.15 Aston's Quay, Dublin; the son of William O'Connor, printseller.
1809	First exhibited work in Dublin.
1813	Travelled to London with Francis Danby and George Petrie. O'Connor and Petrie returned, O'Connor' to look after his orphaned sisters.
1818-19	Painted series of landscapes, now in Westport House, for the Marquis of Sligo and Lord Clanricarde.
1820	Received a premium of 25 guineas from the Royal Irish Institution.
1821-22	Emigrated to London with his wife, Anastatia, and first exhibited at the Royal Academy.
1826	Travelled to Belgium in May, and remained there until the following year.
1830	Returned to Ireland in August.
1833	To Paris in September. Abandoning plans to visit Italy, travelled to Germany, and spent several months in Rhine Valley. Returned to London, via Paris, in November.
1839	Health began to fail, and eyesight weakened.
1841	Died on January 7th, at no.6 Marlborough Street, off College Street, Brompton, London.

FOREWORD

WHEN IT WAS first announced about eighteen months ago that the National Gallery of Ireland was planning a major exhibition of the work of James Arthur O'Connor, a Dublin collector said to me that he wished good luck to anyone who would attempt to select such an Exhibition. This meant that there existed so many paintings attributed to O'Connor that the task of knowing which of them he had actually painted would be well-nigh impossible. Implied by the comment was the observation that such an exhibition would be a dull room of almost identical green-brown pictures showing little men in red waistcoats walking along country roads. For such is the reputation of O'Connor who for long has been the best-known and most-loved of all Irish painters. Such an assessment of him, as is startlingly demonstrated by the choice of pictures in the Exhibition, is very far from the truth; and O'Connor is revealed as a major Romantic landscape painter whose works demonstrate a considerable variety of styles, superior technical skills and a poetic sensibility in the treatment of nature. Nor is the story of O'Connor's life exactly without interest: struggling early years; an abortive trip to England, returning home, penniless, to orphaned sisters; then important commissions in Ireland; travels on the Continent and moderate success in London; and, at the end, failing eyesight and financial hardship. It could be the plot of an opera by Balfe or William Wallace.

The Exhibition has been selected and catalogued for the National Gallery of Ireland by John Hutchinson and is based on his M.Litt. thesis on the artist for Trinity College, Dublin. He has discovered a great deal of information and writes about the painter in the context of both his literary and artistic contemporaries. The paintings, which are catalogued and shown in chronological sequence according as they were painted, demonstrate the development of the artist's talent. The Governors and Guardians of the National Gallery are deeply indebted to John Hutchinson for putting the fruits of his researches at the disposal of the Gallery by writing a catalogue which will stand as an important monograph on a major Irish painter for many years to come. The catalogue has been edited by Joanna Mitchel and typeset in the Gallery by Barbara Goff. The Exhibition has been arranged in its entirety by the Exhibitions Officer Kim-Mai Mooney.

To these and in particular to the many owners who have lent their pictures for the Exhibition the Governors and Guardians and myself are particularly grateful.

HOMAN POTTERTON
Director, The National Gallery of Ireland, *November 1985*

PREFACE

I REMEMBER WELL my own discovery of James Arthur O'Connor's paintings. One day, during a visit to the National Gallery of Ireland, I was forcibly struck by *The Poachers* and *The Devil's Glen*: there was something about them that I instantly empathized with and responded to, perhaps because they captured one of the moods of the Wicklow hills, which I had been exploring with my dog on lengthy walks. (Indeed, working on this exhibition has revived great memories of those excursions with Sam, who died some years ago. He is sadly missed). I like to think, then, that I came to enjoy O'Connor's work in a way that he would have appreciated, and it is meant as a tribute to his strength as an artist when I say that I've never really lost that sense of affinity with his Romantic paintings, and that I still come across woods and valleys in Co. Wicklow that remind me of his landscapes.

So much for the personal associations. Some years later I completed an M.Litt. thesis on O'Connor for Trinity College, Dublin, and I'd like to express my gratitude here to Professor Anne Crookshank, who supervised my research, and to Dr. James White, who encouraged me to work on the project while I was employed at the National Gallery. Dr. Eric Adams, Professor Barbara Wright, and Dr. Michael Wynne all helped me with the thesis, for which I am thankful. I should also like to thank the many people who allowed me to examine their paintings by O'Connor, both while I was writing the thesis and since.

As far as this exhibition is concerned, my gratitude is due to Homan Potterton, Director of the National Gallery, who first suggested it, to Raymond Keaveney, Dr. Michael Wynne, and to Kim-Mai Mooney, who has been an incessant source of good humour and efficiency, and who wrote the biographical notes in the first section of the catalogue. Barbara Goff, Joanna Mitchel and Adrian Le Harivel who edited the text, and Frances Gillespie have been very helpful. Rosie Black, Dr. Julian Campbell, The Knight of Glin, Sir Robert and Lady Goff, James and Therese Gorry, and Ciaran MacGonigal have given me valuable assistance, for which I am indebted. Finally, I should like to thank my parents and friends for their warm support.

I have to admit to a bias in the selection of paintings for this exhibition. In an attempt to show O'Connor's work in a relatively new light, I have not chosen many of the paintings for which the artist is best known — namely, the pleasant little rural landscapes that turn up with rather tiresome regularity at auctions. O'Connor seems to have painted literally hundreds of them, and

most, to put it mildly, are undistinguished. It is also a curious accident of fate that other, usually thoroughly awful, paintings have had O'Connor's signature affixed to them, and while this attests to a kind of enduring popularity, it has also ensured that O'Connor is unfairly associated with fakes and bad pictures. What I have tried to do in the selection is to demonstrate the way O'Connor progressed from eighteenth century topography, through the picturesque, to a fully realized and personal form of romanticism. There is also a section of paintings by O'Connor's Irish predecessors and contemporaries, which may help visitors to put his work into historical perspective. This reveals yet another bias, because ideally that section would have included work by his English contemporaries, but that, unfortunately, would have stretched the boundaries of the exhibition beyond reasonable limits.

The biography, which is perhaps overly detailed in some respects, is intended to document virtually all our current knowledge of O'Connor's life, and it closely follows the corresponding part of my thesis. The introduction, a recent and personal interpretation of O'Connor's work, is based on what I hope is a deeper understanding of relevant issues than that which I possessed when I wrote the thesis. I should add, at this point, that whatever mistakes or omissions there are in the catalogue and selection are my own: Homan Potterton was generous enough to allow me 'carte blanche' in my approach to the exhibition.

INTRODUCTION

UNTIL ABOUT TEN years ago, when his popularity was surpassed by that of Walter Osborne, James Arthur O'Connor was possibly the best loved of all Irish painters. This affection for O'Connor's work was not based on any real knowledge of his paintings, but on an affinity with the lyrical mood of his most common landscapes, which, it was widely believed, always included tiny figures wearing red waistcoats walking down country lanes on fine summer days. Nor was this a totally inaccurate conception of O'Connor's style, for if the majority of his paintings do not, strictly speaking, correspond to that description, they do fall into the category of pleasant picturesque rural scenes — a genre that had wide currency in these islands during the early decades of the nineteenth century.

It is worth considering why O'Connor's less distinguished paintings, for that they indubitably are, have so long been regarded with such sympathy. They are technically less impressive than the best of his early topographical pictures, less original and powerful than his romantic works; a glance at Colonel Grant's *History of Old English Landscape Painters* reveals that there were large numbers of contemporary artists producing similar images. There are two possible reasons for their popularity. First, it may be because O'Connor was Irish, and died poor and forgotten in England; and second, because O'Connor was an artist of unusual sincerity — a quality which shows in his work. Even when he was turning out scores of 'pot-boilers', which he was once forced to sell off at auction, O'Connor put his heart into what he was doing.

But perhaps more importantly, O'Connor's picturesque views might square with an idealized notion of nineteenth century rural life in Ireland, which would also account for the comparative neglect of O'Connor's topographical pictures and the romantic landscapes. The former are too redolent of an Ascendancy ethos, and the latter are altogether too broody and disconcerting. It becomes obvious, however, if we give the issue any thought at all, that O'Connor's paintings have very little to do with the reality of life in Ireland at the time. After all, O'Connor spent two thirds of his working life in England, only returning home for brief visits. Most of his rural scenes were painted for the English market, and are certainly not of specific Irish localities. Moreover, even if it were to be established that O'Connor painted Irish views in England (as, in fact, he did with his romantic pictures), that would not make them any more authentic as social documents.

Indeed, it would be odd if O'Connor's paintings were 'true to life':

with the notable exception of Nathaniel Grogan — and he infused his pictures with jolly *bonhomie* and stage-Irish humour — it was decidedly uncommon for an early nineteenth century Irish artist to paint a rural scene that was in any sense 'realistic'. Who would have wanted to buy such pictures? On Irish roads, in the 1830s, as in many other parts of Europe, there were to be found not a profusion of good-natured farmers wearing red waistcoats, but 'a mass of filth, nakedness and squalor … roaming around the country entering every house, addressing itself to every eye, and soliciting from every hand'.[1] An artist, to have been realistic in his depiction of the countryside and rural workers, would have to have painted the life of cottiers who formed the manual labour force, and who held their plots of ground at the whim of landowners, farmers or middlemen. (As often as not the cottiers were peasants who migrated in search of seasonal work, in which case their families were not infrequently to be found begging on the streets of the nearest town). Irish artists, in ignoring the reality of rural life, were simply doing what painters have always done: they provided views of the countryside that people wanted to hang in their drawing-rooms. Idealized pictures have a perennial appeal, and are not necessarily any the worse for that.

O'Connor, however, did not always paint picturesque scenery. His early topography is a form of direct description, and is clearly descended from the commissioned 'portraits of houses' which Thomas Roberts and William Ashford painted in the last decades of the eighteenth century. It had long been the case in Ireland, as everywhere, that the ownership of land created a fundamental base for wealth, authority, and social status, and artists were employed to paint pictures that showed estates in their best light — symbols of their owners' success and self-esteem. The painter was expected, moreover, to make private property look as much like an earthly paradise as possible, and to make this state of affairs look natural. The status quo, these pictures imply, has its origins in the distant classical past, and, to put it bluntly, the artists' brief was to bolster the pride and pleasure of the land-owning class.

There were simple pictorial means of achieving this effect. A common eighteenth century convention was to describe a view from a high vantage point, which suggested control over it, without which, it is further intimated, the landscape might revert to its pre-cultivated, and thus inferior, condition. What is more, the high viewpoint allowed the spectator to perceive in detail those aspects of the scene — such as a Palladian country house — that the patron wished to be noticed. The ruling class was conventionally depicted as cultured and beneficent, leisurely strolling around their landscaped gardens, hunting, or observing their employees at work. Contemporary patrons liked to see their workers shown as content and industrious, happily engaged in simple occupations like fishing or washing clothes. It was a pastoral vision of rural life, in which the fruits of nature were readily accessible without too much toil and sweat, and where everybody was perfectly satisfied with his station in life.

It is scarcely surprising, then, that the paintings of Claude Lorraine were immensely fashionable in the British Isles during the eighteenth century. Claude's pastorales were appreciated for their classical and Virgilian associations, which reminded the aristocracy and gentry of the Augustan ideals to which they aspired, and when they could not afford to buy the genuine article, they purchased pastiches by local artists — in Ireland, by painters like George Barret, Robert Carver, and George Mullins. These stylistically derivative paintings, far less prestigious than originals by Claude or Gaspard Dughet, were basically decorative, and served as social indicators of taste and breeding, for by the late 1750s, in Britain and Ireland, there were growing numbers of people with money, leisure, and cultural aspirations, who knew what constituted good taste. Claudean landscapes fitted the bill nicely: They were eminently acceptable from a social point of view, and their aesthetic standards were enshrined in treatises such as Edmund Burke's *A Philosophical Enquiry into the Origin of Our Ideas about the Sublime and the Beautiful* (1767). (To the newly wealthy, who needed some assistance with the formation of their taste, Burke's volume became a *vade mecum*, as did Reynolds' *Discourses*, and Uvedale Price and Payne Knight's books on *The Picturesque*).

Fifty years later, O'Connor's paintings still bore traces of eighteenth century concepts of 'Beauty': many of his pictures were composed in the Claudean manner, using *coulisses* and a winding road to lead the eye towards ethereal, light-filled distances. By then, however, the soothing, mellow tones of 'Beauty' were becoming decidedly old-fashioned, and like the 'Sublime', its aesthetic counterpart, 'Beauty' was about to be transformed by Romanticism. But apart from the wheel of fashion, there was another important reason for this change. The Britain — and Ireland — that was developing under the influence of capitalist agricultural economics was no longer able to sustain the old landscape ideals, and by 1820 very few painters were allowed the luxury of an aristocratic vision of the countryside.

Michael Rosenthal has clearly shown[2] that Constable abandoned his 'Georgic naturalism' in the 1820s because he understood, if only half-consciously, that it no longer had a part to play in a society that was in the midst of profound changes. Turner, indeed, the other major British landscape painter of the day, had made that shift in perception some years earlier, in 1813, when he painted *Frosty Morning* (illus. no. 1) — a picture that the young O'Connor, with his friends Francis Danby and George Petrie, admired during their first visit to London. *Frosty Morning* showed two labourers hedging and ditching, observed by a man and his daughter; they are all equally discomfited by the cold, gloomy day, and *Frosty Morning* is an unsentimental, naturalistic image. Turner, however, had little interest in this kind of picture, and began to paint Claudean pastiches like *Crossing the Brook*, which, unlike their eighteenth century precedents, contained no social implications. Before long he had totally abandoned both his early topographical style and his incipient naturalism.

Nevertheless, the Dutch-inspired style and tonality of *Frosty Morning* were taken up more determinedly by other contemporaries, (especially by John Crome (illus. no. 2) and other Norwich School artists), who painted British landscapes in the manner of Hobbema – a genre which appealed strongly to the new middle classes, as it had before to the lesser gentry in the eighteenth century. This kind of painting, which O'Connor adopted once he settled in England in the 1820s, (illus. no. 3) avoided the classical allusions of earlier British landscapes, and conveyed a world-vision that appeared more 'authentic' and realistic, but which in fact was almost as idealized as the Claudean pastorales (illus. no. 4).[3]

O'Connor must have been at least vaguely aware of these developments in British landscape painting when he left Ireland in 1822, but he still hoped to find traditional patronage in England. By then, though, the pictorial 'disappearance' of the country house was well underway, because the demand for that kind of picture was rapidly diminishing. O'Connor however, clinging to the coat-tails of the old regime, even when it was obvious that he had to fall in with current taste, never lost his enthusiasm for the way things had been in the recent past. Consequently, on his visits to Ireland in the 1820s

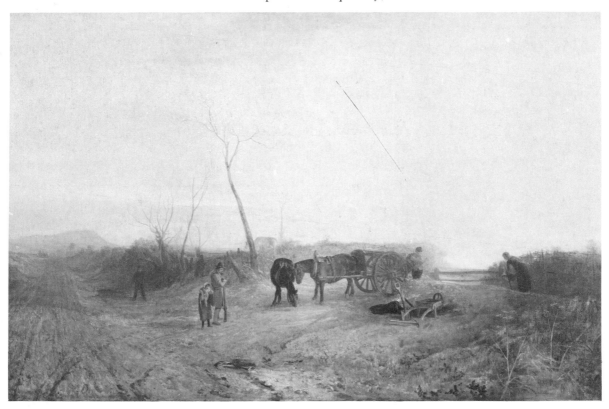

Illustration 1 JOSEPH MALLORD WILLIAM TURNER, *Frosty Morning*, The Tate Gallery, London.

Illustration 2 JOHN CROME, *A Heath Scene; Sun after Storm*, National Gallery of Ireland.

and 1830s, O'Connor inevitably returned to celebrated beauty spots like the Dargle, the Devil's Glen and the Meeting of the Waters in County Wickow, and, at least once, to the Lakes of Killarney. In so doing, he was following a well-trodden path that had been frequented by tourists ever since the 1780s, for Kerry and County Wicklow were constantly visited by those in search of the 'Sublime' and the 'Beautiful'. These fashionable excursions were facilitated by improvements in coach-building and road construction, such as the extensive Military Road that opened up County Wicklow, and became decidedly popular.[4] It was a curious phenomenon, and one which calls for some explanation.

Marjorie Nicolson[5] has demonstrated that in Europe, until the end of the seventeenth century, there was virtually no interest in the aesthetic appeal of mountains, and from then onwards there was a change in the way they were viewed — a transition in taste that was prompted by new theological

Illustration 3 JAMES ARTHUR O'CONNOR, *Landscape with Mill,* (detail), Gorry Gallery.

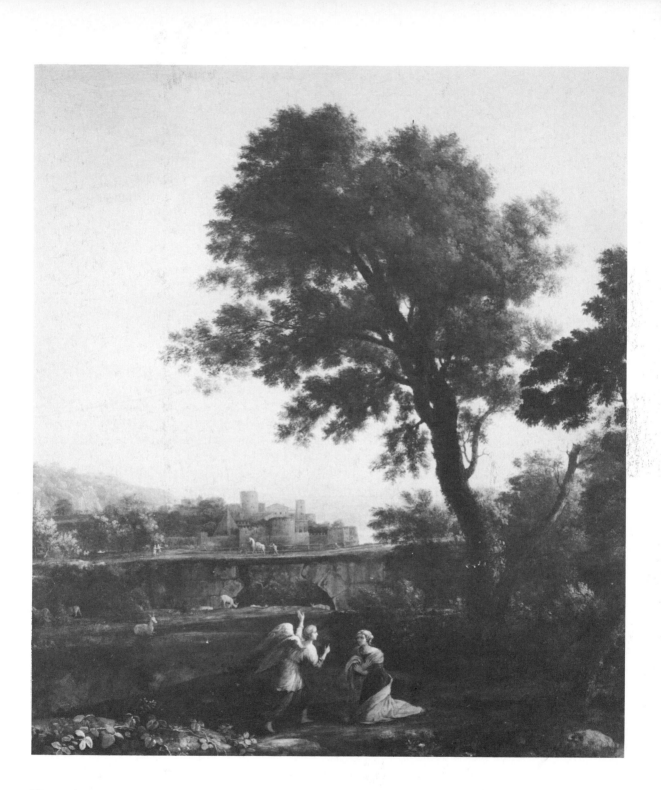

Illustration 4 CLAUDE LORRAINE, *Hagar and the Angel,* coll. The Lady Dunsany.

views concerning the appearances of the Earth before the biblical flood. Hitherto, Nicolson observes, it was generally held that mountains were a kind of deformation of nature resulting from the Deluge, an opinion that was challenged in 1635 by George Hakewell in *Apologia of the Power and Providence of God*, where he argued that mountains, like the rest of the Earth, were as primordial as the rest of creation. Even more influential in its subversion of conventional thought was Thomas Burnet's *Sacred Theory of the Earth*, (1684), in which the author expresses his pleasure in the wildest, most imposing aspects of nature, to a degree that would have been almost impossible in an earlier epoch. Burnet's enthusiasm seems to have had an effect on the architects of what became known as the 'Sublime' (Shaftesbury, Addison, Thomson, and Burke), but the first real interest in the concept was shown by John Dennis, in several works that were published between 1693 and 1704. Taking much of his inspiration from Longinus' notion of the 'Rhetorical Sublime', Dennis wrote about what eventually came to be known as the 'Natural Sublime' — in other words, about the aesthetic impact of powerful and overwhelming natural features — and he described the paradoxical 'delightful horror' and 'terrible joy' that he felt while crossing the Alps in 1688.

Not long afterwards, in 1709, Shaftesbury gave an equally rapturous account of a similar journey in *The Moralists*, and three years later Addison developed the idea of the 'Natural Sublime' in his celebrated *Spectator* essay, 'The Pleasures of the Imagination'. By the time James Thomson had written about mountain scenery in his extraordinarily influential poetry sequence, *The Seasons*, (1726-30), there was a reasonably widespread appreciation of mountain grandeur among writers. This was not the case, though, among artists; before the 1760s, landscape painting was in the main comprised of topographical pictures and classical pastiches. The first British pictorial representations of the 'Sublime' roughly coincided with the publication of Edmund Burke's treatise on ... *The Origin of our Ideas about the Sublime and the Beautiful*.

To Burke, the 'Sublime' was the opposite of the mellow delicacy of Claudean 'Beauty'; it was the awe-inspiring sort of feeling that one might experience on top of a mountain or in a rocky ravine with a cascading waterfall. It was also, he said, more profound than 'Beauty'. This artistic apotheosis of terror appears at first to be contrary to all that one would expect from the conservative Burke and an augustan, patrician society that kept rigidly to its class-oriented sense of order. But examined more closely, it is clear that the Sublime/Beautiful antithesis was a form of *Concordia discors* — a pair of binary opposites that is subservient to an absolute. Besides, delight in the 'Sublime' was predicated on the absence of actual danger, so the 'Sublime' and the 'Beautiful' were safely integrated into British classical landscapes in the same way as other such oppositions.[6] Thus they were comfortably subsumed by the status quo, and the upper classes could enjoy the piquant

thrill of raw, untamed countryside without being threatened by it.

But if the taste for the 'Sublime', as Michael Rosenthal suggests,[7] revealed that 'confidence in contemporary achievement needed to be sharpened by experiencing landscapes which dwarfed man', the concept of 'Sublimity' was soon to be modified, for as the Industrial Revolution dawned, the brilliance of the old society dimmed. Yet again aesthetics reflected the social condition. Almost as if they foresaw that the stable absolutism which allowed safe indulgence in the 'Sublime' was about to crumble, Uvedale Price and Richard Payne Knight developed a less emotional and more formalist approach to landscape. They were preceded in this by William Gilpin, who set up the 'Picturesque' as a category to take its place beside 'Beauty' and 'Sublimity', and argued that the artist needed to add 'composition' to nature in order to produce a pleasing effect.

Gilpin, however, was not a systematic thinker. It was left to Price to argue that the 'Picturesque' included all those qualities in nature and art which could be appreciated through the study of painting, and, more importantly, that much which had hitherto been regarded as ugly could, if treated in the right way, become 'Picturesque'. In 1805, Payne Knight's *Analytical Inquiry into the Principles of Taste* took another line. 'Picturesque beauty', Knight wrote, could be seen in the effects of 'refracted lights' (a definition which anticipated aspects of the work of Turner and Constable), and also in those objects which became significant through their association with paintings. In short, 'Picturesque' meant literally 'like a picture'.

As the 'Picturesque' gradually superseded the Sublime/Beautiful antithesis as the dominant aesthetic standard, so did landscapes come to be assessed on their pictorial qualities alone. If, in the past, paintings were largely cultural signifiers of social standing and of a particularly aristocratic view of the world, by the beginning of the nineteenth century those allusions were less crucial. The content of a landscape was to be judged aesthetically; a peasant in a picture was no longer part of a pastoral idyll, but a 'Picturesque' element, and the countryside in which he was situated was neither too 'Beautiful' nor too 'Sublime'. Classical landscapes showed reality being adjusted to suit the aristocracy, and the 'Picturesque' did the same for the middle classes. As Rosenthal has observed, 'The picturesque allowed artistic acceptability to a mass of material which would not otherwise have had it. It was a process of aesthetic laundering … And, therefore, a picturesque painting should tend to have no significant subject-matter'.[8] It is unlikely that O'Connor was in any way aware of the implications of the styles he adopted. His ideas changed slowly, and then partly under the pressure of the market-place; he was never in the vanguard of artistic styles, and seems to have craved for the security of well-tried ways. Indeed, it was probably a need for financial advancement, rather than a wish to follow his muse to more stimulating reaches, that took O'Connor to England. The visual arts in Ireland were then in extreme disarray:

Strickland quotes the author of *The Picture of Dublin* as writing, in the year before O'Connor emigrated, 'Owing to the want of taste and encouragement, though there are many painters of merit, there is no exisiting Society of Artists in Dublin, and many have been compelled to seek for support in other occupations, tired out and disgusted with repeated efforts unrewarded'.[9]

The period immediately following the Rebellion of 1798 and the Act of Union, was, of course, undeniably unsettled. Before 1800, two-hundred and sixty nine peers and three-hundred M.P.s had houses in Dublin, but by 1821 there were only thirty-four peers, thirteen baronets and five M.P.s in the city.[10] Large houses and estates — and artistic patronage — began to decay as the wealthy settled in England. There were serious social problems, the most serious being the land question: the population was expanding, and available land did not seem adequate to provide a living for all those who worked it, so competition drove up rents. Nor did the labour market expand proportionately with the upsurge of population after the 1770s. Following the fall in agricultural prices after 1815, farmers tried to economize on hired labour, so rivalry for available employment ensured that, in spite of the rise in rents, there was no increase in wages.

This in turn brought about more migrant labour and seasonal emigration to England and Scotland. Factions and fights were often started by quarrels over land, but it is notable that these were not usually ideological in nature, for among the peasantry the revolutionary ideals of the 1790s did not run very deep. There were local secret societies who had Republican aspirations, but their membership was stronger in towns than in the country, and agrarian unrest was normally due to local problems. Indeed, the hostility of these societies was often less directed at landlords than at other peasants — often outsiders who took farms from over the heads of native residents.[11]

As John Barrell and Michael Rosenthal have amply demonstrated,[12] the advent of the Industrial Revolution and the post-Napoleonic War agricultural depression led to the demise of English 'Georgic' landscape painting. Parallel changes took place in Ireland. After William Ashford died in 1824, the more important Irish landscape artists (excluding O'Connor and Danby, who worked in England) usually painted either generalized picturesque views or anecdotal urban topography. 'House portraits' and classical landscape painting quickly faded away. It is interesting, though, that while the passing of eighteenth century traditions heralded the advent of Romanticism in England, little of the kind happened in Ireland.

This was true not only in the visual arts, but in the Irish literary world. Roger McHugh and Maurice Harmon have pointed out that 'In nineteenth century Ireland a tradition of Irish writing struggled into existence'[13]. What literary energy there was expressed itself largely in pamphlets and periodicals, and was usually of a political or religious nature. After the Catholic Emancipation Act of 1829, however, there were signs that something different

was happening, but this new writing did not have an easy birth. Its readers were mainly English, and the Irish novel — the backbone of the new movement — found itself involved to an inordinate degree in explanation, didacticism, and defiance, perhaps to the detriment of more conventional literary concerns. Maria Edgeworth, for instance, constantly brings to the attention of the reader of *Castle Rackrent* the necessity of reforming the habits of absentee landlords. (Others, though, like William Carleton in *Traits and Stories of the Irish Peasantry*, soon became content to tell rambling anecdotal stories of Irish life, which had no obvious political edge).

This literary representation of Ireland, a kind of fictionalized realism, was only one side of the coin: there was also a pronounced escapist element in early nineteenth century Irish literature. Lady Morgan's *The Wild Irish Girl*, published in 1806, was fundamentally a Gothic Fantasy that dwelt emotionally on the glorious achievements of ancient Ireland, and Charles Robert Maturin's *Melmuth the Wanderer*, a work of high Romanticism, brought Irish writing into line with European trends of the time. But Romanticism seems not to have been an endemic strain in Irish writing, for as Patrick Rafroidi has observed, 'One cannot rule out that in the beginning what served the Romantic cause in Ireland was the desire, at least in the ruling class, to imitate England'.[14]

Rafroidi goes on to say, though, that Irish romantic writing borrowed at least as much from France and Germany as from England, and that Irish romanticism took to its heart not a love of nature or the influence of Wordsworth, neither German philosophy nor the ideas of Coleridge, but a taste for exotic surroundings, and for the unfamiliar, mysterious, and terrifying. He also disposes of the supposition that Edmund Burke's treatise was in any way typical of Irish thinking. In otherwords, while Rafroidi acknowledges a genuine strand of Romanticism in nineteenth century Irish literature, he recognizes both its limitations and its comparatively slow development, which he ascribes both to an 'Anglo-Irish hostility to novelty' and to 'The conviction that forms of power and literature interact, and the intuitive knowledge that one does not lay siege to artistic traditions without also endangering the whole political and social citadel'.[15]

It may be significant, then, that the two Irish artists who most closely allied themselves with the Romantic cause — Danby and O'Connor — both worked in England, as did Daniel Maclise, who straddled the boundary between Romanticism and Victorian narrative painting. Of the two, Danby was unquestionably the more Romantic, his life dramatic and Bohemian, his paintings fantastic and extravagant; and it is revealing that Eric Adams, in his monograph on the artist, virtually ignores the question of Danby's Irishness. The background to Danby's 'poetic landscape', according to Adams, lies in the style of landscape painting that was pioneered in the latter half of the eighteenth century by Richard Wilson and Joseph Wright, and, in a more

popular vein, by J. P. de Loutherbourg. Apart from chronicling Danby's early years in Ireland, and describing the stricken state of the visual arts in Dublin,[16] he allows for no Irish influence on the artist's career. Rightly or wrongly, Adams fits Danby neatly into an English context, and implies that his upbringing in Ireland had little effect on him.

That is certainly not the case with O'Connor, who, as well as deeply absorbing the eighteenth century heritage of Irish landscape painting, kept up strong links with his native country, even though he conscientiously attempted to adapt to a new way of life in London. Still, after thirty years or so in Dublin, O'Connor must have found the artistic climate in England distinctly bracing. He would doubtless have been impressed by the healthy interest in landscape painting, and in art generally, which led to the establishment of the National Gallery in 1824, and the foundation of the new Society of Artists in the same year, (which was managed by the artists themselves, and had little to do with royal or aristocratic patronage). O'Connor also found himself competing with artists of a much higher calibre than his colleagues at home, and it must soon have become clear to him that there was not going to be much of a market for topography, for as Constable said, reflecting a widespread view, 'A gentleman's park is my aversion. It is not beauty because it is not nature'.[17] The kind of picturesque landscape with which O'Connor was experimenting before leaving Ireland was very much the norm in England; John Crome and the Norwich School, David Cox, John James Chalon, William Delamotte, and scores of others were producing pictures in a similar vein.

O'Connor, perhaps predictably, appears to have found it difficult to make a living during his first few years in England, and in 1826 he set out on a journey to Belgium in the company of a picture dealer, presumably to try his luck further afield. This decision to go abroad, while not exactly common, was not unusual for an artist of that period. There was an appreciable increase in continental travel after the Napoleonic wars, and a potential market for English painting across the Channel: Constable, Bonington, Eastlake, and Callcott all had some success in Paris, and before the 1830s English art was widely believed to be the best in Europe. One can safely assume, then, that the dealer who took O'Connor to Belgium anticipated that they might be able to reap the benefits of this state of affairs, and that O'Connor had the same idea in mind when he subsequently went to France in 1832.

When O'Connor travelled on from France to Germany, however, it was a decision based on a chance meeting — a seed, as it were, which fell on fertile ground. O'Connor had before him the example of his friend Danby, who journeyed down the Rhine in 1831. Moreover, Germany was becoming very fashionable as a source of romantic inspiration — the picturesque scenery, local customs, and historical sites all contributing to its appeal. As was the case with Danby, and in Turner's expedition to Germany in 1817, tours usually

took in the Rhine (particularly the stretch between Cologne and Mainz, and often tributaries like the Moselle), perhaps because the Rhineland had been made famous by contemporary literature, and especially by Byron's *Childe Harold*, one of his most popular works, in which a descriptive account of the area is given in Canto 3 (1818).[18] It is not surprising, therefore, that O'Connor's journey followed this route almost exactly.

Barely a handful of O'Connor's continental pictures are now known, but on the basis of available evidence it appears that his travels had little effect on his style. The dramatic characteristics which are evident in his extant German paintings can be found in a more pronounced form in his other works of the period, and, rather unexpectedly, German and French Romanticism had no impact on his painting — although there are some similarities, probably coincidental, between O'Connor's pictures and those of Caspar David Friedrich. Before going to France and Germany, O'Connor had already begun to paint in a manner which was resolutely romantic in tone and conception, and while there were signs of this development before 1830 — plenty of dark wooded glades and solitary figures, for example — at that point his style changed gear and moved into a different realm, one which was at the same time more 'real' and more subjective. By 1833 O'Connor's Romanticism was already in its stride.

The full character of Romanticism is too complex to discuss here in any detail, so for the sake of simplicity, if not of total accuracy, I shall assume that the essence of romantic landscape painting — its melancholy and drama — is created by a condition of inner struggle in the artist's consciousness.[19] This sense of alienation and perplexity can be explained in two basic ways, which are not mutually exclusive. First of all, there are the psychological causes of this 'malaise'. In O'Connor's case, we know that he had long been labouring, without much success, in the production of picturesque views, and that he was almost certainly missing what he once referred to as Ireland's 'Wild and beautiful scenery'.[20] It is arguable, therefore, that O'Connor threw caution to the winds, ignored the constraints of the market-place, and because of the emotions that were driving him to desperation, painted a series of gloomy pictures which reflected his depressed state of mind. This rationalization of O'Connor's Romanticism may well be — indeed, probably is — correct. Concurrently, though, there were other, less subjective, forces at work on the evolution of his style, which was largely conditioned by ideas and experiences that were shared by others.

Adams, for instance, is enlightening about the cultural background to Danby's most romantic and forbidding pictures, such as *The Opening of the Sixth Seal* (cat. no. 17)[21]. He explains that there was a general state of insecurity in England after the Napoleonic Wars, and that it was widely believed at the time that society was about to undergo dangerous social changes. In some quarters, in fact, there was something of an obsession with doom. Thus

the theme of Thomas Campbell's poem *The Last Man*, a prophetic vision of the total destruction of the human race, was immensely popular in the 1820s — to the extent that it was the basis of a novel by Mary Shelley, a parody by Thomas Hood, and a series of illustrations by John Martin. Nor were these exceptional: there were other poems about the end of the world, such as Byron's *Heaven and Earth* and *Darkness* and Barry Cornwall's *Flood of Thessaly*, as well as the poetry of Shelley, Keats, and Coleridge, which was not apocalyptic, but contained a significant proportion of images of dark glades, impenetrable forests, and gloomy ruins.

The reasons for this mood of unease and insecurity are obvious enough. Economically, the first thirty years of the nineteenth century were a critical period in the Industrial Revolution, in which the new technical expertise was applied to a new range of commercial activities, with an ensuing transfer of economic muscle from the landowning classes to urban businessmen and merchants. This era also marked a definite change in the mood of British intellectuals, who, after the excesses of the French Revolution and the reestablishment of successive tyrannies there, rather lost their enthusiasm for new regimes. As Arthur Klingender has pointed out, they were depressed by 'the unexpected frustration of hopes placed in science and political reform, and their despondency was further heightened by twenty years of war with France'. This, he argues, 'led to a revival of the eighteenth century taste for the sublime. The stresses and contradictions arising from the conflict of classes in a rapidly changing economy were dramatized as a struggle between "man" and "nature" or between rival forms in nature'.[22]

Whether or not romanticism can be accepted as primarily rooted in the 'class struggle' is, of course, debatable, but the main thrust of Klingender's argument, that the renewed taste for the 'Sublime' (or Romanticism — its new guise) can be associated with social upheaval, seems beyond question. Put another way, as another left-wing historian, Ernst Fischer, has remarked: 'The romantic attitude could not be other than confused, for the petty bourgeoisie was the very embodiment of social contradiction, hopeful of sharing in the general enrichment yet fearful of being crushed to death in the process, dreaming of new possibilities yet clinging to the old security of rank and order... In the capitalist world the individual faces society alone, without an intermediary, as a stranger among strangers'.[23]

How do these ideas advance our understanding of O'Connor's work? They at least suggest that O'Connor was not alone in being caught up between the old world and the new, finding himself deprived of traditional patronage, and failing to summon up the strength or talent to carve out a niche for himself in a changing society. (It is worth noting here that O'Connor, as late as 1836, still hoped for commissions from his old patron, the Marquis of Sligo). It also makes it easier to see why the sentiments of Romanticism were so universal, and how the pictorial 'language' employed by an artist could be understood.

24

After all, the visual conventions implicit in any work of art normally correspond to a set of perceptions shared by an artist and his public, however small that audience may be.

The visual 'ideology' of eighteenth century landscape painting has already been briefly discussed, and it remains to shed some light on the content of O'Connor's romantic pictures. It should be stressed, that because romanticism was fundamentally a middle-class way of thinking, and one which put great store on individualism, there are often no signs of commitment to one stratum of society or another. This does not mean, however, that romanticism is necessarily escapist or devoid of social implications. Ronald Paulson has convincingly shown, for instance,[24] that Turner not only used revolutionary metaphors in his paintings, but was also radical in his replacement of natural objects with an innovative use of paint as an expressive medium. And Constable, like Wordsworth, was revolutionary in his search for fundamental changes in subject-matter and sources of inspiration — a quest which led to a fruitful battle between a desire to represent the landscape as he saw it and a wish to express his own feelings, with the consequent subjection of the landscape to a form of personal control. This was an attitude which O'Connor shared, at least in his romantic period: his landscapes were excluded from specific historical and social contexts, and given personal impetus. But unlike the romantic landscapes of Turner and Danby, those of Constable and O'Connor were always founded on a more or less naturalistic approach to the subject — their pictures are in that sense not imaginary.

In *Literary Landscape*,[25] Paulson goes on to submit aspects of romanticism to a form of psychoanalysis, which, because of the pronounced emotional content of the subject-matter, sometimes yields interesting observations. In his view, the 'Sublime' acts as a block to the 'Beautiful', which is symbolic of a peaceful past, of childhood and nature — of the alternatives to adult agony, strife, and suffering. The 'Sublime', Paulson further argues, prevents access to the 'Beautiful' (or 'female') by its threatening, generally 'male' shapes. James B. Tritchell has followed a similar interpretative course. The horizon (which is roughly equivalent to the 'Beautiful'), he reasons, is supremely important to romantic paintings because 'the contemplation of the horizon directs attention to speculation about what lies beyond it', and 'ultimately, in Romanticism, nature up too close is what confines the self, what prevents expansion'.[26]

Unlikely though it may seem, we find that by applying all these ideas to O'Connor's late work, they coalesce rather satisfactorily; the artist's unsettled life in a transitional state of society accords with both psychological and social interpretations of romanticism. And when we look at the pictures themselves, we also discover that, unlike his picturesque views (which often contain several small figures in the landscape, contentedly going about their business), the romantic paintings usually show only a single person, which

serves to emphasize a mood of isolation. The landscapes are dark and foreboding, their horizons frequently obscured, with only a hint of blue sky which seems to beckon invitingly from behind sombre trees or high, inaccessible, rocks. The terrain is rough and untamed, and man is portrayed as an intruder or stranger. And unlike eighteenth century 'Sublime' landscapes, where figures are included merely to define scale or for human interest, O'Connor intends the viewer to identify with his protagonists — with the solitary man staring out at us in *The Eagle's Rock, Killarney* (cat. no. 72), and with the driver in *A Thunderstorm: The Frightened Wagoner* (cat. no. 73). As Hugh Honour has written about O'Connor's great German contemporary, Caspar David Friedrich, the figures are 'extraneous to the landscape ... neither wholly of its world nor of ours, standing on the edge of reality. Motionless, isolated, they seem to be both within and yet somehow outside nature, at once at home in it and estranged — symbols of ambiguity and alienation'.[27]

It is perhaps this call to identification with the figures in these tense, melancholy landscapes which accounts for their lack of popularity. *The Poachers* (cat. no. 79), with its low horizon, open distances, and group of men with their backs to the viewer, is the only romantic picture by O'Connor that has ever been much liked by the public). At the same time, however, the stringent balance between the implied threat of the landscape and the dogged uprightness of the solitary 'strangers' gives these pictures an enduring ability to convey a sense of hard-won optimism.

Finally, because O'Connor's romantic paintings depend for their effect on the observer's acceptance of them as naturalistic — which, by and large, they are — it is more difficult to distance oneself from them, or to treat them, like Danby's later work, as fantasy or escapism. In their own way, O'Connor's romantic images can speak to us as vitally now as they did to his contemporaries. Therein, I think, lies their significance. Moreover, they justify John Berger's assertion that the history of landscape painting is a movement from direct description to self-expression, from either topography or emblematization to 'landscapes of the mind'.[28] In O'Connor's work can be seen the progression of the eighteenth to the nineteenth century; his 'portraits of houses' are thoroughly conditioned by his patrons' expectations, his picturesque views are idealized, but the romantic paintings provide us with surprisingly direct access both to the artist's times and to a genuinely personal perception of life.

1. George Nicholls, one of the architects of the Irish Poor Law, made this comment. (Cited in L.M. Cullen, *Life in Ireland*, London, 1976, p. 126). Such descriptions of rural poverty at the beginning of the 19th century were not uncommon. As B.A. Hutchinson points out, ('On the Study of Non-Economic Factors in Irish Economic Development', *Economic and Social Review*, Vol. 1., No. 4, Dublin, 1970, p. 511), 'The received nineteenth-century English opinion of the Irish people is familiar enough to require little illustration: it was on the whole a derogatory opinion. But it is essential to view this in its contemporary perspective, for such opinions were not at all unusual. Shelley, liberal idealist though he was, described the Italians as '... a tribe of stupid and shrivelled slaves ...' In Germany, Mary Shelley noted '... the horrible and slimy faces of our companions in voyage ... Our only wish was to absolutely annihilate such uncleanly animals...'. The Rev. G. R. Gleig found the Slavonian villages he passed through in the 1830s, 'nowhere remarkable for their cleanliness, but anything to approximate the filth of St Marton I never beheld ... I remember it as the most perfect sink of abominations into which my evil fortune has ever led me'.

2. See M. Rosenthal, *Constable: The Painter and his Landscape*, Yale, 1983.

3. As Michael Rosenthal observes in *British Landscape Painting*, Oxford, 1982, p. 118, 'The post-war agricultural depression meant penury for the poor, and social concord was shown as an illusion by disturbances in East Anglia in 1816 and 1822: disturbances, however, differing from the traditional bread-riots, for these were labourers rioting for work. The availability of machinery and a reduction in corn prices encouraged farmers to lay men off rather than pay them for doing nothing'. The Norwick School made few, if any, references to these disturbances in its paintings.

4. For a full description of such tours, see E. Malins and The Knight of Glin, *Lost Demesnes*, London, 1976.

5. See M. Nicolson, *Mountain Gloom and Mountain Glory*, Ithaca, 1959. A good account of the development of interest in mountain landscapes is also given in *Presences of Nature* — an exhibition catalogue written by Louis Hawes for the Yale Center for British Art in 1982.

6. For further discussion of these ideas, see M. Rosenthal, *British Landscape Painting*, pp. 21-42.

7. Rosenthal, op. cit., p. 60.

8. Rosenthal, *Constable*, p. 36.

9. W. G. Strickland, *A Dictionary of Irish Artists*, Dublin and London, 1913, Vol. II, p. 607.

10. A. Crookshank and The Knight of Glin, *The Painters of Ireland*, London, 1978, p. 173.

11. For further information on this subject, see L. M. Cullen, op.cit., and C. Maxwell, *Country and Town in Ireland under the Georges*, London, 1940.

12. Rosenthal, op.cit., and J. Barrell, *The Dark Side of the Landscape*, Cambridge, 1980.

13. R. McHugh and M. Harmon, *A Short History of Anglo-Irish Literature*, Dublin, 1982, p. 85.

14. P. Rafroidi, *Irish Literature in English — The Romantic Period*, Gerrards Cross, 1980, Vol. 1, p. 39.

15. Rafroidi, ibid.

16. E. Adams, *Francis Danby — Varieties of Poetic Landscape*, Yale, 1973, pp. 3-4. 'It may be assumed ... that Danby's nationality had a possible bearing on the politics of his career but no effect on his art, which developed along lines laid down by English taste'.

17. *Constable's Correspondence*, VI, p. 98.
18. For an account of English interest in Germany and her art, see: W. Vaughan, *German Romanticism and English Art*, Yale, 1979.
19. Probably the most satisfactory analysis of the Romantic movement can be found in H. Honour, *Romanticism*, London, 1979.
20. Letter from O'Connor to John Gibbons, August 28th, 1830.
21. Adams, op.cit., p. 77.
22. F. D. Klingender, *Art and the Industrial Revolution*, St. Albans, 1972, p. 104.
23. E. Fischer, *The Necessity of Art*, Harmondsworth, 1978, pp. 53-54.
24. R. Paulson, *Literary Landscape: Turner and Constable*, Yale, 1982.
25. Paulson, op.cit., p. 11 etc.
26. J.B. Tritchell, *Romantic Horizons — Aspects of the Sublime in English Poetry and Painting 1770-1850*, Columbia, 1983, p. 8.
27. Honour, op.cit., p. 81.
28. J. Berger, *Ways of Seeing*, London, 1972, p. 105; and Paulson, op.cit., pp. 8-9.

Predecessors
and
Contemporaries

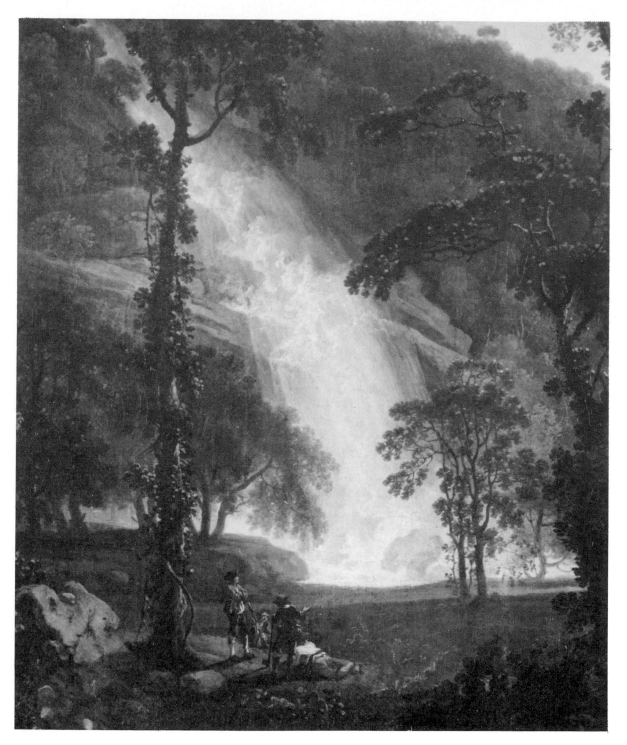

Detail of *Powerscourt Waterfall*, c.1760. (Cat. No. 2)

GEORGE BARRET

(1728/32-1784)

BORN IN DUBLIN, Barret's birthdate is still uncertain, being noted variously as 1728 and 1732. He began his career as an apprentice to a staymaker but later became a pupil of Robert West at the Dublin Society Schools, winning a first prize in 1747. He often studied from nature, sketching views in Wicklow of the Dargle and Powerscourt Demesne. Finding little support in Ireland, however, he left in 1762-63 to go to London where, from 1764 to 1768, he exhibited his works at the Society of Artists as well as with the Free Society. His compositions were greatly admired and he received many important commissions. It was at this time that he befriended his fellow countryman James Barry. Barret was very active in the artist life of London at this time and is listed among the founder members of the Royal Academy, (1768), exhibiting there until 1782. Despite the popularity of his work Barret became bankrupt in the 1780s, a situation be brought upon himself through his spendthrift ways. Through the intervention of Edmund Burke he was appointed Master Painter to Chelsea Hospital and saved from financial ruin. Barret died soon after this appointment, in 1784, and was buried in Paddington Church, close to where he had spent his last years. One of the best known Irish landscape painters, Barret's sons Joseph, James and George also became artists.

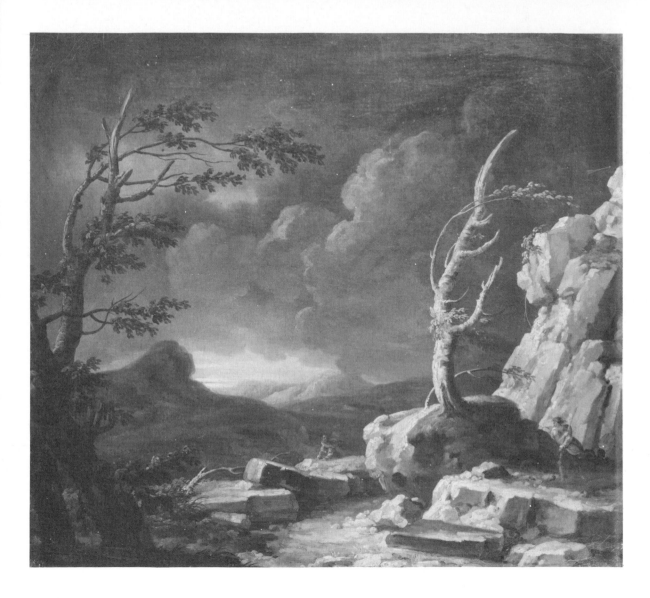

George Barret

1. A Stormy Landscape, *c.1760*

Oil on canvas,
55.0 x 60.0 cm.,
(21⅝ x 23⅝ ins.).

PROVENANCE:
Presented by Mrs. A.
Bodkin through the
Friends of the National
Collections, 1963; N.G.I.
Cat. No. 1760.

A Stormy Landscape, traditionally attributed to George Barret, closely resembles an earlier painting that was once ascribed to Salvator Rosa, but which was recently given to Marcantonio Sardi.[1] In any case this one is a Rosa pastiche, and if it was painted by Barret, it suggests that the artist had fully absorbed Edmund Burke's ideas about the 'Sublime'. (Barret knew Burke, who helped him in his early career).

Many of the 'Sublime' characteristics of this picture — the dark clouds, windswept trees, and mood of desolation — can be seen in a developed form in paintings by O'Connor such as *A Thunderstorm: The Frightened Wagoner* (cat. no. 73) and *The Glen of the Rocks* (cat. no. 71).

1. See catalogue of Sotheby's sale, October 27th, (1976), lot. 56, illus. 8.

Lent by the National Gallery of Ireland.

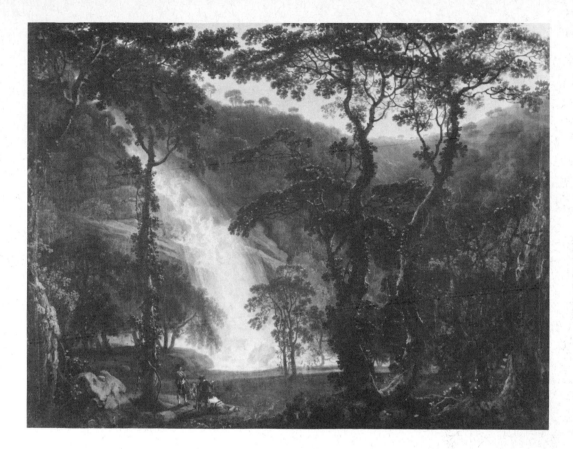

George Barret

2. Powerscourt Waterfall, c.1760

Oil on canvas,
100.0 x 127.0 cm.,
(39⅜ x 50 ins.).

PROVENANCE:
Purchased, London,
Christie's, 1880; N.G.I.
Cat. No. 174.

Powerscourt Waterfall was a major tourist attraction by the 1760s, when Barret painted this picture. The waterfall is typically 'Sublime', but the artist modified its 'Sublimity' by introducing 'beautiful' elements, such as the golden sky in the background. Unlike O'Connor's figures in his romantic landscapes, Barret's staffage adds nothing to the painting but a definition of the scale of the waterfall. O'Connor, as a young artist, is said to have spent a great deal of time painting in the nearby Dargle Valley, and at least one view of the waterfall by O'Connor has been exhibited in the past. (see appendix 1).

Edward Malins and The Knight of Glin have observed with reference to Powerscourt Waterfall: 'as early as 1741, the Reverend Edward Chamberlayne's eulogistic couplets echo the prevailing Augustan taste with regard to art and nature, and exhibit the customary sycophancy towards the owner ... Pococke on his tour in 1752 admired the scene; and a picturesque traveller who had seen both Killarney and the Giant's Causeway as early as 1761 was so charmed by the waterfall that he doubted whether he was "awake or in some scene of enchantment ..." Arthur Young was unusually picturesque in his response: "the shade is so thick as to exclude the heavens: all is retired and gloomy, a brown horror breathing over the whole. It is a spot for melancholy to muse in.'[1]

1. Edward Malins and The Knight of Glin, *Lost Demesnes*, p. 174.

Lent by the National Gallery of Ireland

JONATHAN FISHER

(fl.1763-1809)

FISHER, BORN IN DUBLIN, is first recorded in 1763 when he was awarded a premium by the Dublin Society for a landscape. Despite this award, Fisher does not appear to have studied at the Dublin Society Schools as he started his career as a woollen draper. From 1765 until 1801 he exhibited his work at the Society of Artists, where he won a prize for the best landscape in 1768. He is best known for his fine engravings and aquatints of Irish scenery though he does not appear to have enjoyed much success during his lifetime. Fisher travelled all over Ireland, making series of engravings:- in 1770 he published views of Killarney and in 1789 again. In 1792 he commenced, for the first time, a comprehensive series consisting of sixty plates of views of Irish scenery. He held the post of Supervisor of Stamps in the Stamp Office for some time. Fisher resided in Great Ship Street from about 1778 until 1805 when he moved to Bishop Street where he died in 1809. In the sale of the contents of his house there were sixty-five paintings by other artists which Fisher had collected, including works by George Barret, Richard Wilson, Gainsborough and Angelica Kauffmann.

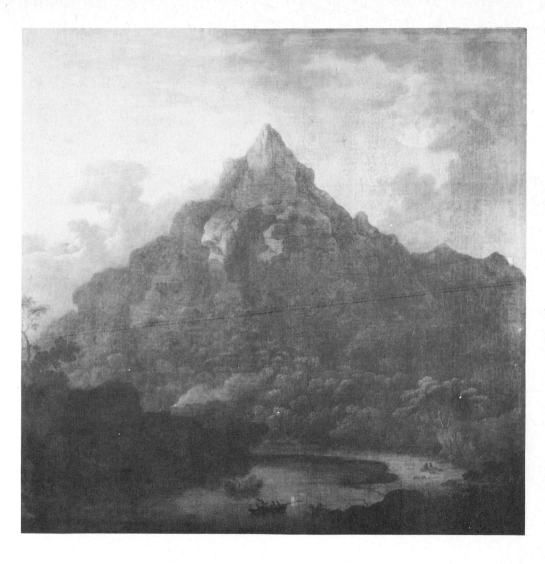

Jonathan Fisher

3. The Eagle's Nest, Killarney, *c.1770*

Oil on canvas,
117.0 x 117.0 cm.,
(46 x 46 ins.)

PROVENANCE:
Purchased, Mr. A.
Thompson, Belfast, 1967;
N.G.I. Cat. No. 1813.

When Fisher painted *The Eagle's Nest, Killarney*, it was a 'Picturesque' attraction and frequently the subject of landscapes. Visitors in search of the 'Sublime' and 'Picturesque' 'embarked amid the wild and sublime grandeur of the upper lake with its many islands and tremendous mountains, then they passed between the perpendicular cliffs called Coleman's Eye, under the Eagle's Nest, a rugged cone-shaped mountain, towering over the river, thickly wooded at the base. In this three-mile strait between the lakes, unearthly echoes of horn and trumpet can be made to ring round, especially on a summer's evening when the winds are still.'[1]

O'Connor, painting the Eagle's Rock (cat. no. 72) some fifty years later than Fisher, chose to ignore its picturesque aspects, and to concentrate on a personal, romantic image of solitude — which could, in fact, have been set in almost any wooded valley.

1. Edward Malins and The Knight of Glin, *Lost Demesnes*, (1976), p.162.

Lent by the National Gallery of Ireland.

THOMAS ROBERTS

(1748-1778)

BORN IN WATERFORD in 1748, Thomas was the eldest son of the architect John Roberts. He entered the Dublin Society's Schools in 1763, winning a prize in his first year there. A pupil of the landscape artists James Mannin, George Mullins and John Butts, by 1766 he was showing his work at the Society of Artists, and one of the paintings shown there won him the Dublin Society's premium for the best landscape. Quickly establishing a reputation for himself, his art attracted many eminent patrons from among the establishment, including the Duke of Leinster, Viscount Powerscourt, Viscount Cremorne, the Earl of Ross and Earl Harcourt. Due to ill health, however, he was compelled to leave Ireland and he travelled to Lisbon, but soon after his arrival there in March 1778 he died.

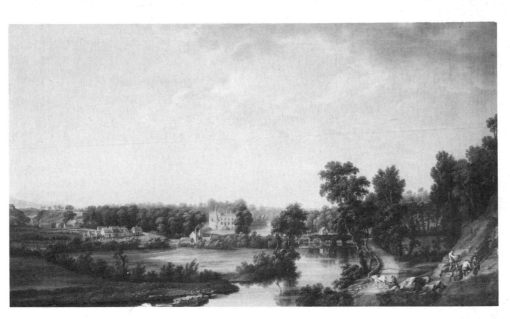

Thomas Roberts

4. Lucan House and Demesne, *c.1770*

Oil on canvas,
60.5 x 100.0 cm.,
(23¾ x 39⅜ ins.).

PROVENANCE:
Commissioned by
Agmondisham Vesey of
Lucan House; by descent
to Captain R. St John
Colthurst, by whom sold
at the Lucan House sale,
29 September, 1925, lot
115, where purchased by
the Wright family of
County Monaghan;
purchased from Mrs.
Marshall Wright, 1983;
N.G.I. Cat. No. 4463.

EXHIBITED:
Society of Artists in Ireland,
1772, (60), *View of the
house and domain of Agm.
Vesey Esq; at Lucan, from
the low road. National
Gallery of Ireland,
Acquisitions 1982-83,* 1984,
(19).

LITERATURE:
G. Breeze, *Society of Artists
in Ireland Index of Exhibits
1765-80,* (1985), p. 24,
illus. 16.

This delightful painting by Thomas Roberts shows Lucan House and Demesne from the Dublin road. It embodies many of the conventions of the eighteenth century 'house portraiture' — a high perspective, the patron's house and grounds in the centre of the composition, cottages sited around it and labourers working industriously. The house's owner, the picture implies, is cultivated and benevolent. The picture is one of a set of four.

The Westport and Ballinrobe series are part of this tradition, but O'Connor never quite equalled Roberts' excellence. In any case, as George Mulvany observed, 'artificially illustrated demesne scenery was not to his (O'Connor's) taste.'[1]

1. 'M' (George Mulvany), *Dublin Monthly Magazine*, April, 1842.

Lent by the National Gallery of Ireland.

WILLIAM SADLER

(1782-1839)

WILLIAM, THE SON of the portrait painter and engraver William Sadler, was born about 1782 and worked in Dublin, painting views of the countryside around the city. At intervals between 1809 and 1821 he exhibited his paintings, mainly on small mahogany panels, in Dublin and in 1828 and 1833 he exhibited at the Royal Hibernian Academy. He also taught painting and James Arthur O'Connor was one of his pupils.

Sadler was greatly influenced by Dutch genre painting and this influence is best seen in his landscape compositions where small figural groups have been incorporated. Moving from place to place Sadler finally settled in Manders' Building, Ranelagh, where he died in December 1839 at the age of fifty-seven. His son William, also a painter, continued to work in the same tradition as his father.

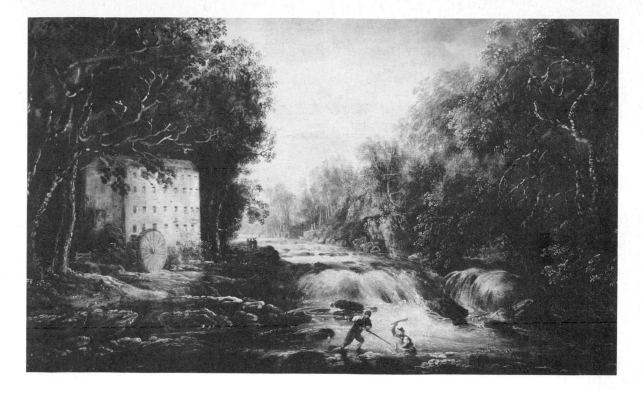

William Sadler

10. A View of the Salmon Leap, Leixlip, *c.1810*

Oil on panel,
30.0 x 48.0 cm.,
(11¾ x 18⅞ ins.).

PROVENANCE:
Mrs. G. Little, Dublin;
from whom purchased,
1965; N.G.I. Cat. No.
1776.

Sadler is said to have taught O'Connor to paint (see Biography), but their styles are not particularly alike. O'Connor's early topographical works, with their deliberate, slightly laboured technique, do have something in common with Sadler's manner of handling paint, but the latter was usually cruder and more stylized. It is possible, however, that if we were to discover some signed paintings by O'Connor that were dated before 1815,

the parallels between their work might be closer.

O'Connor also painted *The Salmon Leap*, (which is presently in a private collection, Dublin) a scene that was depicted by Francis Wheatley, among other 18th century artists. The fishermen in Sadler's picture are probably poachers — the subject of one of O'Connor's most celebrated landscapes (cat. no. 79).

Lent by the National Gallery of Ireland

45

THOMAS SAUTELLE ROBERTS

(c.1760-1826)

THOMAS SAUTELLE was the younger brother of Thomas Roberts, having being christened Sautelle after his Huguenot mother. Following in his father's footsteps, he started as an architect and studied in the Dublin Society's Architecture Schools. He later became an apprentice to Thomas Ivory, though he soon abandoned this choice of career to turn to painting. This perhaps was due in part to his wishing to take up his brother's practice. He appears to have visited London quite regularly exhibiting at the Royal Academy between 1789 and 1811 and at the British Institution in 1816. He also contributed, at intervals, to exhibitions at the Society of Artists in Dame Street, Dublin from 1800 to 1821.

Thomas Sautelle Roberts chiefly painted canvases showing views of the scenery around Dublin and Wicklow, particularly the countryside around the Dargle. Held in high esteem in the Dublin artistic circles of the time he was, with William Ashford and William Cuming, selected for the exhibition committee for the first Academicians of the Royal Hibernian Academy. He himself, showed seven paintings at the first exhibition in 1826. This, unfortunately was also his last exhibition as he died shortly after. Having received an injury to his right shoulder in a travelling accident a few years previously he found he could no longer use his hands, this effectively prevented him from painting, and he fell into a state of great melancholy. Eventually, in 1826 he took his own life, dying in his house in Portobello.

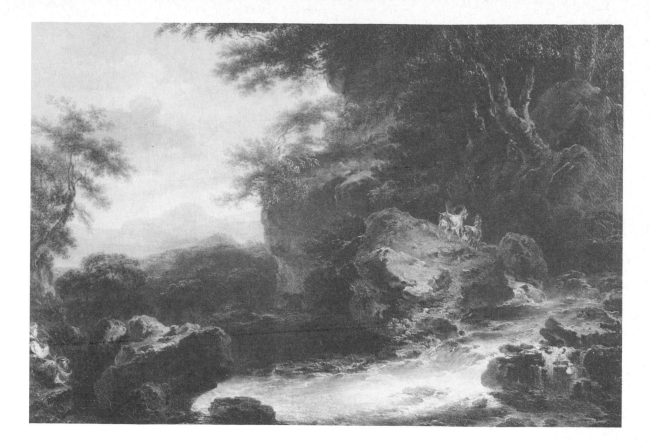

Thomas Sautelle Roberts

11. A Landscape, c.1810

Oil on canvas,
57.0 x 83.0 cm.,
(22½ x 32¾ ins.).
Signed: T.S.R.

PROVENANCE:
Mr. E. Machin, from
whom purchased, 1923;
N.G.I. Cat. No. 848.

Thomas Sautelle Roberts painted scenery in the Dargle Valley, but he did so in a looser, more generalized way than O'Connor. This landscape is 'Picturesque' in the strict sense of the term: Roberts has brought together the 'Beautiful' (the golden light, and shepherd boy and full unfolding trees) with the 'Sublime' (the gushing stream, the rocks and the goat). The result is a pleasant, but rather ineffectual picture.

Lent by the National Gallery of Ireland

JOSEPH PEACOCK

(c.1783-1837)

PEACOCK PRACTISED FOR many years as a painter in Dublin from 1810 to 1826 at 40 Great Strand Street, and afterwards, until his death at 21 Bachelor's Walk. Throughout the years 1809 to 1821 he contributed to a number of exhibitions in Dublin. During 1826 to 1835 he exhibited in the Royal Hibernian Academy where he was chosen as one of the original members on its foundation in 1823. In 1871 he exhibited a painting in London at the Royal Academy and the following year showed the same painting at the British Institution. It is thought that Peacock added figures to some of James Arthur O'Connor's landscapes. He painted chiefly outdoor fair scenes which demonstrate his careful attention to detail, as well as the influence of Dutch genre painting on his work. He died of dropsy in 1837 in his house on Bachelor's Walk at the age of fifty-four.

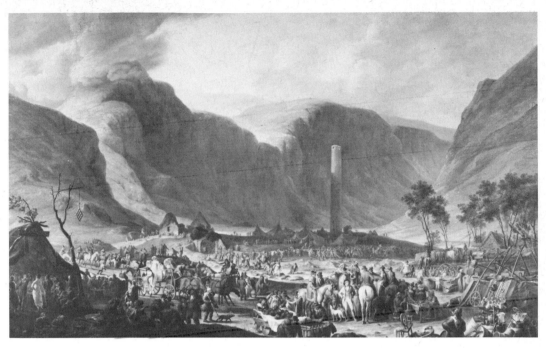

Joseph Peacock

12. Glendalough, *1813*

Oil on panel,
86.4 x 137.8 cm.,
(34 x 54¼ ins.).
Signed and dated:
J. Peacock Pinxit 1813.

PROVENANCE:
Lord Deramore, Belfast
c.1865; Lady Edith Dixon,
O.B.E., Belfast, 1964;
Ulster Museum Belfast.

EXHIBITED:
Royal Academy, 1817,
(390).

LITERATURE:
Walter Strickland, *A
Dictionary of Irish Artists,*
(1913), Vol. II, p. 223;
Anne Crookshank and The
Knight of Glin, *The
Painters of Ireland,* (1978),
p. 195, illus. 185, 186;
Jeanne Sheehy, *The
Rediscovery of Ireland's Past,
The Celtic Revival
1830-1930,* (1980), p. 32,
illus. 32, 33; Brian de
Breffny, *Heritage of Ireland,*
(1980), p. 60, illus. 62,
63.

Joseph Peacock, like William Sadler, copied 17th century Dutch paintings, and he is reputed to have painted the figures in some of O'Connor's paintings in 1819 and 1820. None of these pictures are now known, although two were exhibited in the O'Connor Centenary Exhibition in 1841. This picture was exhibited in 1817, with the title *The Patron (sic) or Festival of St. Kevin at the Seven Churches, Glendalough.* It depicts the Pattern at Glendalough, a country religious festival, and contains vivid images of peasantry that are probably close to reality. Peacock artificially heightened the mountains and the round tower, to make them more picturesque.

Lent by the Ulster Museum, Belfast

49

JOHN HENRY CAMPBELL

(c.1755-1828)

BORN IN 1755 in Herefordshire John Henry's family eventually settled in Dublin and it was there that he attended the Dublin Society's School. A painter of landscapes in watercolours and oils, by 1800 he was exhibiting his paintings in the various Dublin exhibitions and continued to do so until his death in 1828. He also showed his work at the opening exhibition of the Royal Hibernian Academy in 1826 and again in 1828. Best known for his watercolours he painted views of Dublin, Bray, Wicklow and Killarney and other scenic parts of Ireland. Some of these were later engraved. Two of his children inherited his talent for art. His son John became a designer of patterns for damask and linen while his daughter Cecilia Margaret took up painting.

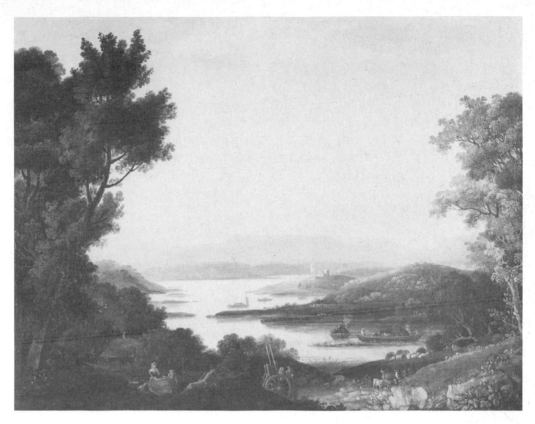

John Henry Campbell

13. View of Lough Erne, with Devenish Island and Round Tower, *c.1821*

Oil on canvas,
49.0 x 65.0 cm.,
(19¼ x 25⅝ ins.).

PROVENANCE:
By descent through family of the artist from whom purchased by present owner.

EXHIBITED:
Irish International Exhibition, Palace of Fine Arts, Dublin, 1907.

LITERATURE:
Walter Strickland, *A Dictionary of Irish Artists*, (1913), Vol. 1., p. 151.

Although Campbell's watercolours have long been well-known, his oils have only recently been identified.[1] Some of them, dark and introspective, are not dissimilar to O'Connor's romantic landscapes, although they were painted in a manner that was redolent of the 18th century.

This view of Lough Erne, with its 'Picturesque' Round Tower, combines topography with the style of classical landscapes, and, as such, is fairly typical of Irish painting of the period. O'Connor left Ireland for London about the time Campbell painted this picture.

1. Anne Crookshank and The Knight of Glin, *The Painters of Ireland*, (1978), p.191.

Lent by Mrs Marie Hickey

GEORGE PETRIE

(1790-1866)

GEORGE PETRIE, a close friend of both O'Connor and Danby, was born in 1790, the son of the miniature painter James Petrie. Showing an inclination for art at an early age he was sent to the Dublin Society's Schools where he won the silver medal in 1805 at the age of fourteen. He first assisted his father with miniature paintings but soon turned to landscape painting in watercolours, making his first sketching tour in Wicklow in 1808 followed two years later with a tour through Wales. He travelled to London with O'Connor and Danby visiting private and public collections, but he soon returned to Dublin, leaving his two colleagues behind, managing to pay his fare home by selling one of his paintings.

He was to make many sketching tours of Ireland and by 1819 was supplying illustrations for publications such as G.N. Wright's guides of Killarney, Wicklow and Dublin; Cromwell's *Excursions through Ireland*; Brewer's *Beauties of Ireland*, and many others. He also exhibited his delicate drawings and watercolours at the various Dublin exhibitions from 1809 to 1819 and was made an Associate of the Royal Academy in 1826 and became a full member in 1828 — the first watercolour artist to receive such an honour. In 1829 he became a Librarian at the Royal Hibernian Academy and until 1846 he worked in the Ordnance Office on the Topographical Survey of Ireland. During this period, being very interested in archaeology, he devoted much of his time to writing a book entitled *Ecclesiastical Architecture of Ireland*. After 1846 however, he returned to painting for a brief period. He died in 1866 and was buried in Mount Jerome.

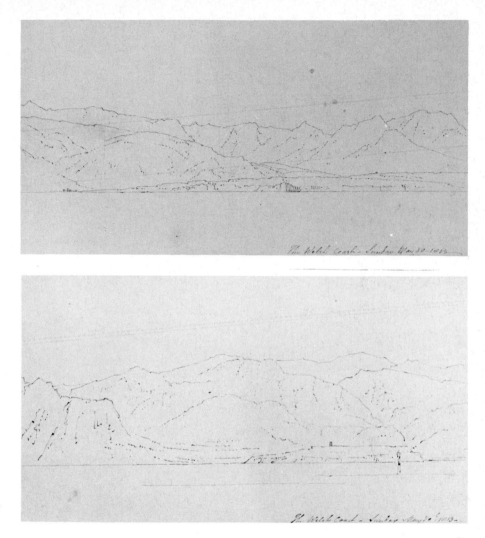

The Welsh Coast — Sunday May 30 1813

The Welsh Coast — Sunday May 30 1813

George Petrie

14. Drawings of the Welsh Coast, *1813*

a) ink over pencil on paper, 14.3 x 26.5 cm., (15⅝ x 10½ ins.). Dated: Sunday 30th May 1813
b) ink over pencil on paper, 14.6 x 26.5 cm., (15¾ x 10½ ins.). Dated: Sunday 30th May 1813

PROVENANCE:
Miss M. Stokes Bequest, 1900; N.G.I. Cat. Nos. 6742 and 6745.

LITERATURE:
George Petrie, unpublished M.Litt. thesis by Peter Murray, Trinity College, Dublin, (1980).

These sketches were drawn in 1813, when Petrie, Danby and O'Connor set off together to visit London. Stylistically, they are very similar to O'Connor's drawings.

Lent by the National Gallery of Ireland

53

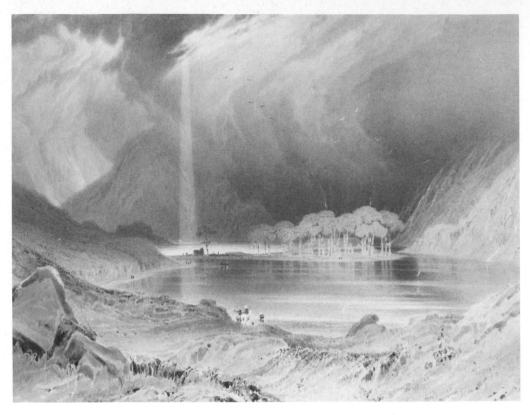

George Petrie

15. Gougane Barra Lake with the Hermitage of St. Finbarr, Co. Cork, *1831*

Watercolour on paper: 30.9 x 39.7 cm., (12⅛ x 15⅝ ins.). Inscribed and signed: To my friend R. Callwell by Geo. Petrie, R.H.A.

PROVENANCE:
Bequeathed by Miss A. Callwell, 1904; N.G.I. Cat. No. 6028.

EXHIBITED:
Royal Hibernian Academy, 1831 (226).

LITERATURE:
George Petrie, unpublished M.Litt. thesis by Peter Murray, Trinity College, Dublin, (1980).

Gougane Barra, near Ballingarry in Co. Cork, is surrounded by mountains, and St. Finbarr had a hermitage on an island in the lake. This view is one of the more dramatic of Petrie's watercolours: the artist's technique is as meticulous as ever but the lighting and the subject itself are typical of romanticism. It will be noticed that Petrie painted a specific hermitage with a fairly high degree of topographical accuracy, while O'Connor, at roughly the same date, painted images of solitary monks in generalized, yet 'realistic' landscapes. Even two friends, then, could paint similar romantic subjects with appreciable differences in approach.

Lent by the National Gallery of Ireland.

FRANCIS DANBY

(1793-1861)

BORN IN 1793, Francis was the youngest son of James Danby, a small landed proprietor of Co. Wexford. After the death of his father in 1807 he decided to take up art as a career and he studied in the Dublin Society's Schools with O'Connor and Petrie with whom he formed a close friendship. In 1813 he exhibited some of his pictures at the Society of Artists and from the proceeds of the sale of these works he travelled to London with Petrie and O'Connor. Due to shortage of money, however, he and O'Connor were forced to travel on foot to Bristol from whence the latter returned to Dublin, while Danby remained in Bristol until 1824 teaching and selling his watercolours. He first exhibited at the British Institution in 1820 and at the Royal Academy in 1822. In 1824 he moved to London, there becoming an Associate of the Royal Academy the following year. Due to unfortunate domestic crises, (the exact details are not known), he never became a full member of the Academy and his career was severly affected. Furthermore, he was compelled to leave England in 1830 for the Continent where he lived for ten years, both in France and Switzerland painting and drawing while also spending much of his time and money building boats. Danby returned to England in 1841 and exhibited once more at the Royal Academy. He was still not made a member, however, and this overshadowed the rest of his life. He also exhibited his works at the Royal Hibernian Academy from 1844. He died at his home in Exmouth in 1861.

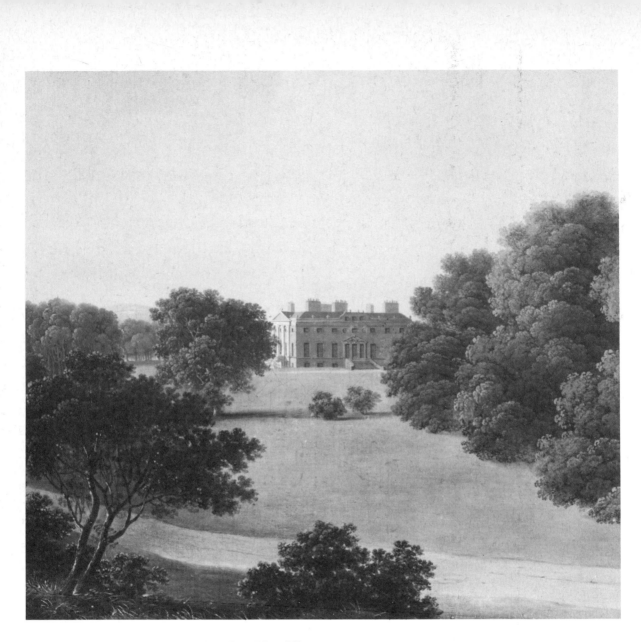

Detail of *Westport House*, c.1818. (Cat. No. 33).

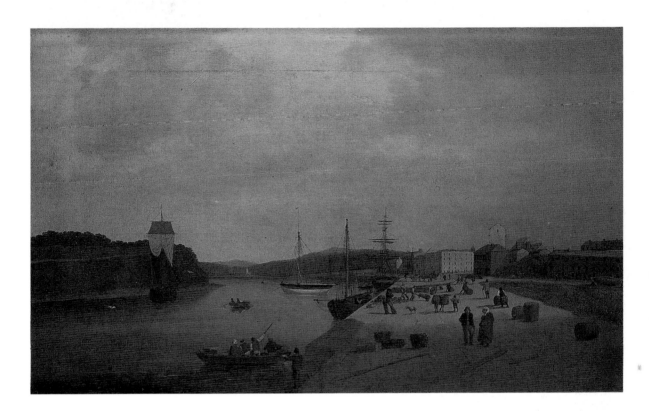

Cat. No. 29. James Arthur O'Connor — *Westport Quays*, 1818

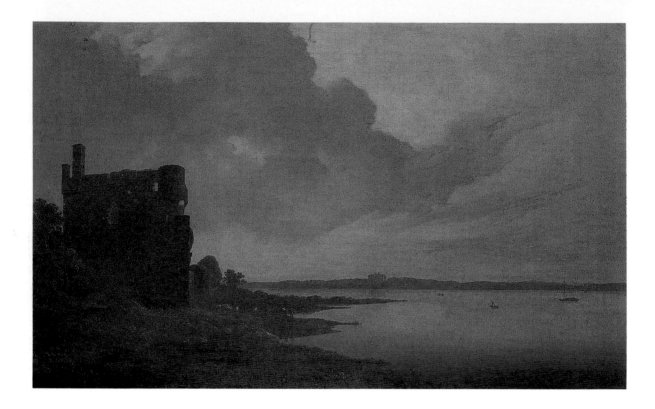

Cat. No. 32. James Arthur O'Connor — *View of Lough Derg with Portumna Castle in the Background*, 1818

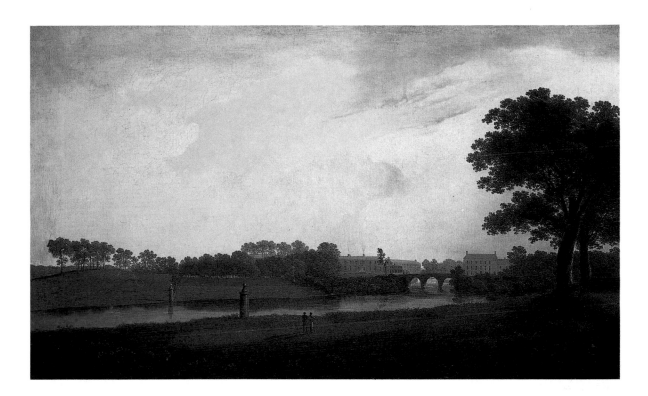

Cat. No. 34. James Arthur O'Connor — *Ballinrobe House*, c.1818

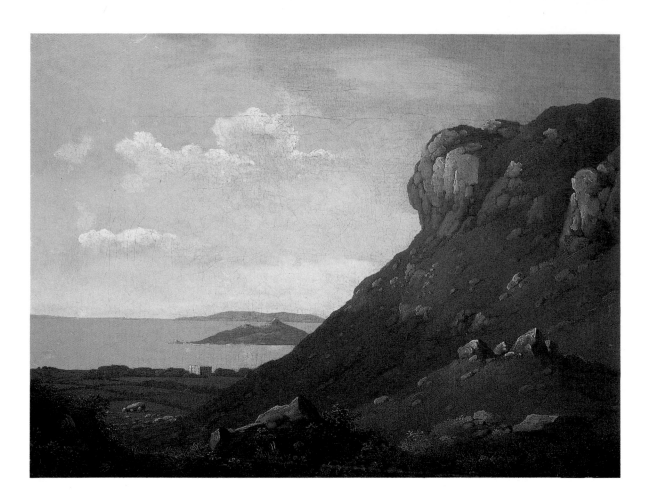

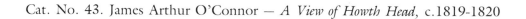

Cat. No. 43. James Arthur O'Connor — *A View of Howth Head*, c.1819-1820

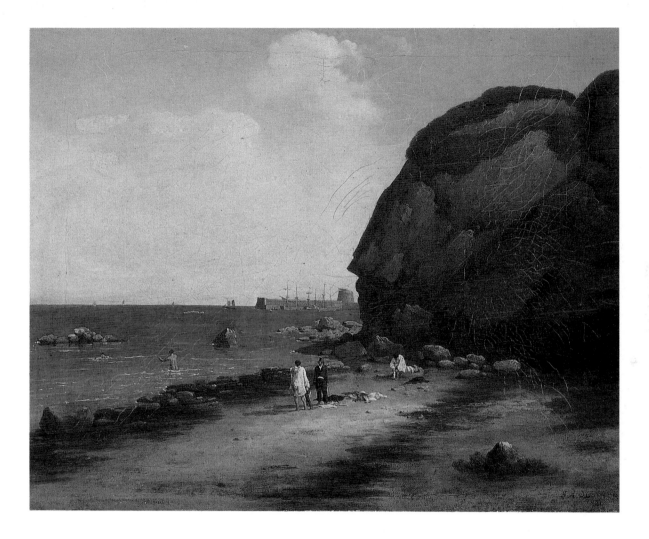

Cat. No. 44. James Arthur O'Connor — *Bay Scene, Seapoint*, 1820

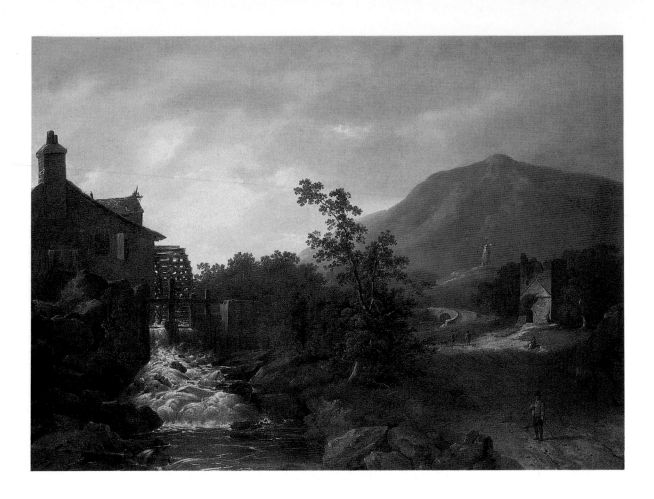

Cat. No. 46. James Arthur O'Connor — *Landscape with Mill*, 1821

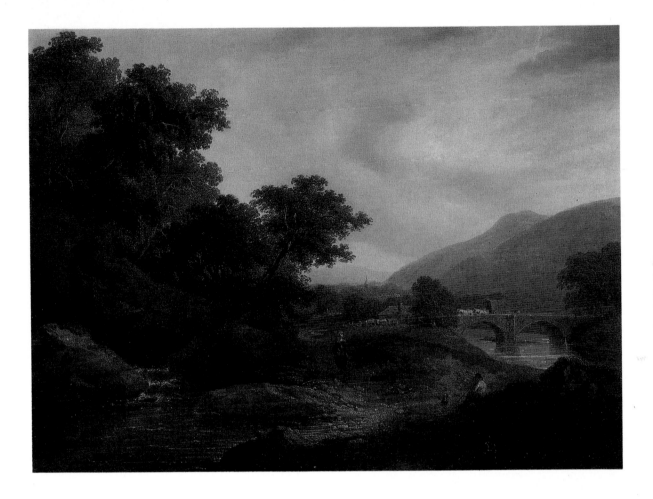

Cat. No. 49. James Arthur O'Connor — *A Wooded River Landscape*, 1823

73

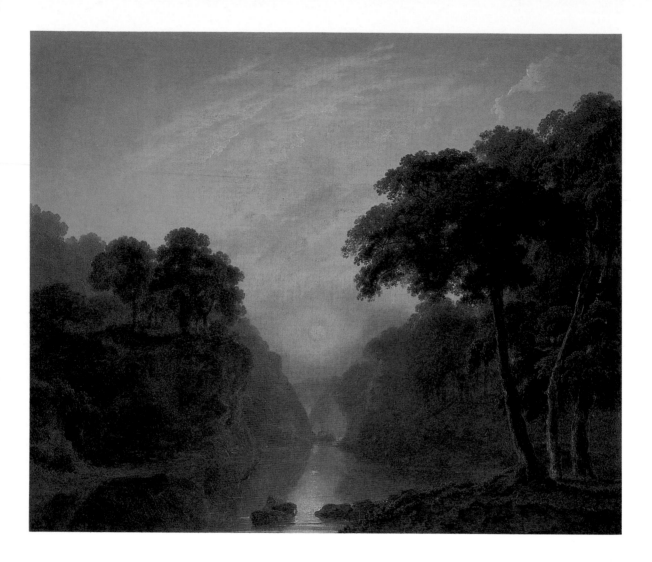

Cat. No. 59. James Arthur O'Connor — *River Scene,* 1826

74

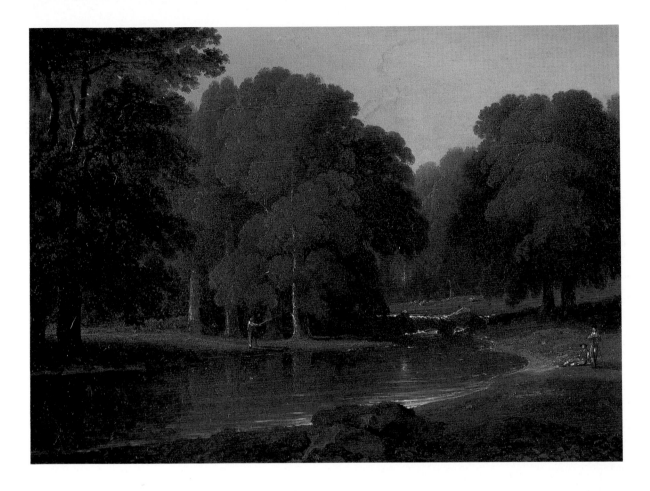

Cat. No. 60. James Arthur O'Connor — *A River Scene, Co. Wicklow,* 1828

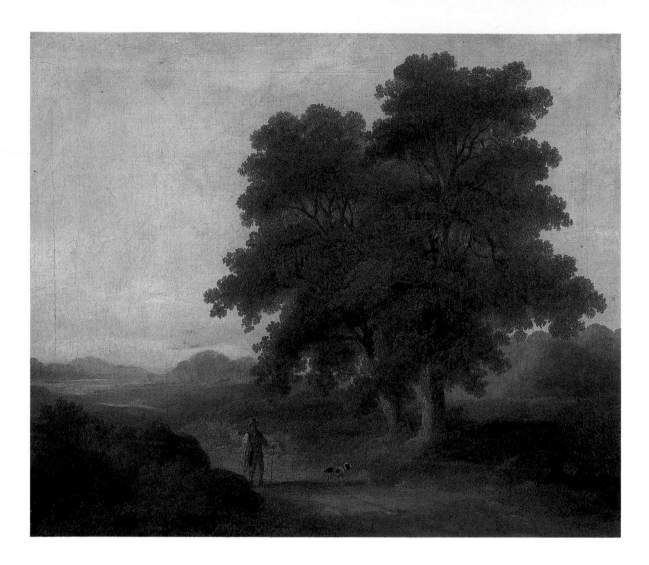

Cat. No. 63. James Arthur O'Connor — *Homeward Bound*, c.1825-1830

Cat. No. 73. James Arthur O'Connor — *A Thunderstorm: The Frightened Wagoner*, 1832

Cat. No. 78. James Arthur O'Connor — *A View of an Avenue*, 1835

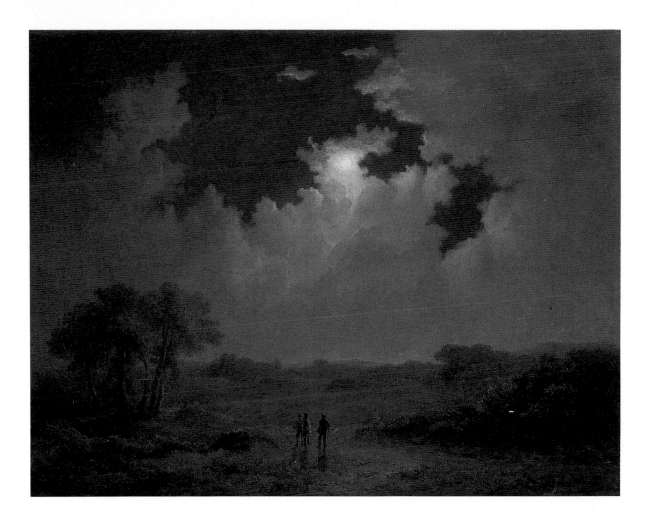

Cat. No. 79. James Arthur O'Connor — *The Poachers*, 1835

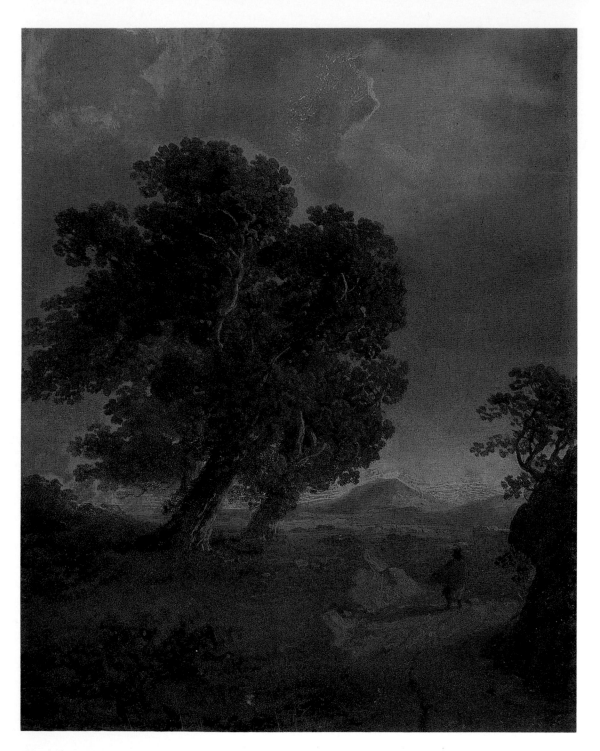

Cat. No. 86. James Arthur O'Connor — *Windy Landscape with Figure,* c.1839

James Arthur O'Connor

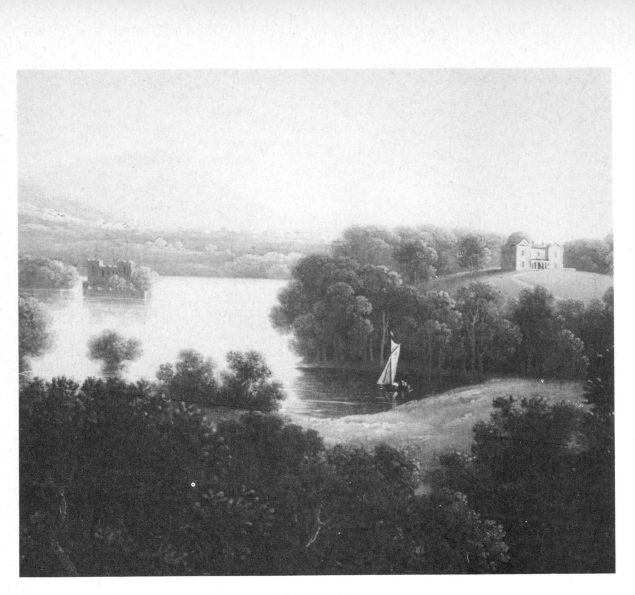

Detail of *Rockingham House, Co. Roscommon.* (Cat. No. 38).

THE EARLY PERIOD

1792-1820

REFLECTING THE uncertainty that marks so much of the artist's life, the birthplace of James Arthur O'Connor is unsure. He was the son of William O'Connor, and was born at no. 15, Aston's Quay, in Dublin, probably in 1792. It has not proved possible to trace any documentary evidence of O'Connor's birthdate,[1] but both Strickland and Bodkin concur on the year and place of his birth, as does 'M' in the *Dublin Monthly Magazine*. As these three biographies are the most comprehensive accounts of O'Connor's life, (although none of them give the sources of their information) it would appear reasonable to accept their findings, given the lack of primary sources. It should be pointed out, nevertheless, that Redgrave, in his *Dictionary of Artists*, and *The Gentleman's Magazine*, (in two separate obituaries: March and June, 1841), states that the artist was born in 1793.

O'Connor's father was a printseller and engraver, and it is clear that he was sympathetic to his son's artistic interests, as the young boy may have been trained in his father's profession.[2] This supposition is best supported by the fact that several etchings are amongst O'Connor's earliest documented works.

By 1791, William O'Connor was established at Aston's Quay, having earlier carried on business at no. 9, Exchequer Street.[3] Little is known about his life either before or after that date, apart from a few details of information about his family. From evidence in a letter from Francis Danby,[4] a life-long friend of O'Connor, it appears that James had sisters, one of whom, was called Mary.[5] The letter from Danby explains that O'Connor was forced to return to Ireland in 1813, after a brief visit to England, in order to support his orphaned sisters — so it is certain that O'Connor's parents were dead by this date. William O'Connor's name does not appear in the *Dublin Commercial Directory* after 1807, although his name had been included for many years previously, so it is possible, therefore, that the artist's father died in that year.

Bodkin and Strickland state that O'Connor was given lessons in painting by William Sadler, a prolific painter of small landscapes, who was strongly influenced by the work of seventeenth century Dutch artists. It is possible that Sadler came to know the young O'Connor through his father, and gave the boy some initial instruction, but there is little evidence for this traditional assumption.

The *Dictionary of National Biography* relates that George Petrie, another friend of O'Connor, was also a source of instruction, but again there is no

other evidence to support this statement. And although Stokes, in his biography of Petrie,[6] mentions that O'Connor, Danby and Petrie met while they were studying at the Dublin Society Drawing Schools, there is no record in the Society that O'Connor was a pupil in that institution, although he may have attended the classes without officially enrolling.[7]

In 1809 there is the first indication of O'Connor's serious interest as an artist — he exhibited at the Dublin Society House, from 15 Aston's Quay.[8] He also showed a work entitled *The Card Players* at the Society of Artists of Ireland, in Hawkins Street. The following year he published a series of etchings in Dublin, which were rather eccentricly reviewed in *Hibernia*, as follows:[9]

'Three etchings, designed and etched by J. A. O'Connor. When we consider these Etchings, as the first productions of a young, and as we have reason to believe, self-taught artist, we dare assert that they afford an infinitely better promise of ultimate excellence in this art than the etchings of Mr. Gabrielli [reviewed above] — It is true, that the etching of landscape and figure require so very different a manner, as scarcely to admit of a comparison between these branches of art, but we are induced to draw this imperfect contrast, for the purposes of encouraging Mr. O'Connor, by even associating the mention of his performances with those of an artist of indisputable excellence, in no mean department of his art. — If our recollection does not deceive us, we were pleased with a pen and ink drawing which we saw of a Mr. O'Connor's, in the last exhibition of the Dublin Society House — we proceed to a critical remark or two, upon the prints before us.

The conception and drawing of the figure upon crutches, is upon the whole, extremely characteristic, but the left crutch is incorrectly and awkwardly set under the arm pit, and indeed the left arm itself, is indifferently set on the body. We know not what induced the artist to stick a feather in the cap of this figure: we have seldom recognised such an article of ornament in the costume of a beggar man.

In the second plate, no keeping whatever has been preserved, and the sitting figure, if we are to credit appearances, is employed in the novel occupation of smelling the side of the mountain.

In the last plate, the attitude of the figure holding a smoking pipe, is not perfectly easy, and the artist here by working his hatches much too closely in the drapery, has caused the aquafortis to break up his ground, and consequently his impressions have printed foul. Notwithstanding, however, some inaccuracies, inseparable, perhaps, from the first essays in this art, we venture to predict the success of this young artist, in the walk of life which he has selected for himself, if, by constantly writing literary study, with professional practice, he endeavours to deserve it'.

In 1810, apart from publishing the etchings, O'Connor exhibited again at the Dublin Society House, and also at the Society of Artists of Ireland, as an 'associate exhibitor'. The following year, O'Connor exhibited at the Society of Artists of Ireland, from Aston's Quay, showing two drawings of rustic figures, 'Sketched with a Pen', and a *Sunset Composition*. He also exhibited there in 1812, and submitted five landscapes.

The *Dictionary of National Biography* and the *Art Journal*, in Danby's obituary,[10] state that O'Connor instructed Danby in painting during 1812, but according to Ottley's *Dictionary of Artists*, O'Connor's relationship to Danby was on a different footing: 'Danby, looking in at [O'Connor's] shopwindow, was attracted by his talent, made his acquaintance, and brought him to London, where the pair for some time worked industriously for the dealers, partly in copying old masters. Amongst others reproduced in considerable extent was Canaletti'.[11] Adams, in his recent biography of Danby, does not discuss the origins of O'Connor's long friendship with the artist, except to say that '[Danby] became a student at the drawing school of the Dublin Society, although at exactly what date is unsure, since there appears to be no record there of his entry ... During his studentship at the Society, he made friends with two young landscape-painters: George Petrie, three years older than Danby and the educated and well-to-do son of a miniaturist, and James Arthur O'Connor, one year older, the son of a print-selling engraver ... O'Connor, according to the *Art Journal* obituarist, gave him his first practical instruction in in painting'.[12]

O'Connor's journey to London in 1813 with Danby and Petrie is recounted differently by all his biographers. Bodkin, the *Dictionary of National Biography*, and Redgrave observe that O'Connor went to the capital city in 1813, with his two friends, and that he returned in the same year. Strickland concurs, adding that the journey took place in June. Stokes[13] specifies that the three artists arrived on June 2nd, and that all three hoped to settle there. Adams[14] comments: 'It was normal practice for any Irish artist who could afford it to finish his education by coming to London, and, if he had any ambition, to try to settle there. In Ireland there was little art to study beyond the plaster casts of the schools, and little patronage either. "Even distinguished talents", wrote a contemporary historian, "if they aim at fame or fortune, must not expect to find them in Ireland — the country is too poor, and if it were not poor, there are too few connoisseurs in it to appreciate the merit of a living artist". The Dublin Society regularly made travelling grants to selected students, a practice they had lately changed to that of buying one of the student's paintings, but from the examples given in Berry's *History of the Royal Dublin Society* of students of Danby's generation who were helped to London in this way, it does not seem that the society bought landscape-paintings. Danby, Petrie, and O'Connor paid their own way'.

When they arrived in London, Petrie, according to Stokes, or all three, according to the *Art Journal*,[15] presented introductory letters to Benjamin West, the celebrated American artist, whose collection was accessible to students. At any rate, West gave Petrie two interviews, and arranged visits to some private collections in London. About a month later, Petrie was the first to return to Ireland, his father had written, asking him to come home, and sent a painting with the letter, to ensure that his son could raise the fare.

Petrie sold the painting, and before leaving, lent his friends two valuable rings, with the instructions that they were to be pawned if funds ran too low.

Whether or not they pawned the rings, O'Connor and Danby soon found themselves without cash, and set off for home, heading for Bristol on foot. Adams[16] sheds further light on the return journey quoting an account of the arrival from Danby's obituary, in the *Western Daily Press*.

'On their arrival in Bristol they found themselves (to use a familiar expression) "hard up", and they had the greatest difficulty in obtaining a night's lodging. Among other places they inquired at a baker's shop, kept by a person whose name we forget, on Redcliff Hill, but the woman of whom they inquired could give them no encouragement. At last, however, she agreed to let them have a night's lodging at the house. Here the two pilgrims set to work the next day to make drawings. Danby succeeded in making three drawings, which he sold for seven shillings a piece to one Minthorn a fancy stationer of College Green. Thus encouraged, Danby soon collected enough to enable him to frank his friend O'Connor back to his native shores'.

A letter from John Minthorn to the *Western Daily Press* (also quoted by Adams)[17] gives a slightly different and more detailed report:

'In reading a notice on the death of my late friend, Mr. Danby, in your paper of the 13th inst., I am anxious to afford you some additional information in connexion with his early career in Bristol ... Your informant is quite correct as to my friend's arrival in Bristol, with his friend O'Connor, in great pecuniary distress. It is also true he did, in the hour of need, apply to one John Minthorn alluded to by your correspondent. I am proud to say that gentleman is my highly respected father, now residing at Clifton. He was one of his earliest patrons.

His first introduction was to offer, in company with O'Connor, two small sketches of the Wicklow Mountains, near Dublin, in a somewhat dilapidated state, slightly coloured, on letter paper, for eight shillings, stating the distress of himself and friend, they wanting the amount to pay for their night's lodging. As they knew the captain of the packet (a sailing one) which was to start for Cork the following morning, and he would give them a free passage, my father rendered the assistance required. I was present at the interview. Attached as I was to everything connected with fine art, I put the question to Danby if he was aware of the beautiful scenery of the district. Receiving his answer in the negative, I induced him and his friend to stop and make a few drawings of the locality, my father undertaking to purchase them. The following morning they took their breakfast with me. I accompanied them, and four sketches were taken from the Downs of the river scenery; two were sketched by my friend, one by O'Connor, and the other by myself. They were coloured by Danby. The originals are at this time in the possession of my father, and highly valued by him ... [Danby subsequently] determined to make Bristol his residence for some years'.

Considering that patronage in Ireland was distinctly limited, it is clear that Danby had reason enough to remain in Bristol. He had little to lose, and there was at least a chance that he could succeed in making a name for

himself in Bristol. It would appear somewhat surprising that O'Connor did not remain with his friend in England, to try his luck in the same field, but a letter, written by Danby many years later, reveals the reason for O'Connor's decision to return home.[18]

> 'I took to painting, and by this means got acquainted with O'Connor who was much in the same predicament, and we set off together to see an exhibition in London for the purpose of improvement, we soon spent all our cash and walked to Bristol to embark for the land of bogs, we made some drawings and sold them to Minthorn in College Green but could only get enough to pay the passage of one. O'Connor's poor little sisters who were orphans and depended on him could not be without him, therefore I was left behind, is this fate or chance, should I have been better had I returned, perhaps not, I should have carried the same stock of folly to provide for me in Ireland which did for me here ...'.

Predictably, London made a strong impact on the three young men. Stokes[19] quotes a letter from George Petrie to his father, dated June 10th, 1813. 'Eight days have passed since I arrived in this magnificent seat of arts and learning, the entire of which has been busily employed in seeing and admiring the various interesting objects which this vast and truly wonderful city presents to the astonished mind of a stranger. I would fair give you an account of the points in which London and Dublin most differ, and of the superiority of the former, but such would be impossible in the form of an epistle'. One particular object of their admiration was Turner's *Frosty Morning*, (illus. no. 1) exhibited at the Royal Academy. Danby wrote to Petrie in 1850:[20] 'Turner is a good example of painting in age. He was well advanced in years when you and I, with our dearly remembered friend, poor James O'Connor, first visited London, when we saw his beautiful and wonderful picture of the *Frosty Morning*'. It is interesting, moreover, that it was the naturalism of *Frosty Morning*, and not the melodrama of the *Deluge*, another of Turner's exhibits at the Royal Academy that year, that the three young artists found impressive.

Stokes further relates[21] that O'Connor, Danby, and Petrie visited Wales again that year, which would seem highly improbable, were it not for the fact that Minthorn, in his letter to the *Western Daily Press*, states that O'Connor and Danby knew the Captain of the packet to Ireland, and that he was willing to give them a free passage. There is a possibility, therefore, that O'Connor and Petrie availed themselves again of the Captain's generosity.

As yet, there is no trace of any paintings by O'Connor which date from his first trip to England. Adams, however, illustrates a *Lake Scene*, (illus. no. 5) which he describes as an early collaboration between Danby and another artist. The painting was recently shown in the exhibition of *The Bristol School of Artists*, when it was suggested that the landscape may have been painted by Danby, and the figures by O'Connor.[22]

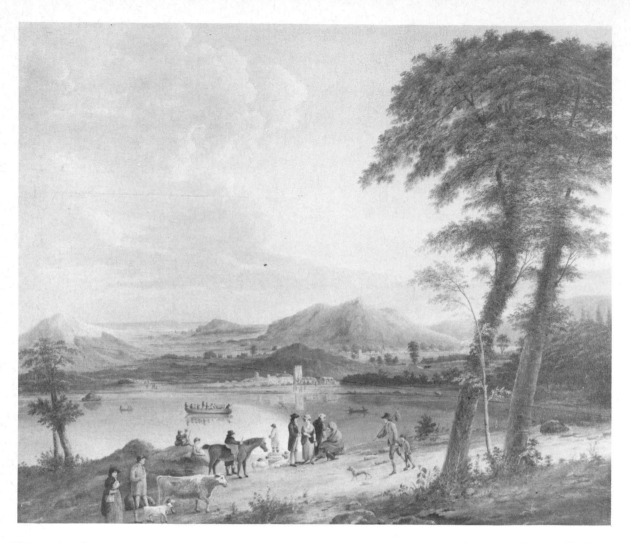

Illustration 5

FRANCIS DANBY AND UNKNOWN COLLABORATOR, *A Lake Scene*, Private Collection, photograph courtesy of Paul Mellon Collection, Yale Centre for British Art.

A story told in O'Driscoll's memoir of Daniel Maclise[23] may have some bearing on the origins of this painting:-

'The three companions [O'Driscoll states that the three artists all walked back to Bristol together], as they had previously arranged to do, painted a kind of "joint-stock picture" on a pretty large scale, each taking that part of the work for which he felt himself best qualified. O'Connor did the landscape and background, Petrie finished some architectural ruins, and to Danby was allotted the figures and foreground. The picture was sold by them in Bristol, and the proceeds divided. O'Connor and Petrie returned to Dublin. Danby held to his original resolution and proceeded to London, where he speedily distinguished himself. Many years after this Petrie again visited Bristol,

and was asked to dine with a gentleman who possessed some excellent pictures. He showed his collection to Petrie, and remarked, as to one, that although it was considered the best work in his gallery, no one could tell the name of the artist. The moment Petrie saw the picture he recognised it as the joint-stock performance, and told its history to his host, who was rather disappointed at learning its hybrid origin'.

Allowing for inaccuracies in the tale, it is possible that the'joint-stock' picture referred to may be the *Lake Scene*.

Among O'Connor's more interesting early exhibits were at The Society of Artists of Ireland, they included *Sea View, Martello Tower,* (1810), *Italian Seaport* and *Aeneas and Dido: Landstorm,* (both 1813). From 1814 to 1818 there is very little information about O'Connor's life, other than the fact that in 1815 he was a member of the Hibernian Society of Artists, and on their General Committee.[24] O'Connor exhibited with them in 1814 and 1815 and presumably in the following two years, although there are no catalogues to verify this. The only known works that can definitely be ascribed to this period are two ink sketches in the Royal Academy, both dated 1813, that were drawn during the artist's brief stay in London (illus. nos. 6 and 7).

The major series of sixteen paintings at Westport House, Co. Mayo, (cat. nos. 29, 30, 31, 32) completed on commission during 1818-1819 for the 2nd Marquis of Sligo,[25] and Lord Clanricarde, marks a stage of increased activity and patronage. Another series, the four views of Ballinrobe, (cat. nos. 34, 35, 36 and 37) in the National Gallery of Ireland, was probably completed at the same date for the owner of Ballinrobe House, while O'Connor was working at Westport.[26] A drawing of Castle Troy on the Shannon, (which is in the British Museum), is inscribed 'Mount Shannon, Lord Clare's', and may suggest further commissions, as it probably dates from this period.[27]

There was no exhibition at the Hibernian Society of Artists in 1818, but O'Connor was well represented in the 1819 exhibition of the Artists of Ireland at the Dublin Society's House, where he showed seven paintings, including a view of *Rockingham House, Co. Roscommon*, the seat of Lord Lorton, which was engraved by J. and H. S. Storer in 1825, (cat. nos. 38 and 39). O'Connor also exhibited two landscape compositions which were painted in conjunction with Joseph Peacock, a subsequent Royal Hibernian Academician. (Although one of these was shown at the *Centenary Exhibition*,[28] it has not been possible to trace an extant picture which we can be certain that Peacock helped to paint).

In 1818, O'Connor was instrumental in arranging the Exhibition of the Artists of Ireland at the Dublin Society's House, for he is a signatory to the following petition:[29]

'Feb. 12 1818
 We the undersigned artists of the city of Dublin, feel with deep regret the injury, which the arts have sustained by the want of unanimity among

the profession, and being anxious that the joint efforts of all the artists of the country should be executed to render the ensuing exhibition as respectable as possible, have proposed to the Committee of Artists a plan for that purpose, which, by a liberal and equal system of management, might contribute to so desirable an object'.

'To further these efforts, we therefore respectfully request that the Right Honourable the Dublin Society will grant the use of their Exhibition-Room for such joint and united exhibition — totally independent of any party, that those, who contribute their works to the exhibition, may have an equal share in its management'.

The Society of Artists of Ireland was founded in 1800, and held exhibitions for a number of years, but after 1812 it split into several short-lived societies. From 1815 to 1819 exhibitions of the Dublin artists were held in the Dublin Society's premises in Hawkins Street, under that Society's control, and when the premises in Hawkins Street were given up, and the Dublin Society moved to Leinster House, there was no room for the exhibitions. The artists then considered forming a permanent organization that was free from outside control — the first step towards the eventual establishment of the Royal Hibernian Academy in 1823.

Besides travelling to Co. Cork,[30] and moving to no. 18 Dawson Street,[31] O'Connor was married to a girl named Anastatia[32] at some time before 1822, when he moved with her to England, perhaps to seek more stable and remunerative employment. For although he exhibited again at the Dublin Society House in 1820, and in the same year received a premium of twenty-five guineas from the Royal Irish Institute, this 'does not seem to have improved either his practice or his prospects'.[33]

1. It has proved impossible to trace any documentary evidence of O'Connor's birth in either the Genealogical or the Public Record Offices in Dublin.

2. Redgrave *Dictionary of Artists* and the *Dictionary of National Biography* concur. Ottley states the O'Connor himself 'kept a printshop'.

3. Walter Strickland, *A Dictionary of Irish Artists*, Dublin and London, 1913, vol. 2, p. 179; Thomas Bodkin, *Four Irish Landscape Painters*, Dublin and London, 1920, p. 17.

4. Letter from Francis Danby to John Gibbons, February 29th, 1836.

5. Letter from O'Connor to his sister Mary, October 20th, 1836.

6. Stokes, *The Life of George Petrie*, p. 2.

7. But in W. Carey's *Some Memoirs of the Patronage and Progress of the Fine Arts in England and Ireland*, pp. 347-8, 'Connor' is included in the list of artists instructed in the Dublin Society's Schools, under 'Landscape'. J.D. Herbert, in *Irish Varieties*, (London, 1836, p. 57), concurs.

8. Bodkin, op. cit., p. 95; Strickland, op. cit. vol. 2, p. 179. Because of the difficulty of finding catalogues of all the early Irish exhibitions, I have accepted Bodkin's lists of O'Connor's Irish exhibitions as being correct.

9. *Hibernia*, May, 1810.

10. Obituary of Francis Danby, *Art Journal*, February 13th, 1861.

11. Ottley, *A Biographical and Critical Dictionary* . . ., (1876), p. 125.

12. Adams, *Francis Danby; Varieties of Poetic Landscape*, p.2. He also writes, on page 7: 'Redgrave suggests in his *A Century of Painters* that Danby might have been influenced by "a certain massive and somewhat melancholy character" in O'Connor's work, but this is probably because Redgrave had no knowledge of the work of either artist at this period. O'Connor's typical landscape style — heavy, rustic, and Dutch-inspired — seems to have developed later; at least I have found no example of it dated earlier than 1826. The pencil drawings in the British Museum, and the two oil paintings belonging to the Marquis of Sligo, all done in 1818, are topographical and myopically precise in technique. It seems likely that O'Connor's spirit is seen more in the somewhat prim precision of Danby's early topographical landscapes than in the melancholy of his later imaginative painting'.

Adam also notes on p. 146: 'The only first-hand evidence about Danby's relationship with O'Connor is a coarse pen drawing *Anglers in a Landscape* (undated, British Museum, London), inscribed on the back with rhymed couplets signed by Danby and addressed to "Dear James"". The verses pleasantly chide O'Connor for his "manner" (mannerism) and the "wretchedness" (poverty-stricken aspect) of his figures, and they recommend a more simple, chaste, and sentimental style'. I think that the drawing is more probably by Danby's son, James Francis, who was also an artist, then by O'Connor.

13. Stokes, op.cit., p.8.

14. Adams, op.cit., p.3.

15. Obituary of Francis Danby, *Art Journal*, February 13th, 1861.

16. Adams, op.cit., pp. 4-5.

17. Adams, op.cit., p. 5.

18. Letter from Francis Danby to John Gibbons, February 29th, 1836.

19. Stokes, op.cit., p. 8.

20. Stokes, op.cit., p. 8.

21. Stokes, op.cit., p. 10.

22. *The Bristol School of Artists — Francis Danby and Painting in Bristol 1810-1840*; City of Bristol Museum and Art Gallery, 1973.

23. W. J. Driscoll, *A Memoir of Daniel Maclise*, p. 6.

24. Address from the Hibernian Society of Artists to the Dublin Society 1815.

25. The 2nd Marquis of Sligo was Lord Lieutenant of Mayo, and a Knight of St. Patrick. In 1816 he married Hester de Burgh who laid out the pleasure grounds at Westport House. A friend of Byron and George IV, Lord Sligo later became Governor of Jamaica. The 2nd Marchioness was a daughter of the Earl of Clanricarde, who lived in Portumna Castle. This probably explains why views of Portumna, traditionally held to have been commissioned by Lord Clanricarde, are now at Westport.

26. Information kindly supplied by Mrs. M. Kenny of Ballinrobe, Co. Mayo.

27. Bearing in mind other documented pictures, (views of Monasterevin, the Dargle, and the Salmon Leap near Leixlip), it appears likely that O'Connor may have travelled, fairly extensively in Ireland during these years.

28. James Arthur O'Connor, *Centenary Exhibition*, 1941, no. 7.

29. Royal Dublin Society records.

30. There are two recorded paintings of Gilhooley Castle, Cork, and Roche's Castle, Ballyhooly, near Macroom, that are both dated 1821, (both sold at the auction of the collection of W. Cremin, 1948).

31. Bodkin, op.cit., p. 97.

32. His wife's christian name is recorded in the Grant of Administration of O'Connor's estate.

33. Bodkin, op.cit., p. 19.

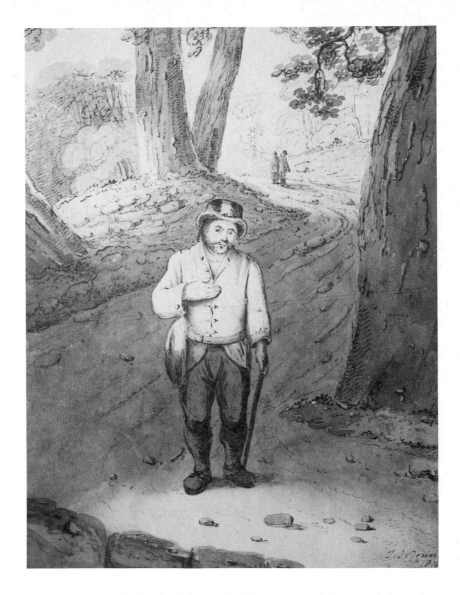

22. A Man with Stick,
1815

Pencil, ink and wash on paper, 36.5 x 26.5 cm., (13⅜ x 10½ ins.). Signed and dated: J. A. O'Connor 1815.

PROVENANCE:
J. Stewart, from whom purchased by present owner.

This early drawing is worked in the tight, linear technique that is characteristic of O'Connor's sketches. The man faces the viewer with a serious air, while light filters through the trees and falls on the path directly in front of him. The combination of the figure's somewhat melodramatic pose and the odd lighting effect gives the drawing a strange mood, which prefigures the romanticism of his later years. Another early drawing, (present whereabouts unknown) shares this incipient romanticism, and is a late example of 18th century 'graveyard melancholy'. It shows a woman seated on a tombstone, deep in thought, in front of the ruins of Tullow Church, Co. Dublin. Both these drawings are a transition between 18th century 'Sensibility' and the more emotional romanticism of the following decades.

Lent by Hans-Peter Mathia

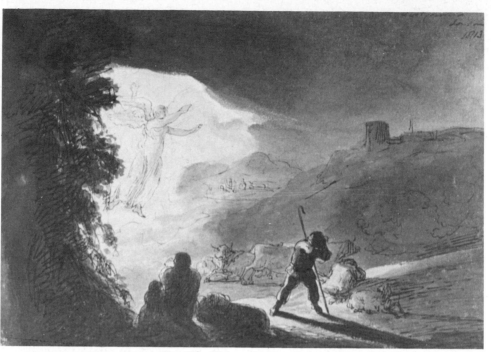

Illustration 6 JAMES ARTHUR O'CONNOR, *The Vision: An Angel Appearing to Shepherds,* The Royal Academy of Arts, London.

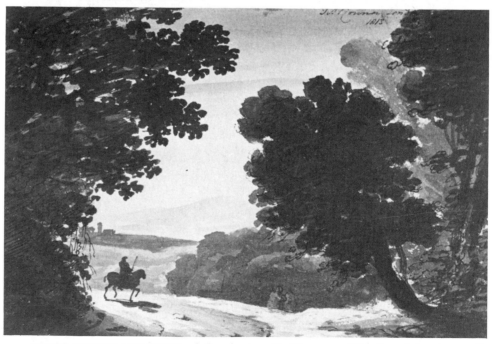

Illustration 7 JAMES ARTHUR O'CONNOR, *A Landscape with Horseman,* The Royal Academy of Arts, London.

25. A Turk's Head,
1817

Oil on panel,
14.5 x 12.0 cm.,
(5¾ x 4¾ ins.).
Signed and dated:
J. A. O'Connor 1817.
Ink drawing on verso:
A Turk's Head.

PROVENANCE:
William Bury; (probably
purchased in 1875 by W.
Bury from Mrs. Clarke,
née FitzGerald sister of
James FitzGerald, a friend
of the artist); John Bury;
D. N. Lowe; Private
Collection Dublin, from
which purchased by
present owner.

Among the earliest of O'Connor's dated works are two sketches in *Jupp's Interleaved Catalogues* in the Royal Academy; both are signed and dated 'London 1813' (illus. nos. 6 and 7), and were drawn during O'Connor's visit to England with Danby and Petrie. One of the drawings, *The Vision*, is almost certainly derived from Rembrandt's etching of *The Angel Appearing to the Shepherds. A Turk's Head* may also have been inspired by Rembrandt, as it bears some similarity to his portrayals of figures in oriental dress, but if it is a precise copy of a Dutch 17th century painting, the original has not yet been traced. O'Connor's father was a printseller, so the artist would have had access to a great variety of engravings.

Lent by Denzil O'Hanlon

THE EARLIEST OF O'Connor's views of Westport was probably the painting that was recently in a London gallery, which is signed and dated 1817 (illus. no. 8). It is a smaller variant of the picture that hangs in the hall of Westport House, (unfortunately not available for this exhibition), and it may have led to the Marquis of Sligo's patronage. It is more finely painted then most of the landscapes at Westport, and its lighting effects are particularly accomplished: shadows are cast diagonally across the canvas, accentuating depth and space.

The two most important O'Connors in the Westport House collection (illus. nos. 9 and 10) are also the largest, and were painted, according to tradition in, 1818. The first, already mentioned, is the *View of Westport with Croagh Patrick*; the other, its pair, is *Westport House from Barratt's Hill*. Neither of these pictures would suffer in comparison with almost any British

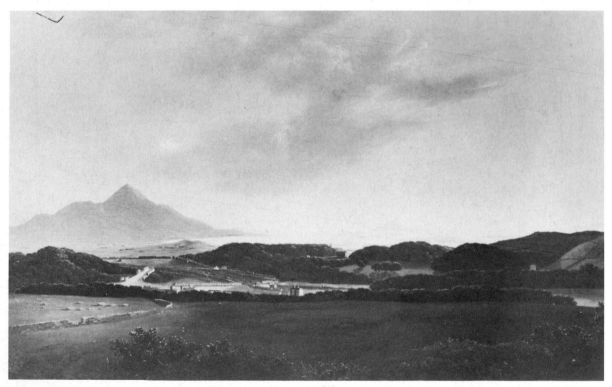

Illustration 8 JAMES ARTHUR O'CONNOR, *View of Westport and Croagh Patrick,* photo collection of the National Gallery of Ireland.

Illustration 9 JAMES ARTHUR O'CONNOR, *A View of Westport with Croagh Patrick*, Westport House, Lord Altamont Collection.

Illustration 10 JAMES ARTHUR O'CONNOR, *Westport House from Barratt's Hill*, Westport House, Lord Altamont Collection.

topographical paintings of the period — unlike others in the series, which are relatively gauche in execution and composition.

A trait common to many of the Westport paintings is O'Connor's stylized treatment of still water, which he painted in broad, smooth washes of colour, flecked with streaks of white — a technique that is clearly visible in *Westport Quays* (cat. no. 29), and which can also be seen in many later works. O'Connor's way of painting foliage also remained constant, and is an easily recognizable characteristic of his style. First of all the broad shape of a tree is blocked out in dark, rounded contours, and then the leaves are defined and accentuated by neat, precise dabs of lighter-toned paint. A related effect, also common in his early paintings, is the way in which O'Connor used 'impasto' on the highlights, particularly in the foreground, where the paint is often less delicately handled than in the trees.

Westport House, designed by Richard Castle, was built on the site of a seventeenth century building, and it was enlarged by James Wyatt. Wyatt is also said to have designed the town of Westport, which was moved from its original position. As Edward Malins and The Knight of Glin have observed in *Lost Demesnes*, 'the cruciform or circus plan, with its tree-lined mall and hexagonal market-place is a most interesting example of town planning after a forcible removal of the population from its medieval site. It was not a difficult matter for the Marquess of Sligo to move Westport town away, for no blocking of local roads was required and, doubtless, permission was easy to obtain. However, the inhabitants managed to hold right of way through the park'. They later quote the opinions of 19th century visitors to Westport, both written in 1836: 'Maria Edgeworth, on a tour of the West writes that "the present and living wonders are the town and bay and prosperous country and people made at Westport by the exertions chiefly of one individual — the late Lord Sligo..." Yet John Barrow saw Lord Sligo's tenants clothed in rags, living in cabins "More fit for cattle than people", built with loose stones, "sodded" roofs and windowless ... In 1842 Thackeray described (Westport) with unusual delight: 'the Bay, the Reek (Croagh Patrick), which sweeps down to the sea — and a hundred islands in it, were dressed up in gold and purple and in unison with the whole cloudy west in a flame'.[1]

It would be surprising, however, if the forcible removal of the town's population was as simple as it sounds: the number of people living on Lord Altamont's estate in the late 18th century had doubled in twenty years.[2] Oliver Goldsmith protested against such eviction of village people by landlords intent on creating pleasure grounds in 'The Deserted Village', (1770).

1. Edward Malins and The Knight of Glin, *Lost Demesnes*, (1976), pp. 106-107.
2. Louis Michael Cullen, *Life in Ireland*, (1979), p. 119.

Illustration 11 JAMES ARTHUR O'CONNOR, *Ben Grugaan, Co. Mayo*, a drawing on reverse of *Delphi Lodge, Co. Mayo* (cat. no. 30). Reproduced by courtesy of the Trustees of the British Museum.

26. Westport, Co. Mayo, *c.1818*

Ink on paper,
16.0 x 22.0 cm.,
(6¼ x 5⅝ ins.).
Signed:
J. A. O'Connor delt.
Inscribed: The Marquis of
Sligo's house and demesne
with the town and bay of
Westport, Co. Mayo.

PROVENANCE:
Purchased 1872 by the
British Museum, London.

27. Mount Browne, Co. Mayo, *c.1818*

Ink on paper,
10.5 x 18.0 cm.
(4⅛ x 7⅛ ins.).
Signed:
J. A. O'Connor delt.
Inscribed: Mount Browne
the Seat of the Right
Honble. Dennis Browne,
Co. Mayo.

PROVENANCE:
Purchased 1872 by the
British Museum, London.

Lent by the Trustees of the British Museum

28. Delphi Lodge, Co. Mayo, *c.1818*

Ink on paper,
9.5 x 17.0 cm.
(3⅞ x 6¾ ins.).
Signed:
J. A. O'Connor delt.
Inscribed: Finloch, with
Delphi Cottage, the
Fishing Seat of the Marquis
of Sligo, Co. Mayo.
On verso, a drawing of
Ben Grugaan with part of
Dooloch, Co. Mayo. (illus.
no. 11).

PROVENANCE:
Purchased 1872 by the
British Museum, London.

O'Connor's paintings of Westport were commissioned house and estate 'portraits', which gave little scope for his imagination, and O'Connor seems to have used these sketches merely to take notes and work out his compositions. His careful, rounded hand — O'Connor drew almost as if he were writing — is not untypical of the period; Petrie's early sketches (cat. no. 14 a,b,c), are very similar, as are Daniel Maclise's early landscape drawings.

Lent by the Trustees of the British Museum

103

29. Westport Quays, *1818*

Oil on canvas,
38.0 x 61.0 cm.,
(15 x 23 ins.).
Signed and dated:
J. A. O'Connor 1818.

PROVENANCE:
Painted for Westport
House.

EXHIBITED:
*Paintings from Irish
Collections*, Dublin 1957,
(163).

LITERATURE:
'O'Connor at Westport
House', James White,
Apollo, (July, 1964).

The quays are not far from Westport House, which can be seen in the background, and they look much the same today, except rather less busy. Indeed, the bustling activity, which was no doubt intended to suggest Lord Sligo's successful business interests, is very unusual for O'Connor, who took great pains in the painting of all the figures, ships, and objects that strew the quayside, which are meticulously, if rigidly, handled. The two figures in the foreground, and another slightly behind them, all face the viewer with the direct gaze that is conspicious in many of O'Connor's pictures.

*Lent from the Collection of Lord Altamont,
Westport House, Co. Mayo.*

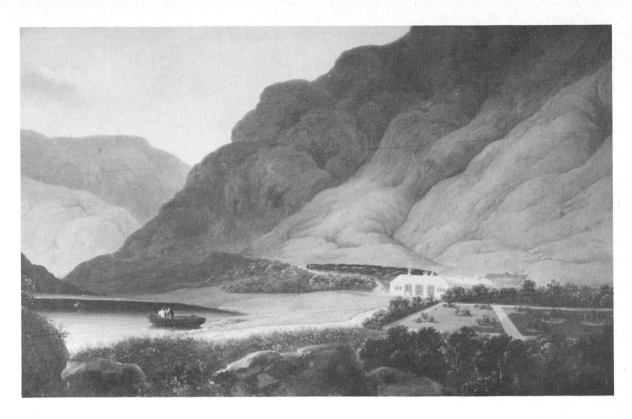

30. Delphi Lodge, Finloch, *c.1818*

Oil on canvas,
38.2 x 61.0 cm.,
(15 x 24 ins.).

PROVENANCE:
Painted for Westport House.

The Marquis of Sligo, much struck by his Grand Tour, named his fishing lodge 'Delphi'. It is tucked away in the hills of Co. Mayo, about seven miles south of Louisburgh, and not far from Killary harbour. Even in such a remote setting, modest 'pleasure grounds' have been laid out near the cottage.

Lent from the Collection of Lord Altamont, Westport House, Co. Mayo

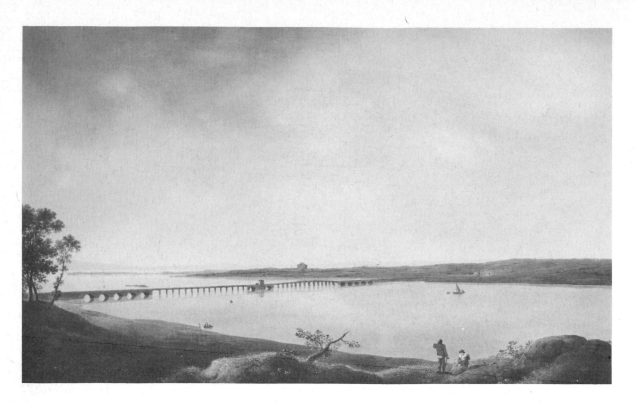

31. Portumna Castle, with Wooden Bridge, from Belle Isle, *c.1818*

Oil on canvas, 39.0 x 62.2 cm., (39 x 15½ ins.).

PROVENANCE:
Painted for Westport House.

Portumna Bridge, a wooden structure that was erected in 1796, spans the river Shannon. The Galway side of the bridge was destroyed by floods in 1814, and it was rebuilt in 1818, when the picture was probably painted.

This is typical of the less distinguished paintings in the Westport series — a thoroughly dull picture, with a tree inserted to frame the composition and a curious stump in the centre, which was presumably meant to define the foreground.

Lent from the Collection of Lord Altamont, Westport House, Co. Mayo

32. View of Lough Derg with Portumna Castle in the Background,
c.1818

Oil on canvas,
99.0 x 157.5 cm.,
(39 x 62 ins.).

PROVENANCE:
Painted for Westport
House.

In contrast to cat. no. 31, this is probably one of the finest of the smaller Westport paintings. The ruin in the foreground is Derry Castle; the two figures standing beside it, admiring its 'gothick' character, form a typical late eighteenth century motif, and illustrate the contemporary antiquarian interest in Irish ruins. Portumna Castle was the seat of Lord Clanricarde, and its interior was destroyed by fire in 1826.

Lent from the Collection of Lord Altamont,
Westport House, Co. Mayo

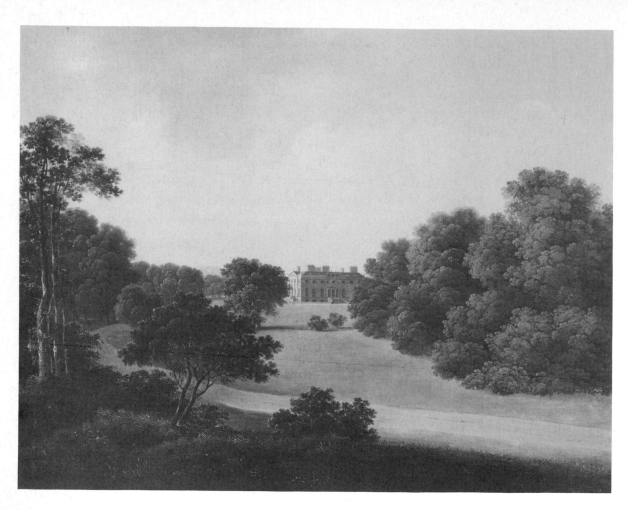

33. Westport House, *c.1818*

Oil on canvas:
53.3 x 63.5 cm.,
(21 x 25 ins.).

PROVENANCE:
Originally in Westport
House, by descent,
through Lord Richard
Browne, to the present
owner's father, Cyril
Browne.

EXHIBITED:
Irish Houses and Landscapes,
Belfast and Dublin, 1963
(35).

This picture of Westport House, which was presumably painted at the same time as the series in Westport House, is a straight-forward 'house portrait' in the 18th century manner. It is utterly conventional in its approach — both from a formal and painterly point of view. O'Connor has taken no risks, and doubtless his patron would not have wished it otherwise.

Lent by Mrs Phyllis Pennefather

108

ACCORDING TO Mrs. M. Kenny, a descendent of the family, this series was commissioned by Courtney Kenny the owner of Bridge House in Ballinrobe. When the house was built in 1750, there was no road in front of it, the pleasure grounds extended right up to the door, and a foot bridge led to the mill across the river. When the road was built and a stone bridge spanned the river, the Mrs. Kenny of the day expressed a fear that she would be run down by donkey carts while crossing the road to reach the pleasure grounds. In due course a stone passage was built under the road, so she could cross in safety, but the passage was eventually blocked up. During the famine this stretch of the River Robe was canalised, to give employment.

In its stylistic coherence, the Ballinrobe series is arguably more impressive than the Westport sequence. One painting shows the house, another the mill; the third is a depiction of the pleasure grounds, and the final canvas is a view of the wild countryside at Lough Mask, some miles away. Each picture has an individual mood, yet no one dominates the others. Several of the stylistic features that have been mentioned with regard to the Westport paintings can be seen again here, including the treatment of the water and trees.

The Ballinrobe series is painted more confidently than other commissions of the period: the modulation of light in the four pictures is subtle and convincing, particularly among the trees in *The Pleasure Grounds* (cat. no 36) where the artist has taken pains to distinguish between different types of foliage, and to envelop them in soft, atmospheric colour. It is through the handling of light that O'Connor gives each painting its individual character: the views of *The Mill, Ballinrobe* (cat. no. 35) and *Lough Mask* (cat. no. 37) are both fresh and cool, while the other two pictures are warmer and more mellow in tone. They all share a sense of peace and tranquility that falls beyond the realm of commissioned topography. O'Connor painted these canvases with an air of contemplative detachment that is rare in a provincial landscapist.

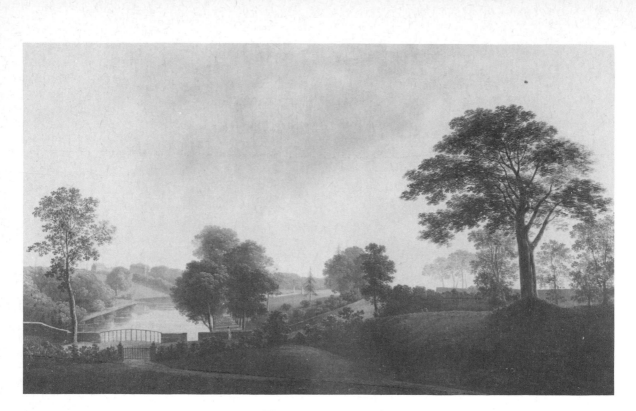

36. The Pleasure Grounds, Ballinrobe, *c. 1818*

Oil on canvas,
42.0 x 71.0 cm.,
(16½ x 28 ins.).

PROVENANCE:
Purchased, London, Mr.
C. Kenny, 1970; N.G.I.
Cat. No. 4012.

Lent by the National Gallery of Ireland

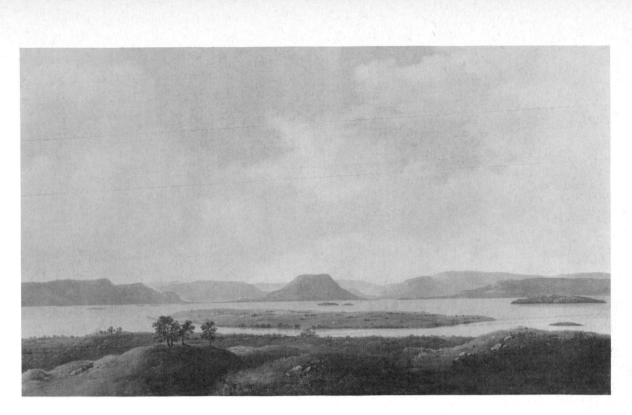

37. Lough Mask,
c. 1818

Oil on canvas,
42.0 x 71.0 cm.,
(16½ x 28 ins.).

PROVENANCE:
Purchased, London, Mr.
C. Kenny, 1970; N.G.I.
Cat. No. 4013.

Lent by the National Gallery of Ireland

113

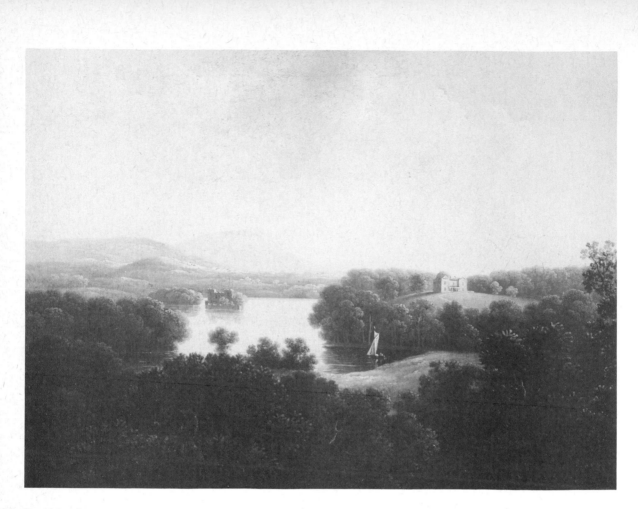

38. Rockingham House, Co. Roscommon, *1818*

Oil on canvas,
27.3 x 37.2 cm.,
(10¾ x 14⅝ ins.).
Signed and dated:
J.A. O'Connor 1818.

PROVENANCE:
Possibly King Harman.

EXHIBITED:
Possibly *Artists of Ireland*,
1819, (51).

The first Lord Lorton created Rockingham Demesne in the 1820s, and the house, originally designed by Nash and subsequently altered, overlooks Castle Island in Lough Key. Edward Malins and The Knight of Glin, in *Lost Demesnes*, write: '... close to the house there is a ruined nineteenth century castle, further off a ruined medieval one ... in the Castle of the Heroes on the rock on Castle (Rock) Island, W. B. Yeats dreamed of a mystical Order which would meet in this castle of the MacDermotts where, in the sixteenth century, Tadhg MacDermott had entertained the poets of all Ireland. These ruins, seen from Rockingham House in the early nineteenth century, must have been the most picturesque of their kind in all the country ...'[1]

1. Edward Mallins and The Knight of Glin, *Lost Demesnes*, (1976), p. 183.

Lent by Christopher Ashe

114

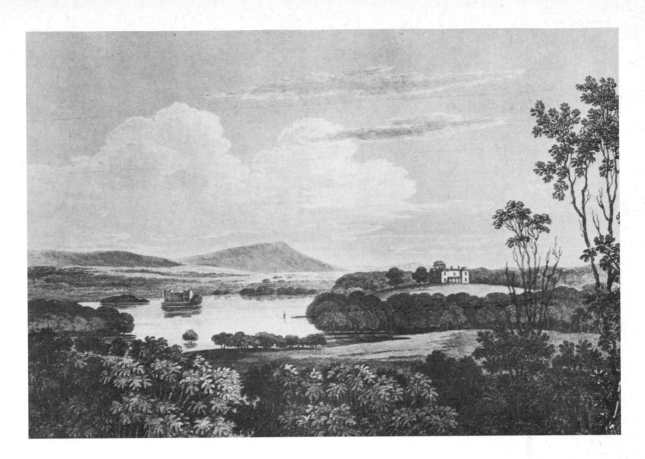

39. Rockingham House, Co. Roscommon, *1825*

Engraving,
15.0 x 22.0 cm.,
(5⅞ x 8⅝ ins.).
Engraved by James Storer
(1781-1852) and Henry
Sargent Storer (1795-1857)
Published by Sherwood
Jones and Co., April 1st,
1825.

This is the only known engraving of a painting by O'Connor.

Not included in Exhibition, photo courtesy of Christopher Ashe

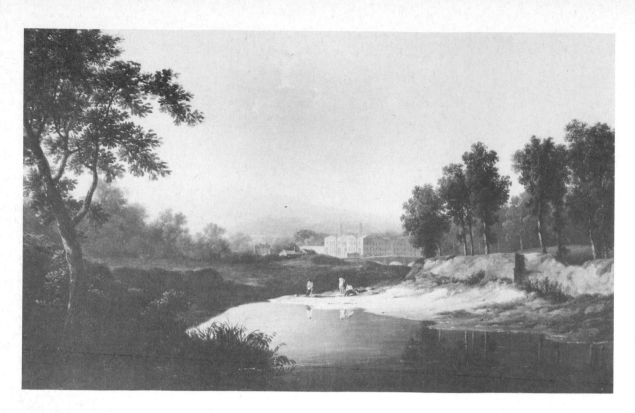

40. Duffy's Cotton Mills, Ballsbridge, *c.1818-1820*

Oil on canvas,
37.5 x 61 cm.,
(14¾ x 24 ins.)

PROVENANCE:
Unknown.

With the exception of his panoramic views of Westport Bay and Howth Head (cat. nos. 43 and 55), O'Connor did not often reproduce topographical scenes. These two paintings are very similar, although cat. no. 40 is less square than cat. no. 41 and it includes a tree which we can assume was inserted for compositional reasons — it acts as a Claudean 'repoussoir'. O'Connor painted bathers on several occasions during this period: sea-bathing, in particular, became popular at this time (see cat. no. 44) O'Connor may also have had in mind the precedent of George Mullins, the 18th century Irish landscape painter, who had also painted bathers by lakes and rivers.

Normally O'Connor's topographical paintings are readily identifiable as by his hand; it is his small rural scenes that can pose problems of attribution. Here, though, in two very similar pictures, we can see differences in technique that are somewhat disconcerting. Cat. no. 41 is more confidently and precisely painted than cat. no. 40, which suggests that it is the earlier of the two. The latter has characteristics (fairly pronounced when the paintings are seen side by side) which might initially raise doubts about the authenticity of the work: the 'banana-shaped' leaves on the repoussoir tree are not typical of O'Connor, and the figures, the trees on the right bank, and the water are less crisply handled than in cat. no. 41. Even the buildings in the two paintings have architectural discrepancies. It is likely, however, that cat. no. 40 is a later version, possibly painted in greater haste than the original.

Private Collection

116

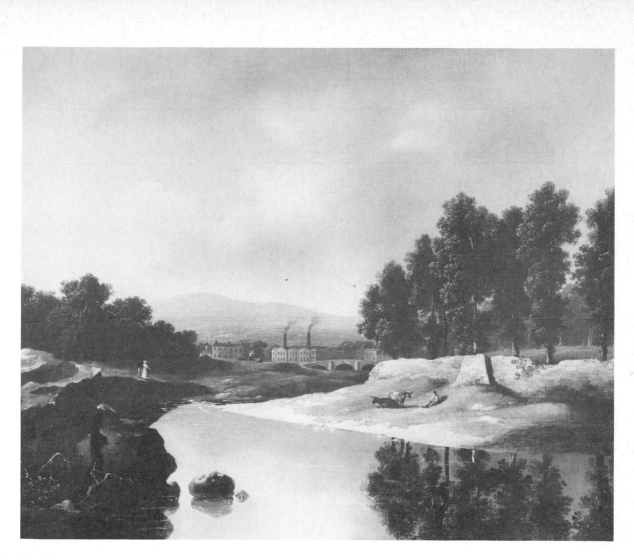

41. Duffy's Cotton Mills, Ballsbridge,
c.1818-1820

Oil on canvas,
38.0 x 48.2 cm.,
(15 x 19 ins.).

PROVENANCE:
Purchased from the Gorry
Gallery by present owner.

Private Collection

42. Trinity College Library, *c.1818-20*

Oil on canvas,
37.0 x 45.0 cm.,
(14½ x 17¾ ins.).

PROVENANCE:
J. Bury; D. N. Lowe;
Prof. E. Sheldon Friel;
Trinity College Library.

EXHIBITED:
Centenary Exhibition, Hugh
Lane Municipal Gallery of
Modern Art, Dublin,
1941, (1) *Irish Houses and
Landscapes*, Belfast and
Dublin, 1963, (36).

O'Connor's 'house-portraits' clearly extended beyond commissions of country estates, as this picture of Trinity College Library makes plain. The artist appears to have spent some time painting topographical views in Dublin and the city's suburbs shortly before leaving for England — possibly because he was unable to find commissions like the Westport and Ballinrobe series.

Lent by the Board of Trinity College Dublin

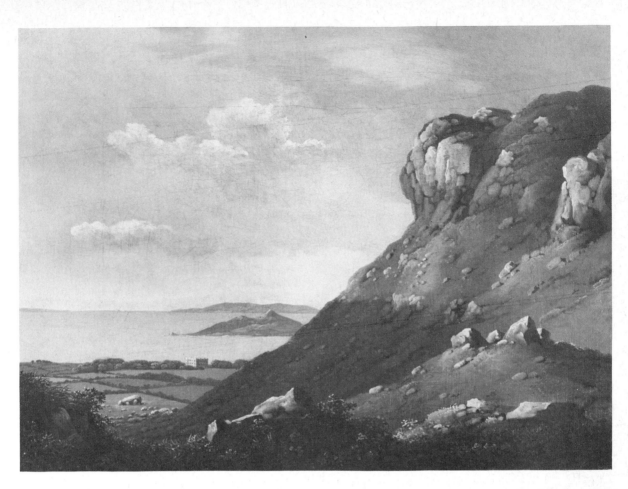

43. A View of Howth Head, *c.1819-20*

Oil on canvas,
29.2 x 39.4 cm.,
(11½ x 15½ ins.).

PROVENANCE:
Unknown.

This is one of several coastal scenes near Dublin that O'Connor painted towards the end of the decade. Another version of this view, also showing Howth Castle in the distance (not available for this exhibition), can be given a later date on stylistic grounds. Like cat. no. 44, *A View of Howth Head* has an awkward rocky mass on the right side of the composition — a curious feature, which is echoed in *Ireland's Eye from the Hill of Howth*, a picture that has been attributed to S. F. Brocas by Anne Crookshank and The Knight of Glin in *Painters of Ireland*, (1978), pl. 40. Brocas however, has inserted a 'repoussoir' tree on the left, to balance the bluff.

Private Collection

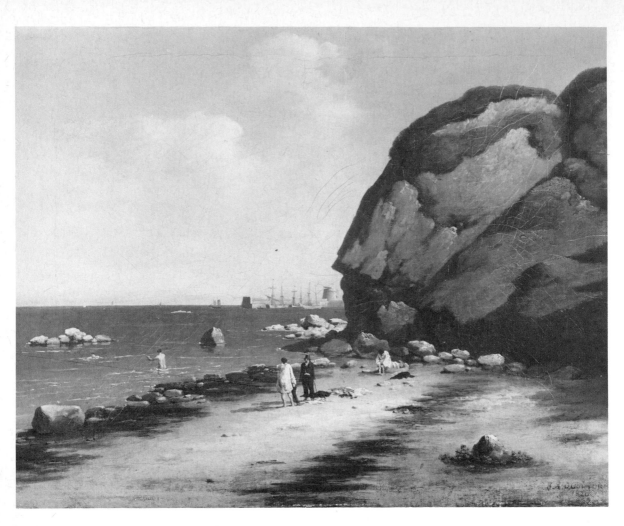

44. Bay Scene, Seapoint, *1820*

Oil on canvas,
36.2 x 44.5 cm.,
(14¼ x 17½ ins.).
Signed and dated:
J.A. O'Connor 1820.

PROVENANCE:
Hon. James A.
Murnaghan, by descent to
present owner.

EXHIBITED:
Centenary Exhibition, Hugh
Lane Municipal Gallery of
Modern Art, Dublin,
1941, (9a).

The picture is close in style to the two paintings of the Mills in Ballsbridge (cat. nos. 40 and 41). The composition, which is similar to that of *A View of Howth Head* (cat. no. 43) is somewhat contrived, for O'Connor has attempted to balance the dominant and massive rock on the right with accentuated light on the bathers. Besides the compositional awkwardness, the irrelevance of the 'snowy' highlight on the rock in the foreground, and the insubstantial flatness of the bluff are obvious 'faults', and foreshadow the weaknesses of many later works. It is interesting to see that O'Connor's later topographical paintings are middle class in their appeal — they are no longer 'house portraits' for the land-owning gentry.

Lent by Francis D. Murnaghan, Jr.

120

THE MIDDLE PERIOD

1821-1829

WHILE BODKIN GIVES 1821 (and on the next page, 1822),[1] as the date of O'Connor's departure, the *Dictionary of National Biography*, Redgrave, Strickland, and the *Dublin Monthly Magazine*, all give the later date, so it is safe to assume that the artist had arrived in London by early 1822, in time to submit a painting to the Royal Academy exhibition. O'Connor apparently soon had some success in selling his works, but then 'fell foul of dealers' commissions and fees'.[2]

After settling at no. 32, Upper Marylebone Street, Portland Place,[3] O'Connor probably travelled around the south of England during his first year abroad, as the National Gallery of Ireland holds a number of drawings, detached from a sketchbook, that are dated 1822. They include views of Hampstead, (cat. nos. 48c,k, and j) and scenes in Surrey, (cat. nos. 48d and n) and around Bristol (cat. no. 48m), which are variously executed in pencil, sepia, and watercolour. Some of the drawings depict 'Botleys', a Palladian house in Surrey, which suggest that O'Connor may again have painted in his early topographical style.

The succeeding years in England were apparently uneventful. In 1823, O'Connor exhibited Irish scenes at the Royal Academy and the British Institution, and among his works at the two exhibitions in the following year were views of Arundel and Offington in Sussex. In 1825, O'Connor moved to no. 29 Frederick Street, Hampstead,[4] near Danby and Constable, and showed a single picture at the Royal Academy. He also exhibited *A View of Westport Bay*, *A Scene on Sandymount Beach*, and *A View of Hampstead Heath* at the British Institution.

Having moved a short distance away to no. 14 Mornington Crescent, Hampstead Road,[5] O'Connor travelled to Brussels in May, 1826,[6] in the company of a dealer by the name of Collier, or Collior.[7] During this year in Brussels (he returned to London in 1827), O'Connor is reputed to have painted a considerable number of pictures,[8] and to have had a certain success with their sale. This success, it is generally agreed,[9] was spoiled by a swindle that the unfortunate artist suffered, possibly at the hands of the dealer who accompanied him from London.

However, 1826 did not pass without a positive achievement. The Nottingham Castle Museum possesses a very fine painting by O'Connor, entitled *The Edge of a Forest, Storm Coming On*, (cat. no. 56) which is signed and dated in that year. It is strongly rooted in the Dutch tradition of landscape

painting, and suggests the influence of Ruisdael and Hobbema, and of Gainsborough's early Suffolk landscapes.

There is a list of the paintings in the Godson Bequest, of which the O'Connor forms a part, that was drawn up when the pictures were bequeathed to the Nottingham Gallery and in a short note after the title of the O'Connor, there is the following remark: 'This picture was one painted for Louis Philippe, King of France *The Coming Thunderstorm*. The scene is land at the Meeting of the Waters, County Wicklow.[10] In one of the two obituaries of O'Connor in *The Gentleman's Magazine*, it is stated that ''The present King of the French possesses many of (O'Connor's paintings), and sent him a commission, which was not executed.[11] The Nottingham painting (cat. no. 56) may possibly be the commissioned work, which O'Connor completed, but for some reason decided not to send to the French King, who presumably came to know O'Connor's work when he was exiled, and living in England.

In 1827, after his return from Brussels, O'Connor exhibited at the British Institution, and probably travelled at least a short distance from the capital, for there is a painting of Worthing Beach which is dated in that year.

Ottley states that the artist visited Brussels with Collior in the autumn of 1828, where he painted and copied pictures; and that he stayed in Belgium until 1830, when the Revolution forced him to return home. It is likely, however, that Ottley was mistaken in his facts, for the little evidence that exists would suggest that O'Connor remained in London for most of that period, although he visited Ireland in 1830, and possibly in 1828. (There are several recorded paintings, all dated 1828, which include views of Wicklow (Cat. no. 60), the Liffey (Cat. no. 61), the Shannon and Connemara.)[12] Whether or not O'Connor returned home to Ireland in 1828, he moved to no. 8 Soho Square in London in that year,[13] and exhibited at both the British Institution and at the Royal Academy. In 1829, O'Connor moved house again, to no. 67 Clarendon Street, which he gave as his address when he exhibited at the Society of British Artists,[14] as well as at the two other major exhibitions in London. The following year O'Connor contributed to them again, from the same address.

1. Bodkin, op. cit., pp. 18-19. He also states, wrongly, that O'Connor was never to return to Ireland.
2. *Dublin Monthly Magazine,* April, 1842.
3. *Royal Academy Exhibition Catalogue,* 1822.
4. *Royal Academy Exhibition Catalogue,* 1825.
5. *Royal Academy Exhibition Catalogue,* 1826.
6. *Dublin Monthly Magazine,* April, 1842.
7. Bodkin, op. cit., p. 20, names the dealer as 'Collier'. Ottley, on the other hand, calls him 'Collior', and states that the journey took place in 1828.
8. Bodkin, op. cit., p. 20.
9. Bodkin, op. cit., *Dictionary of National Biography* (entry on O'Connor); *Dublin Monthly Magazine,* April 1842 (article on O'Connor by 'M').
10. Information kindly supplied by David Phillips, Keeper of Fine Arts, Nottingham Castle Museum.
11. *The Gentleman's Magazine,* March, 1841. (Obituary by O'Connor).
12. *James Arthur O'Connor Centenary Exhibition,* Hugh Lane Municipal Gallery of Modern Art, 1941, nos. 21, 28, 32, 38.
13. *Royal Academy* and *British Institution Exhibition Catalogues,* 1828.
14. Strickland, op. cit., p. 180, states that O'Connor became a member of the Society of British Artists.

Illustration 12 JAMES ARTHUR O'CONNOR, *Self-portrait*. Whereabouts unknown.

After James Arthur O'Connor

47. Self-Portrait

Oil on millboard,
17.8 x 14.0 cm.,
(7 x 5½ ins.).

PROVENANCE:
Mrs. Fitzpatrick; Hibernian
Antiques, from whom
purchased by present
owner.

O'Connor's original self-portrait, (illus. no. 12), has not been traced. This is a later copy of the picture, by an unknown artist. In the original painting O'Connor looks withdrawn and rather fearful, 'as though he presaged his sad career', to quote Bodkin's wistful comment.[1]

1. Thomas Bodkin, *Four Irish Landscape Painters*, (1920), p.26.

Lent by D. J. McCarthy

127

. one of the ponds at Hampstead .

48. Leaves from an 1822 sketchbook

a) Rochester Castle, Kent, from the River Medway (not illustrated)
Ink and watercolour on paper, 13.0 x 21.0 cm., (5⅛ x 8¼ ins.).

PROVENANCE:
Purchased Mr. J. Doyle, London, 1873; N.G.I. Cat. No. 2209

b) Dover Castle, Kent, from the London Road (not illustrated)
Ink and wash on paper, 13.0 x 21.0 cm., (5⅛ x 8¼ ins.).

PROVENANCE:
Purchased Mr. J. Doyle, London, 1873; N.G.I. Cat. No. 2210.

c) Hampstead Ponds, London
Ink and pencil on paper, 13.0 x 21.0 cm., (5⅛ x 8¼ ins.).

PROVENANCE:
Purchased Mr. J. Doyle, London 1873; N.G.I. Cat. No. 2211.

d) The West Front of Botleys House, Surrey from a Garden Building (not illustrated)
Pencil on paper, 13.0 x 21.0 cm., (5⅛ x 8¼ ins.).

PROVENANCE:
Purchased Mr. J. Doyle, London 1873; N.G.I. Cat. No. 2213.

e) Clifton Rock, near Bristol, Avon (not illustrated)
Pencil on paper, 13.0 x 21.0 cm., (5⅛ x 8¼ ins.).

PROVENANCE:
Purchased, Mr. J. Doyle, London 1873; N.G.I. Cat. No. 2214.

f) Ospringe Village, Kent (not illustrated)
Ink and watercolour on paper, 13.0 x 21.0 cm., (5⅛ x 8¼ ins.).

PROVENANCE:
Purchased, Mr. J. Doyle, London 1873; N.G.I. Cat. No. 3218.

g) Sandgate Beach, Kent (not illustrated)
Ink and watercolour on paper, 13.0 x 21.0 cm., (5⅛ x 8¼ ins.).

PROVENANCE:
Purchased, Mr. J. Doyle, London, 1873; N.G.I. Cat. No. 3219.

h) Dover and Shakespeare Cliff, Kent (not illustrated)
Ink on paper, 13.0 x 21.0 cm., (5⅛ x 8¼ ins.).

PROVENANCE:
Purchased, Mr. J. Doyle, London, 1873; N.G.I. Cat. No. 3220.

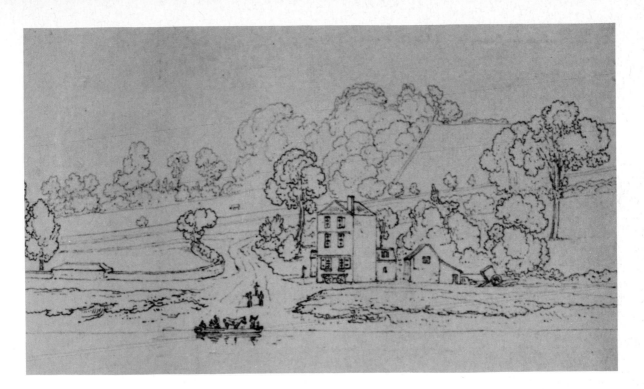

i) Dover Cliffs, Kent (not illustrated)
Ink and wash on paper, 13.0 x 21.0 cm.,
(5⅛ x 8¼ ins.).

PROVENANCE:
Purchased, Mr. J. Doyle, London, 1873; N.G.I.
Cat. No. 3221.

j) Hampstead Heath, London (not illustrated)
Ink on paper, 13.0 x 21.0 cm., (5⅛ x 8¼ ins.).

PROVENANCE:
Purchased, Mr. J. Doyle, London, 1873; N.G.I.
Cat. No. 3222.

k) Pine Trees on Hampstead Heath, London (not illustrated)
Ink on paper, 13.0 x 21.0 cm., (5⅛ x 8¼ ins.).

PROVENANCE:
Purchased, Mr. J. Doyle, London, 1873; N.G.I.
Cat. No. 3223.

l) Clifton Rock, near Bristol, Avon (not illustrated)
Ink and pencil on paper, 13.0 x 21.0 cm.,
(5⅛ x 8¼ ins.).

PROVENANCE:
Purchased, Mr. J. Doyle, London, 1873; N.G.I.
Cat. No. 3229.

m) The Rownham Ferry near Bristol, Avon
Ink and pencil on paper, 13.0 x 21.0 cm.,
(5⅛ x 8¼ ins.).

PROVENANCE:
Purchased, Mr. J. Doyle, London, 1873; N.G.I.
Cat. No. 3230.

n) The East Front of Botleys House (not illustrated)
Pencil on paper, 13.0 x 21.0 cm., (5⅛ x 8¼ ins.).

PROVENANCE:
Purchased, Mr. J. Doyle, London, 1873; N.G.I.
Cat. No. 3231.

These leaves from a sketchbook tell us about the artist's movements in 1822, just after he arrived in England for the second time. There are several drawings of Botleys House in Surrey (cat. nos. 48d and n), which are reminiscent of his topographical paintings, many views along the south coast and some near Bristol (cat. nos. 48e, l and m), where O'Connor may have visited Francis Danby. The sketchbook also included a few drawings of Hampstead Heath (cat. nos. 48c, j and k), where Constable was

129

painting at about the same date, and which was a favourite subject for many contemporary artists who lived in London.

With only a handful of exceptions, all the sketches are handled in O'Connor's typically tight, linear manner of drawing, and a comparison with Constable's sketchbooks of 1813-14 confirms that O'Connor's style was old-fashioned. There is a sense of deliberation about his drawings that is not to be found in Constable's spontaneous sketches, which are worked with a soft pencil, and have gradations of tone that give them a depth and richness that O'Connor's lack.

Nevertheless, O'Connor's drawings are pleasing, for they have something of the simplicity and stillness that characterize his early paintings. The watercolours, painted in warm tints, are particularly attractive, and have a 'finished' quality which suggests that O'Connor worked on them with care and attention, possibly using them as preparatory sketches for oil paintings. It is worth noting that O'Connor's drawings and watercolours change very little in technique throughout his career, and that even in the 1820s he used sepia washes — an 18th century convention.

Lent by the National Gallery of Ireland

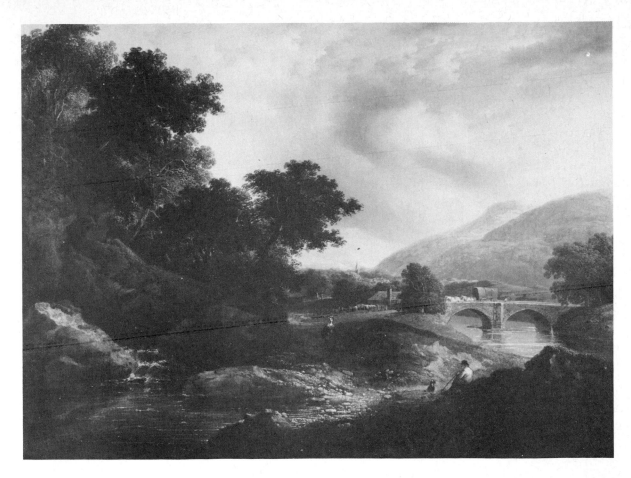

49. A Wooded River Landscape, *1823*

Oil on canvas,
45.7 x 61.0 cm.,
(18 x 24 ins.).
Signed and dated:
J.A. O'Connor 1823.

PROVENANCE:
London salesrooms, where
purchased by present
owner.

As this picture demonstrates, O'Connor had more or less made a complete transition from topography to the picturesque by 1823. The painting shows signs of awkwardness in his new style: the central figure, a young girl, is an uncomfortable addition to the composition, and may have been inserted as an afterthought. It is interesting to see the wagon and horses in the distance — a motif that O'Connor was to use more dramatically in the 1830s.

Lent by Coyle Fine Art, Dublin

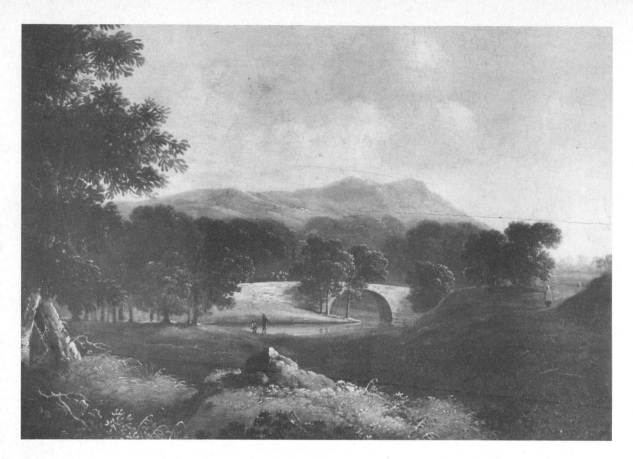

50. A View near Monasterevin

c.1823

Oil on panel,
24.0 x 34.3 cm.,
(9½ x 13½ ins.).

PROVENANCE:
Former collection, W. L.
Cremin.

EXHIBITED:
Centenary Exhibition, Hugh
Lane Municipal Gallery of
Modern Art, Dublin,
1941, (13).

This picture is interesting for two reasons. Firstly, it is probably a non-commissioned view of a specific spot, seen, as it were, through classical eyes; and secondly, the foliage on the tree in the left foreground is another instance of the 'banana-shaped' leaves that are evident in the later version of *Duffy's Mills, Ballsbridge* (cat. no. 41).

Private Collection

132

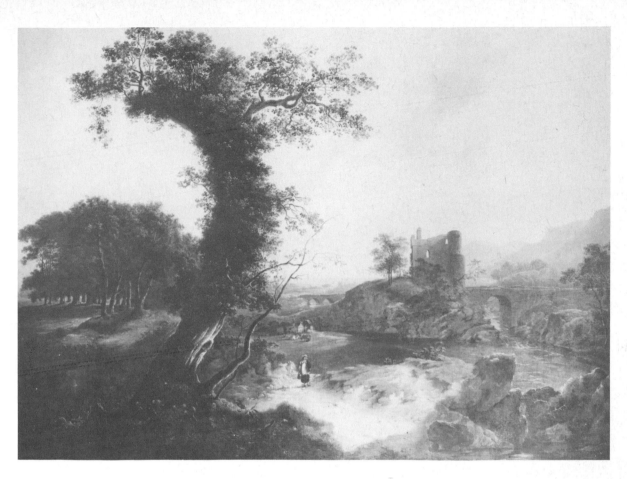

51. Landscape with Girl on a Path, River, Ruins and Bridge, *c.1823*

Oil on canvas,
87.0 x 117.0 cm.,
(34¼ x 46 ins.).
Signed and dated:
J.A. O'Connor 18..(?).

PROVENANCE:
Dr. K. Mullen; R.
McDonnell, from whom
purchased by present
owner.

The date on the canvas is unclear, but has been read as '183..'. If it was in fact painted in the 1830s, this landscape is an anomaly, but not an impossibility, as O'Connor's development was punctuated by many such oddities. Stylistic evidence, however, suggests that the picture was painted about 1823.

The bridge, ruins, and mountains are motifs that O'Connor used in pictures like *A Wicklow Landscape* (cat. no. 45), but the Dutch inspired elements, such as the copse in the left middle-distance, are new developments. While *A Wicklow Landscape* is composed in a classical manner, in this work O'Connor is experimenting with another style: like the Dutch 17th century painter Hobbema, O'Connor has attempted to construct the painting with several view points, using different perspective, and he has bound the different features together with a balanced distribution of dark and light groupings. He was only partially successful in this, however, as each part has an oddly disparate quality, and fails to combine easily with the rest of the painting. Besides, the central tree is too dominant in the composition. The picture is similar in construction to a landscape by the French 18th century artist Lantara, which is in the Musée des Beaux-Arts, Valenciennes.

Private Collection

133

52. Self-Portrait, *1824*

Ink on paper,
7.6 x 6.4 cm.,
(3 x 2½ ins.).
Signed and dated:
J A O'Connor 1824.
Inscribed: O'Connor.

PROVENANCE:
Hibernia Antiques, where
purchased by present
owner.

It is likely that this is a self-portrait — the only one, bar illus. no. 12, of which cat. no. 47 is a copy, that is currently known. It is possible that the male figures in the foreground of cat. nos. 29 and 46 are portraits of the artist, but there is no way of being sure of this.

Private Collection

134

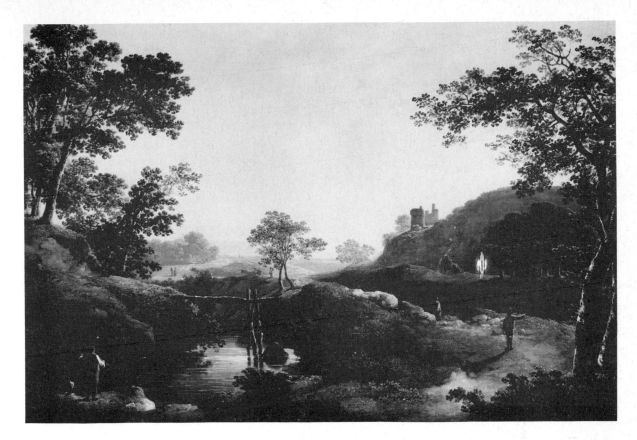

53. Landscape with Anglers, Bridge and Ruins, *c.1824*

Oil on canvas:
36.2 x 48.2 cm.,
(14¼ x 19 ins.).

PROVENANCE:
Cynthia O'Connor Gallery from where purchased by present owner.

Landscape with Anglers, Bridge and Ruins is one of the finest — and most mellow — of O'Connor's landscapes of this period. Stylistically, it acts as a transition between 18th century classical landscapes and later 'Picturesque' views. The painting's antecedent, and possibly its inspiration, is Thomas Roberts' *Landscape with Bridge and Waterfall* (illus. in Anne Crookshank and The Knight of Glin, *Painters of Ireland*, (1978), pl. 27). The composition of the two pictures is broadly similar: O'Connor, like Roberts, has used a serpentine path (with several figures on it) to lead the eye into the distance, and O'Connor's river, like that in the Roberts, is spanned by a rackety wooden bridge — something that seldom, if ever, reoccurs in his work.

Private Collection

J. A. O'Connor delt

54. Etchings

a) Old Man, Stick in Hand, Walking along a Road
b) Man Sitting on a Bank, Holding Hat in Both Hands
c) Seated Man, Asleep, Leaning Forward Across a Table, Head on Arms
d) Man in Profile, Holding Rake
e) Man under Tree, Holding Rake *(dated 1824)*
Plate 11.8 x 8.0 cm., (4⅝ x 3¼ ins.).
Published by T. North, 162 Fleet Street, London
All signed:
J.A. O'Connor, delt; one dated 1824

This series of etchings is a notable, but unmemorable, minor digression in O'Connor's stylistic development. They are rather slight studies in a 17th century Dutch manner: competent, but uninspired.

Lent by the Trustees of the British Museum

136

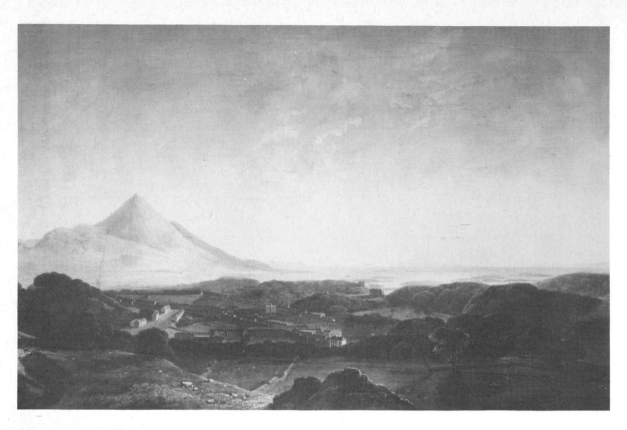

55. Westport and Clew Bay, *1825*

Oil on canvas,
51.5 x 77.1 cm.,
(20¼ x 30⅜ ins.).
Signed and dated:
J.A. O'Connor 1825.

PROVENANCE:
Unknown.

EXHIBITED:
English Romantic Exhibition
(Arts Council), 1947, (64).

The colouring in the sky of this painting is considerably more dramatic than in the earlier versions of the view, and may own something to the influence of Turner.

There is at least one other view of Clew Bay that was painted some years after the original series at Westport and it has a similarly colourful sky.

Lent by the Victoria and Albert Museum, London

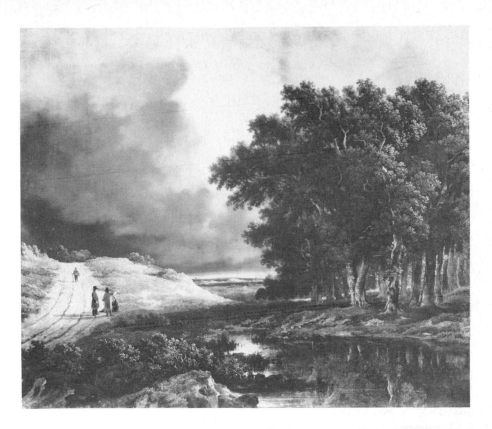

56. The Edge of a Forest, Storm Coming On, *1826*

Oil on canvas:
56.5 x 68.0 cm.,
(22¼ x 26¾ ins.).
Signed and dated:
J.A. O'Connor 1826.

PROVENANCE:
(Possibly Christie's, March 19th, 1881, (284) from the collection of John Wardell, Dublin). Richard Godson Millns Bequest (on a pencil-written list of pictures in the Millns Bequest there is the following note, perhaps copied from a list label: 'This picture was one painted by the artist for Louis-Philippe, King of France *The Coming Thunderstorm* the scene is laid at the meeting of the waters, County Wicklow)', 1904; Nottingham Castle Museum.

LITERATURE:
Anne Crookshank and The Knight of Glin, *The Painters of Ireland*, (1978), p. 212.

Stylistically, *The Edge of a Forest, Storm Coming On*, is related to Gainsborough's *Cornard Wood* (National Gallery, London), and ultimately to Ruisdael, but O'Connor has so stressed the contrasts of dark and light that there is no mistaking its romantic overtones. It remains, however, one of the most purely 'Dutch' of all his works.

In this picture O'Connor is at his most assured. The composition is confident and effective: the foreground shrubs and rocks balance the trees on the far side of the pond, both having dappled highlights, and the lowering bank of clouds corresponds to the water with its delicate reflection. Diagonally across the central plane, sunlight breaks through the wood and focuses attention on the people on the path; one of them points to a parallel path in the distance, where, just visible, are two other tiny figures. The dramatic play of dark and light continues horizontally, too; the alternating bonds of colour disappear into the distance, leading the eye to a final glimpse of clear sky, far beyond the stormy clouds. If this picture was painted at the Meeting of the Waters, near Avoca in Co. Wicklow, as a label suggests, the location has changed beyond recognition.

Lent by Nottingham Castle Museum

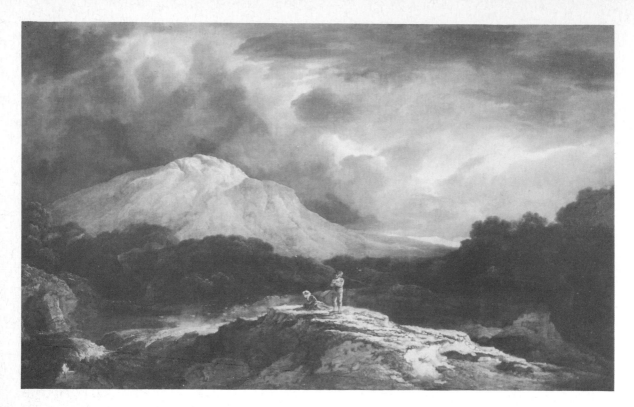

57. The Gathering Storm, *1826*

Oil on canvas,
64 x 101.5 cm.,
(25¼ x 40 ins.).
Signed and dated:
J.A. O'Connor 1826.

PROVENANCE:
Unknown.

This is a curious painting by O'Connor, and among the first of his purely romantic views. The colouring in the picture is unusual, and the treatment of the trees is particularly flat (which may have been caused by poor restoration in the past). The artist has set the two figures — one of them almost a caricature of a stage Irishman — on a brightly lit mound, which serves as contrast to the dramatic stormy clouds over the distant hills. While the woman, reclining on the ground, has a certain conventional elegance, it is obvious that the man is not a partrician in search of the 'Sublime'. This marks a definite shift away from the picture's eighteenth century precedents.

Private Collection

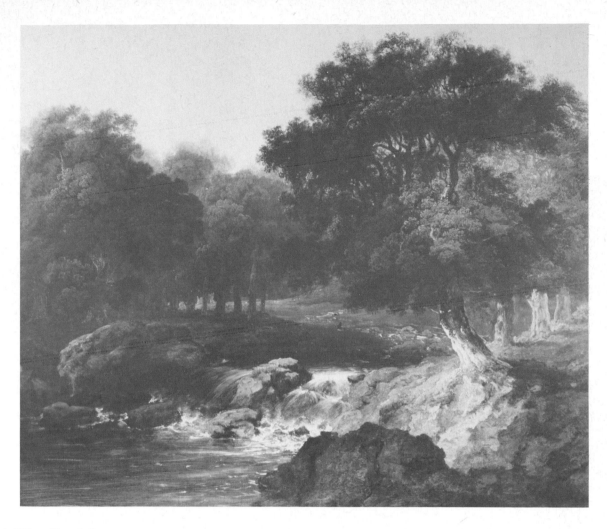

58. A Woodland Scene with River, *1826*

Oil on canvas,
63.5 x 76.2 cm.,
(24½ x 29½ ins.).
Signed and dated:
J.A. O'Connor 1826.

PROVENANCE:
William Carrigan K.C.,
1941; Cynthia O'Connor
Gallery, 1979; from where
purchased by present
owner.

EXHIBITED:
Centenary Exhibition, Hugh
Lane Municipal Gallery of
Modern Art, Dublin,
1941, (30).

One of O'Connor's Dutch-inspired woodland scenes, this is probably the kind of painting that O'Connor was exhibiting at the Royal Academy and British Institution during the second half of the decade. Other artists with whom O'Connor would have been competing for sales were Callcott, Lee, Chalon, Delamotte and Crome — all painters of similar picturesque scenes.

Private Collection

141

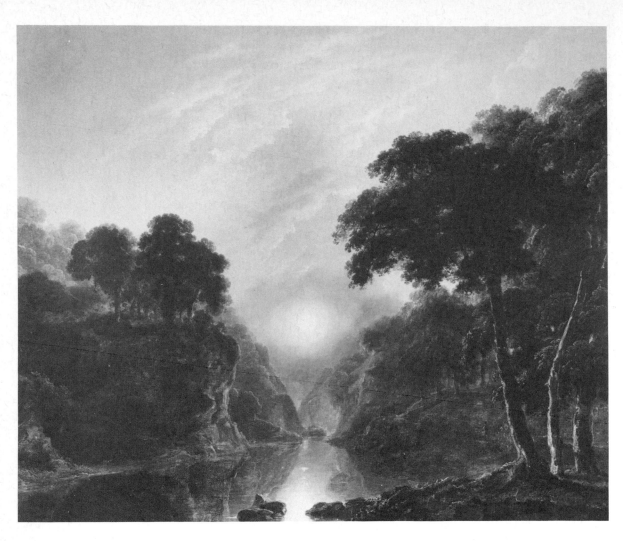

59. River Scene, *1826*

Oil on canvas,
56.0 x 66.6 cm.,
(22 x 26¼ ins.).
Signed and dated:
J.A. O'Connor 1826.

PROVENANCE:
Gorry Gallery; Private
Collection Dublin, where
purchased by present
owner.

EXHIBITED:
Gorry Gallery, Dublin,
May 1984, (4).

This river scene, with its skillfully rendered moonlight effects, may possibly be on the Continent, but that supposition is based only on a subjective feeling that the valley is neither Irish nor English. In any case, it predates O'Connor's most important moonlight painting, *The Poachers*, (cat. no. 79) by nine years.

Lent from a Private Collection, Courtesy Gorry Gallery

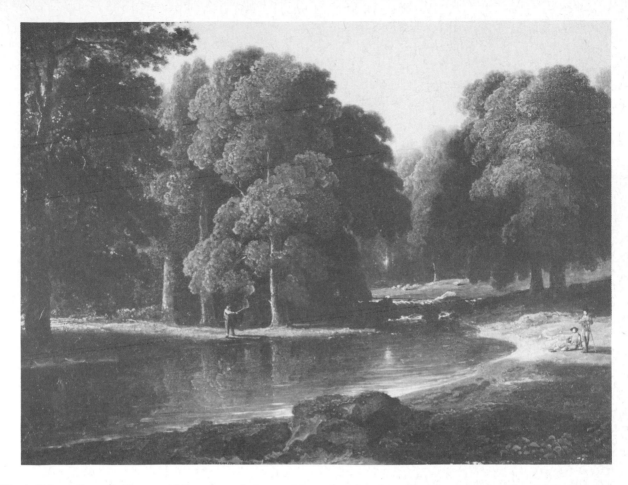

60. A River Scene, Co. Wicklow, *1828*

Oil on millboard,
22.9 x 30.5 cm.,
(9 x 12 ins.).
Signed and dated:
J.A. O'Connor. 1828.

PROVENANCE:
C.P. McGrath, through
the Gorry Gallery, where
purchased by present
owner.

Although, strictly speaking, these two pictures (cat. nos. 60 and 61) are not a pair, they are very similar in conception and style, and were probably painted within weeks of each other. The man in the boat in cat. no. 61 may have been added for annecdotal interest — he is not integral to the scene. Otherwise, these intensely green pictures are fine examples of O'Connor's 'Picturesque' style of the late 1820s.

Lent from a Private Collection, Courtesy of the Gorry Gallery

143

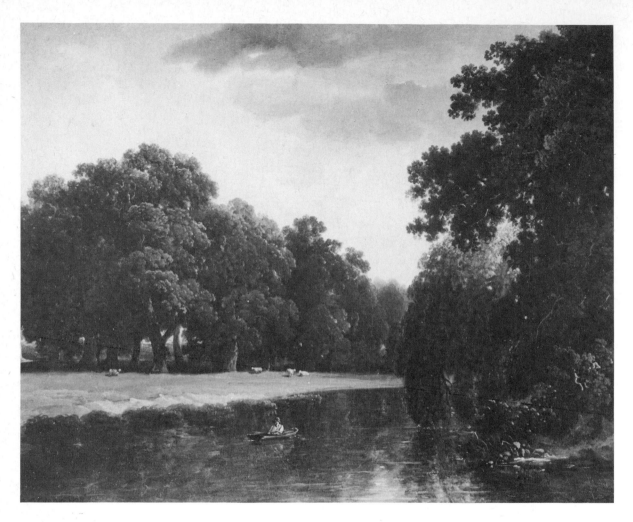

61. A View on the Liffey, *1828*

Oil on board,
22.2 x 28.0 cm.
(8¾ x 11 ins.).
Signed and dated:
J.A. O'Connor. 1828

PROVENANCE:
C.P. McGrath, through
the Gorry Gallery, where
purchased by present
owner.

EXHIBITED:
Centenary Exhibition, Hugh
Lane Municipal Gallery of
Modern Art, Dublin,
1941, (50).

*Lent from a Private Collection, Courtesy of the
Gorry Gallery*

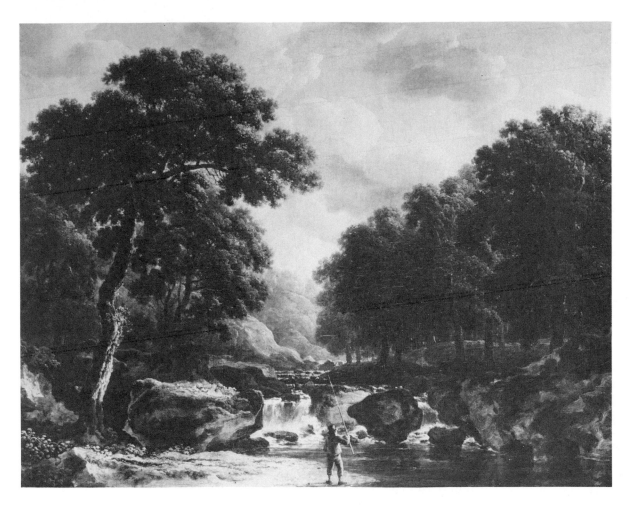

62. The Devil's Glen, Co. Wicklow, with a Fisherman, *1828*

Oil on canvas,
34.0 x 43.1 cm.,
(13⅜ x 17 ins.).
Signed and dated:
J.A. O'Connor 1828.

PROVENANCE:
Henry Spencer; Ashbee
Bequest, 1900.

The Devil's Glen Co. Wicklow, with a Fisherman gives us some intimation of the way O'Connor's style was to develop in the next decade. It is a skilful picture that has both a cheerful, gentle mood and a suggestion of the melancholy of the coming years.

Lent by the Victoria and Albert Museum, London

145

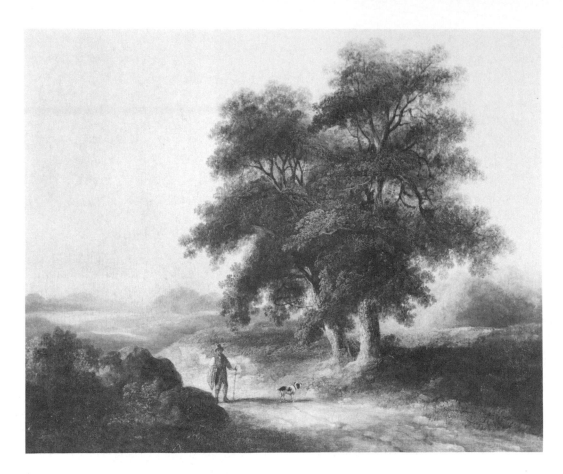

63. Homeward Bound, c.1825-1830

Oil on canvas,
63.0 x 76.0 cm.,
(24¾ x 30 ins.).
Signed: J.A. O'Connor.

PROVENANCE:
Sir Robert and Lady
Woods, by whom
presented, 1950; N.G.I.
Cat. No. 1182.

Many pictures such as *Homeward Bound* — unpretentious, picturesque wooded landscapes with peasant figures — appear to have been painted by O'Connor in the late 1820s and late 1830s, although most of them are undated. They have very little stylistic individuality, but are nonetheless delightfully atmospheric, and express a warm, idealized conception of the countryside.

As a rule, these paintings include an oak or two in the foreground or middle-distance, with a figure on a path that leads into the distance, where hills fade into pale light tones. *Homeward Bound* is no exception, and it loosely follows the classical landscape compositions of Claude Lorraine. A patch of bright red, usually taking the form of a waistcoat or shawl, frequently serves to intensify the strength of the green foliage. (This was a common device at the time, and was used by Constable, among many others — it is by no means singular to O'Connor, as is sometimes imagined). This genre of landscape painting has always proved attractive to the general public, which explains both the relatively large number of works by O'Connor that are painted in this style and the fact that there were so many contemporary British artists working in a similar manner. Because few of them are signed, O'Connor's many weaker pictures of this kind are almost indistinguishable from countless works by other painters, which has led to inevitable problems of attribution.

Lent by the National Gallery of Ireland

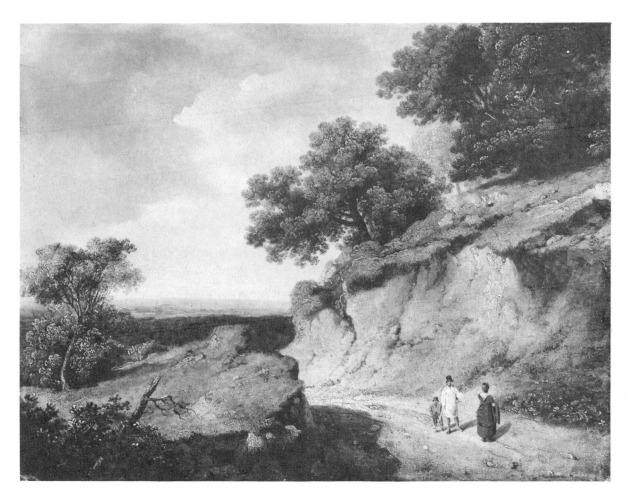

64. A Landscape with Figures and Sandbanks,
c.1826-1830

Oil on panel,
32.0 x 43.0 cm.,
(12½ x 17 ins.).

PROVENANCE:
Mr. H. Scott, Dublin,
from whom purchased
1900; N.G.I. Cat. No.
489.

While O'Connor's picturesque views were, in the main, influenced by Dutch artists like Hobbema and Ruisdael, in this case the artist must have been looking at the landscapes of Wynants and the early work of Gainsborough, which frequently made a feature of sandbanks. The picture is not dated, but is tentatively ascribed to this period. It may, however, have been painted a few years earlier.

Lent by the National Gallery of Ireland

147

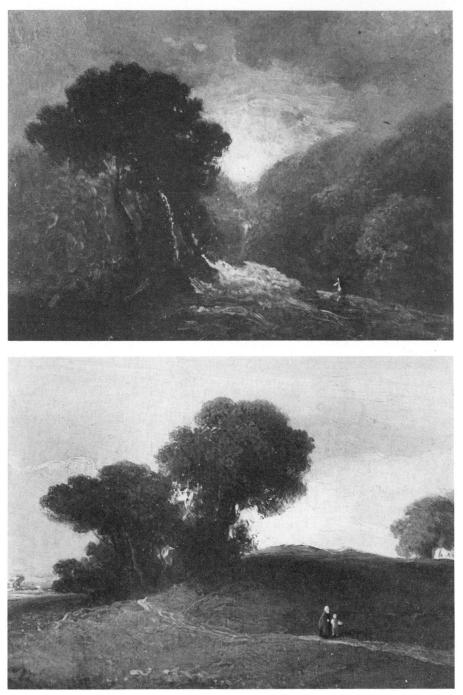

65. Night and Day,
c.1826-30

a) Moonlight
Oil on millboard,
7.6 x 10.1 cm.,
(3 x 4 ins.).
Signed: J.A.O'C.

b) Daylight
Oil on millboard,
7.6 x 10.1 cm.,
(3 x 4 ins.).
Signed: J.A.O'C.

PROVENANCE:
Cynthia O'Connor Gallery,
1984, from where
purchased by present
owner.

O'Connor painted pairs of miniature pictures fairly frequently, but because few of them are dated, it is difficult to locate them precisely in his stylistic development. These tiny paintings are charming 'pot-boilers', doubtless intended for the domestic market.
Private Collection

148

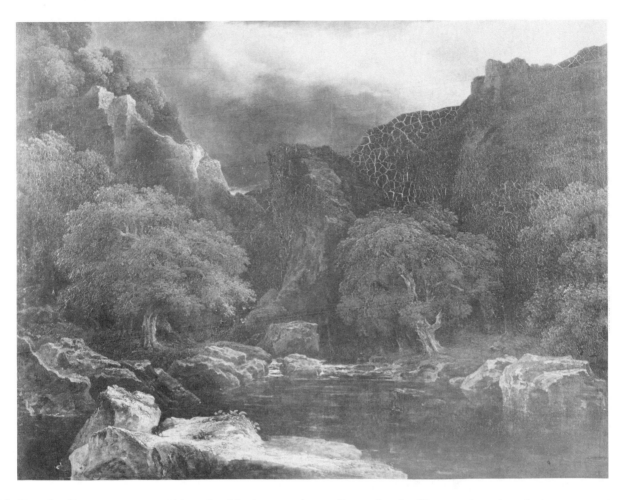

66. Dargle Country, *1829*

Oil on canvas,
70.0 x 91.0 cm.,
(27½ x 35¾ ins.).
Signed and dated:
J.A. O'Connor. 1829.

PROVENANCE:
Presented by Sir Frederick
Thorpe Mappin, 1887.

Although this is not the earliest of O'Connor's dated romantic works — see *The Gathering Storm* (cat. no. 57), it serves to introduce the series of dark, melancholy pictures that O'Connor produced in the early 1830s. It may be significant that in the same year O'Connor was forced to sell off his little 'pot-boilers' at auction, because he found it difficult to find another market for them: his spirits were probably at a low ebb.

Lent by Sheffield City Art Galleries

149

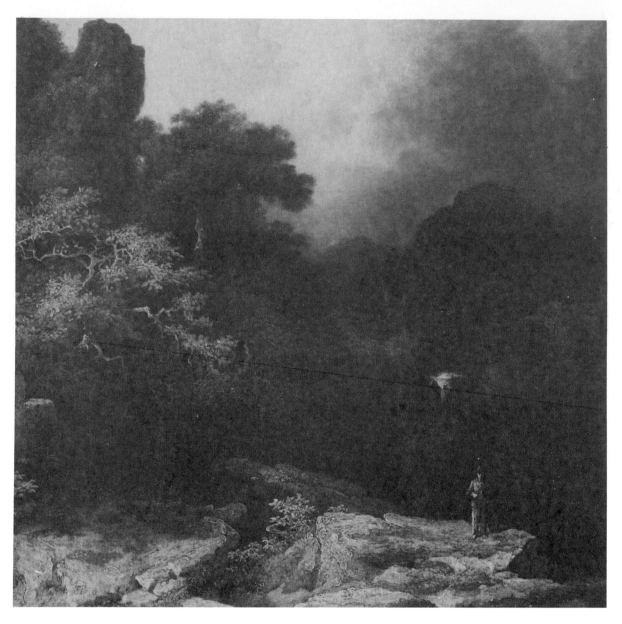

Detail of *The Eagle's Rock, Killarney.* (cat. no. 72).

THE LATE PERIOD

1830-1841

JOHN GIBBONS, a friend and patron of Francis Danby, received a letter from O'Connor in August, 1830,[1] which read: 'I am about going to the wild and beautiful scenery of my native country to refresh my memory, and get some studies to help me in future exertion in my profession — I know I will be benefited by a sight of the grand ... scenery that I will meet with in Ireland and hope to show it on canvas ...'. O'Connor stayed in Ireland until the end of October,[2] and may have made preliminary sketches for one of his greatest paintings, *The Eagle's Rock, Killarney*, which is dated 1831.[3] (cat. no. 72).

It is interesting that the artist's visit to Ireland in 1830 marked an important change in his pictorial style, for O'Connor's paintings became more overtly romantic and darker in tone — which emphasized the sombre and dramatic character of the scenery in Co. Wicklow. It may be that O'Connor realized that his style had been stagnating in the previous few years, for in 1829 the *Morning Chronicle* reported:[4] 'No artist has done himself more mischief by hurry than Mr. O'Connor. The auction rooms were not long since crammed with his hasty productions. "Il faut vivre" was the excuse — but one at which the judicious grieved'. Plainly the artist was forced, out of financial necessity, to paint large numbers of 'pot-boilers', and then to sell them at auction, which suggests that O'Connor was having great difficulty in finding buyers for his work.

Several letters to John Gibbons reveal information about O'Connor's life and opinions during this period, although they mainly concern two paintings, *The Golden Age* by Danby,[5] and a picture by the French artist Isabey. Both works belonged to Gibbons, and had been sent to O'Connor by Danby, who was then in Europe. O'Connor commented on them thus[6] - 'The picture, taking it altogether, does Mr. Danby great merit, it is beautifully composed and color'd — it appears at first sight rather Hot in tone, but that impression soon wears away, at least it did so with me, and I felt that it was right in color, grand in composition, and the effect really splendid. I hope for my friend Danby's sake that it may give you the satisfaction he wishes. The small picture by Isabey is much the best specimen except one that I have met with from the hands of a Frenchman — it does their school great honor — ...'.

Of greater import are the following remarks, which O'Connor recorded in a letter of 1831[7] 'There is very little doing in the way of the Arts at

present in London — I do not think that I ever remark'd so few pictures mark'd sold in the British Gallery and it is not for want of talent in the Exhibiting Artists for there are many good pictures in the rooms and a few better than usual, however, the Exhibition of the British Artists at Suffolk St., and that of the Royal Academy may turn out better and more profitable so that we may have some cause to be pleas'd.' He then comments on Landseer's election to the Academy: 'You may have seen by the Newspapers that Landseer is the new Academician in the room of Lawrence — what a fool Danby has made of himself if he had staid at home and behaved himself as he ought to have done this would not have been — he must have been in at least before the last two members ...'. Danby is mentioned again in a letter of March 5th[8] 'I was quite astonish'd at that part of your letter when you inform'd me of Danby's mad scheme of floating on the Rhine and with his family — he must be insane, for nothing but insanity could prompt him to undertake so wild and dangerous a journey — very truly you say that he will be a lucky fellow if he ever writes again — but I must hope that he has been induced to abandon such an undertaking, and if he will continue his travels that he will go on rationally and profitably — has he ever mentioned to you whether he was pleas'd with the scenery or not - he promised to write to me descriptions of whatever he met that was beautiful but I suppose he has forgotten that he made the promise or perhaps the scenery disappointed him. I know of old that he is very difficult to please'.

O'Connor's interest in Danby's journey down the Rhine is worthy of note: no doubt he had it in mind when he was induced to change his plans in Paris in 1833, and visited Germany instead of Italy. It is remarkable, too, to see the lack of bitterness with which he laments Danby's apparently thoughtless rejection of success and recognition at home; the more so because of O'Connor's own relative failure and neglect.

In April, O'Connor brought up the subject again:[9] 'Have you heard lately from Danby? He has not answer'd my letter, and I have now given up all hopes of a letter from him. I am anxious to know what he is doing and how he is getting on — but excepting yourself I know of no person who could give me any information. He is an unfortunate fellow, kicking at fame and fortune and running a wild goose chase thro Europe. And at such a time, and with such a family — it is so strange that one does not know what to think — but I have made up my mind that he is thoroughly blind to his own interests — he may get some fine scenery from nature but Danby is not a painter of views, and I doubt very much whether any scenery that he may get abroad will be of value to him in his compositions — I may be mistaken and for his sake I hope that my opinion may be wrong — but I really feel convinced that the head that conceived the crossing of the Red Sea, the opening of the Sixth Seal and Enchanted Island had no occasion to travel for subjects for his pictures'.

O'Connor wrote again in May,[10] and described the poor reaction to Danby's *Golden Age* when it was exhibited at the Royal Academy. He commented further on the rest of the exhibition:'Mulready's Picture of the sailing sketch is a very clever production, but he has done much better, he should employ his pencil in a higher walk of Art to which he is perfectly competent — Rippingille's two pictures are likewise very clever, particularly the Miff [location unknown], the subject is exceedingly well told — pictures of this class have not much interest for me. I like Hart's picture of the Catholics of past receiving Communion in a private chapel [location unknown] it is a grand and imposing picture tho on rather a small scale — likewise I very much like Liversegge's pictures there are two in the present Exhibition ... they are beautifully coloured and with a rich firm effect — but the finest picture of this class is Leslie's picture of Falstaff at Dinner in the House of Mr. Page [location unknown — replica in Victoria and Albert Museum, London] — it is a splendid Work of Art and does equal honor to the painter and the country in which such a fine Picture has been produced — Turner has many fine pictures but the best by many degrees, at least in my opinion, is that of Admiral van Tromps Yacht crossing the mouth of the Texel [Soane Museum, London]. The picture is one mass of light, and while it is very powerfull and full of color — he is a most extraordinary man, for everything he paints is sure to astonish the observer — but I never saw one of his works to compare with this. I may be wrong, but I think that this is the finest sea piece that has ever been produced — there are no doubt many fine pictures in this Exhibition and which are worthy of Admiration Calcott's for instance are beautifully painted, but I could not dwell on them as I could on Turner's. They appear tame in comparison — and Wilkie has become a portrait painter which I think a great mistake on his part, as by it he will neither add to his fortune or his reputation, which should be more dear to an artist than gold — Taking the Exhibition altogether it is the best that has been since 1828. The Acting man on the hanging committee this season was Constable and he certainly has got the ill will of all the Landscape painters, out of the Academy, by his illiberal and little conduct as to the placing of the Pictures. He has put my pictures against the ceiling. I have not had a good situation since he has been dubbed RA'.

It is somewhat surprising to note O'Connor's interest in genre scenes, and to observe that he apparently paid no attention to Constable's *Salisbury Cathedral from the Meadows*, (private collection, on loan to the National Gallery, London) which was hanging at the same exhibition. A certain personal antagonism, suggested in the above letter, may have prevented O'Connor from acknowledging Constable's skills, although this is unlikely, considering O'Connor's benevolent temperament.[11]

1832 and 1833 were interesting years in O'Connor's life, and are well recorded by 'M' in the *Dublin University Magazine*: most of the following

details of his travels, and all the uncredited quotations are taken from this source.[12] O'Connor exhibited as usual in 1832, as he had done the year before, and moved house yet again, to no. 39 Charing Cross Road.[13] In September, however,[14] O'Connor and his wife left London for Paris, on the start of a long and eventful journey.

'M' states that O'Connor made 'many valuable studies' in France, (including a view in the Bois de Boulogne, illus. no. 14), and that most of the paintings O'Connor completed in Paris were sent back to London for sale, where they fetched good prices. Bodkin mentions that the artist had even greater success in the French capital than in Brussels, 'for the French had been fired with an enthusiasm for British landscape painting by the Constable pictures shown in the exhibition of 1824.'[15] This is corroborated by one of the obituaries in *The Gentleman's Magazine*,[16] which noted that 'his works have obtained very high prices in France and Belgium. The present King of France possesses many of them …'. Presumably, if this was so, there must be paintings by O'Connor that lie forgotten in private collections in those countries, which will long remain difficult to trace, for the apparently simpler task of finding the works owned by Louis Philippe has not proved successful: inquiries at the Louvre and at the Bibliothèque Nationale[17] in Paris have failed to reveal any references to O'Connor or his paintings.

After eight months in Paris, O'Connor and his wife decided to visit Rome. (According to 'M', O'Connor's wife was his constant companion on his travels abroad. He further notes that although the artist was able to speak French, he was reluctant to do so, and that his wife acted as an interpreter. This shyness might, perhaps, help to explain the naivety which O'Connor expressed in the following encounter). In May 1833, the day before they were due to leave Paris, the O'Connors took a long walk around the city, having had an early breakfast. At lunch time they were far from their hotel, and they went into a restaurant for a meal where they discussed their forthcoming journey to Italy and the studies which O'Connor hoped to paint in Rome. A man who was sitting at an adjoining table soon came up to them, introduced himself as 'M. Elliot', and, after apologizing for the interruption, said: 'I have been listening with deep interest to your conversation; and I think that I can be of service to you as an artist, presuming that you are professionally one. Will you permit me to see your works? I should like to know your style of art, as they will determine me in the advice I shall take leave to offer.' O'Connor thanked the stranger, and invited him to breakfast at their hotel on the following morning.

Elliot arrived punctually the next day, conspicuously elegant in his appearance and manners, examined the artist's sketches and paintings, commenting on their beauty, and assured O'Connor that a visit to the Saar and Moselle in Germany would be of great inspirational value to him. Offering the artist letters of introduction — one to a Herr Boch Bushman in Metlach,

and two to other men of influence — Elliot wished them both well, and left.

O'Connor was obviously delighted by this opportunity, for he did not stop to question the credibility of this unusual acquaintance, and he and his wife left forthwith for Germany on May 3rd, abandoning their plans to visit Italy. The O'Connors' first stop was at Chalons-sur-Marne, where they rested for several days, while the artist made a number of sketches. Much impressed by the local scenery, O'Connor moved on to Saarbruck, where he and his wife spent three days, and where he made further sketches. O'Connor subsequently visited Merzig, and then travelled to Saarlouis, which he greatly admired. After Saarlouis, the O'Connors went to Metlach, where Boch Bushman lived. Duly presenting himself to Herr Bushman, O'Connor was told, no doubt to his horror and distress, that there was no such person as 'Mr. Elliot', and that the name was an 'alias' of 'Chevalier M....', a notorious swindler. Herr Bushman was the town's burgomeister, and had orders to arrest him on sight.

The sequel of this strange tale is rather more pleasing than one might expect (for O'Connor was plainly the butt of a complex practical joke): the burgomeister took a liking to the O'Connors, and he frequently entertained them during their three-week stay in the town, as well as furnishing the artist with introductions to his friends. O'Connor then proceeded on his journey, travelling down the river Saar in a small hired boat, sketching all the scenes which he found interesting, including the town of Saarburg, which he found particularly delightful, and where he apparently met many pleasant and kindly people.

From Saarburg, the O'Connors travelled to Trèves, on the Moselle, where the artist completed several elaborate drawings of the Roman ruins, and where they stayed for almost a fortnight with a family named Bochholst, to whom they had an introduction from the burgomeister. The journey was continued down the Moselle, again by boat, and they stopped at every picturesque locality on the way to Coblenz. O'Connor particularly admired Cocheim, the last town before Coblenz, for he found the mountainous valleys very beautiful.[18]

'M' states that Ehrenbreitstein, a fortress in the town, was O'Connor's main interest in Coblenz, and adds that the weather changed dramatically while he was there, the rain falling in torrents for several days. From Coblenz, the O'Connors travelled to Bingen, 'a charming place', directly opposite Rudesheim, and near the residence of the King of Prussia. His last stop before Frankfurt was Mainz, 'a place in no way interesting to the painter.'

In Frankfurt, the unfortunate artist had another disconcerting experience. On arrival, he immediately made his way to the Post Office, as he was expecting some important letters. The Postmaster, however, assured him that, contrary to his expectations, no mail had arrived. This disappointment, coming after a long and tiring journey that had lasted for three days and four nights, brought

on a severe illness, which lasted for some time, and prevented O'Connor from returning to England. Ironically enough, O'Connor found the letters awaiting him in Paris three weeks later, and discovered that the post had, in fact, been in Frankfurt when he had originally asked for it. Soon afterwards, on November 1st, 1833,[19] the O'Connors arrived back in London. The O'Connors probably moved into no. 61 Seymour Street, Euston Square, on their return to London, as the artist gave this address[20] when he submitted two landscapes to the Academy exhibition in 1834. He also showed a large *View in the Valley of Tieferbach on the Moselle* at the British Institution, and three works at the Society of British Artists: *A Moonlight Landscape*, *A View of Saarbourg on the Saar, Rhenish Prussia*, and *The Mountain Pass*. There are further documented works, dated 1834, which stem from the tour in Germany, and which were presumably worked up from sketches: *A Scene on the Rhine*,[21] and two river views on the Saar or Moselle.[22] In addition, the National Gallery of Ireland holds a painting of *The Glen of the Dargle*, (cat. no. 76) also dated in that year, which suggests that O'Connor returned to earlier sources of inspiration, as well as working from more recent material.

Before long, O'Connor appears to have returned to no. 67 Clarendon Street,[23] and he showed his work again at the principal London exhibitions, with predictable subjects for his paintings: *A Sunset*, *An Oncoming Storm*, *A Moonlight Scene*, and *A View on the River Avonmore, in Co. Wicklow*. There are two particularly interesting works that are dated 1835: *A View of an Avenue*, probably in France or Belgium, painted in a topographical manner (cat. no. 78), and *The Poachers*, in the National Gallery of Ireland (cat. no. 79).

In 1836, while still living in Clarendon Street,[24] O'Connor exhibited as usual. Little else is known about the artist's specific activities during the year, but several letters reveal interesting circumstantial information about his life at that time.

On February 9th the artist P.H. Rogers, (a friend of Danby), wrote to John Gibbons about the arrival in England of Danby's son, Francis.[25] 'The young man arrived in London, certainly in a state of destitution, with only 4d. in his pocket, and scarcely a shoe upon his foot; with nothing more than he was clad in in the shape of clothing. He had travelled from Switzerland on foot on 60 francs, the sum given him by his father to find his way to England. The youth has been brought to no kind of trade, business or profession, by which he might be enabled to obtain a living, consequently he has little more than his physical powers to rely on as a means of existence. The lad appears prudent and well-disposed, and has always expressed himself anxious to have something to do. Mr. O'Connor and myself were the only persons he knew sufficiently to call on when he came to London; but for this, it is shocking to reflect what necessity might have compelled him to resort to to support nature. Since the lad has been in London, he has not been permitted to want for any of the usual comforts of life, as O'Connor

and myself have had him in our keeping, although as artists, we cannot afford to have expenses to meet beyond the limits of our own families. I now inform you, that we have obtained for him a situation, but not sufficient to support him in London ... I have communicated to Mr. O'Connor that I have recd. from you £5, and he agrees with me, in thinking it will be better to apply it for the young man's benefit gradually than to give him the cash at once into his own keeping'

On the same subject, the Rev. T. J. Judkin, a friend of Danby as well as of Constable, wrote to Gibbons:[26] '... he seems a fine spirited youth and anxious to obtain any introduction that may lead to honest independence — I have unsuccessfully sought for one at a book or printsellers and have contributed a poor mite to his necessities — he has been received by Mr. O'Connor with a warm hand and an open heart — where he is now the sharer of his poor crust'

Apart from emphasizing O'Connor's innate kindness, (a fact that Danby acknowledged in his reply to a subsequent letter from Gibbons), the story hints at the diffficulties that O'Connor was experiencing at that time. This impression is strengthened by another letter, written to his sister later in the year.[27]

'My dear Mary,
 Mr. Jordan was so kind as to call on me this day and mention that he would take a letter from me — I did not know him at first but when I did recognise him, I was glad to find that he looked as well, if not better than he did when I saw him in Paris — He has given me a very warm and hearty invitation to visit him at Kingstown whenever I shall visit Dublin, but God knows when that may be at present I see not the slightest chance of it — but times may mend before next season I keep up my spirits as well as I can — I hope that you are quite well and that the school is prosperous. I am literally speaking doing nothing, not selling a single picture indeed they are all in Limbo but things must alter for the better, as with me they cannot be worse — I see by the paper of this day that Lord Sligo[28] and family are hourly expected at Portsmouth from Jamaica, something may turn up for me in that quarter as I expect an order from him for some pictures of West India scenery — if I do get them to do the price will be small and altho painting a kind of scenery which you have never seen is unpleasant and very troublesome still it will be better than doing nothing, I have commenced a large picture (indeed the largest I have ever attempted) for the exhibition at the Royal Academy next season — [possibly cat. no. 83] my brother Artists flatter me very highly as to its merits — but after [all?] the Public are the persons to be pleas'd as they are the purchasers — did you get a letter from me about six weeks or two months back — it went under cover to R. Plunkett Esq., M.P. — I ask'd you in that letter to make an enquiry for a friend of mine of Mr. Fitzgerald — if you have got the letter I know you have made the enquiry that is supposing Fitzgerald was in town with love to Anne [James?] and kindest remembrances to all friends believe me to be my dear Mary
 Your affectionate brother,
 J. A. O'Connor'.

1837, the year Constable died, and when Victoria ascended to the throne, appears to have been a quiet time for O'Connor. Yet again he moved house, to no. 13, Rathbone Place, Oxford Street, from where he submitted single paintings to both the Royal Academy and the British Institution, and a recently discovered notebook suggests that O'Connor was doing some teaching:'[William] Howis was a pupil and got instruction from James Arthur O'Connor. I had a letter in my hands this day 16 November 1861 from O'Connor to Howis on the various colours Howis was to use in painting. The date in this letter is 1837, signed J. O'Connor'.[29] Unfortunately, little more is known about the tuition that O'Connor gave to Howis, who was a minor Irish landscape painter.

According to Strickland, O'Connor stayed with Danby in Paris during 1837, at 8 Rue Vanneau. Adams [30] disputes this, explaining that Danby sent a painting from Paris to O'Connor in London, with his friend's name and address on the back, which gave rise to the misconception that O'Connor himself was in the French capital.

In 1838, still in Rathbone Place, next door to Francis Danby,[31] O'Connor showed a painting at each of the three major exhibitions in London, but he was beginning to feel the strain of his poverty and lack of success. The following story[32] illustrates his continued misfortune: 'Mr. Wells, the wealthy art patron of Penshurst, struck by some of O'Connor's Irish views at the Academy, sallied out one morning on commissions bent. But O'Connor was absent from his house, and the connoisseur, beguiled instead by a passing friend into the studio of F. R. Lee, inaugurated there that long series of purchases and invitations to Redleaf to which the lucky Lee owed much of his success. Such patronage as O'Connor enjoyed, when he enjoyed any, was not of this calibre, his best friend, John Forster, the biographer of Goldsmith and Dickens, being able to buy but the six small works which he bequeathed to the Victoria and Albert Museum.'

The following year, as all sources agree, O'Connor's health began to fail, and his eyesight, apparently never strong, became even weaker. As 'M' wrote in the *Dublin Monthly Magazine*: 'From the year 1833, when he returned from the Continent, to 1839, he continued with unabated zeal, and an untiring industry, to paint; sometimes finding purchasers, but very often not. About the latter end of this year, his health began visibly to decline; his looks were quite changed, and his appetite, which at all times was not only moderate but delicate, quite forsook him. He then lived in Rathbone place, and his medical adviser, Doctor Hamilton Roe, advised change of air. This necessary change of residence, however, was not just then convenient. His income for months had been irregular and greatly diminished, and the embarassments consequent thereon were increased by that very illness which they almost produced. Just at that moment, a highly gifted brother artist and countryman of his, when writing to a gentleman in Dublin, one equally attached to

O'Connor, mentioned with deep regret his illness, and his fears as to his recovery. The gentleman to whom this letter was addressed, just at the moment he received it, was conversing with Captain (later Colonel) Chidley Coote upon the subject of art, with all the ardour and warmth which characterize the conversations of artists and amateurs. Knowing Captain Coote's love of art, and his esteem for artists, and knowing also the willingness with which, on every occasion, he would be obligingly kind, he read the passage of the letter for him, and besought him to procure for his countryman an order for a picture from his brother Sir Charles Coote, Bart., of Ballyfin, a Liberal encourager of the arts and artists of other countries. Sir Charles was then on the Continent, but Captain Coote, with a prompt generosity, which all who know him will be prepared to expect, instantly ordered a thirty guinea picture, and gave the order on his banker for the payment; and with a delicate consideration, made it a condition that Mr. O'Connor should by no means think of painting that picture, until long after his health should be perfectly restored, as his first works, when able to resume his pencil, should be made to meet more urgent demands.'

The artist, wrote 'M', was moved by Captain Coote's generosity, and expressed his gratitude in several letters — he hoped 'that he might be spared to paint a picture worthy of Captain Coote.' He did paint a 'very able' picture in a few months time, which he valued at twenty guineas; probably the *Castle Coote Demesne* (cat. no. 87). If this is so, it would appear that O'Connor returned to Ireland before his death, a supposition that is corroborated by the fact that he exhibited for the first time at the Royal Hibernian Academy in 1840, besides showing a painting in the Royal Academy in London.[33]

O'Connor intended to send Coote another painting to make up the value of the sum that he had been advanced, but he was unable to do so, as he died shortly afterwards, on January 7th, 1841.[34] He was then living at no. 6 Marlborough Street, College Street, Brompton, with his wife, whom he left 'in circumstances of embarassment'.[35] The continued strain of life was evidently too much for his weakened constitution to bear.[36]

Apart from the invaluable account of O'Connor's life in the *Dublin Monthly Magazine*, published in April 1842, there were two kind and slightly differing obituaries of the artist in *The Gentleman's Magazine* of March and June 1841. A few years later, in April 1845, The Art Union Magazine published the following unusual notice: 'A case of distress — we beg to direct the attention of our readers to a case of urgent distress, — in reference to which there is an 'APPEAL' in our advertising columns. We are permitted to state that the lady whose destitution is there alluded to is Mrs. O'CONNOR, the widow of an artist whose genius, seconded by hard and continued industry, was insufficient to provide the smallest provision for that ''rainy day'', which came at the close of life, and has continued with his widow ever since. There are few who love art who have not had some acquaintance with the admirable

works of James O'Connor, they are becoming scarce — and will, ere long, be very valuable — notwithstanding that he produced so many; but, although he was perpetually labouring, he laboured under inauspicious circumstances; and he was never able to extricate himself out of the hands of dealers — to his death day:-[37]

"In the plains of the East there are insects who prey
on the brain of the elk till his very last sigh;
Oh, Genius! thy patrons more cruel than they
First feed on they brain and then leave thee to die."

We lament to know that the latter days of his life were rendered wretched by pecuniary embarassments; and as will readily be believed, distress has consequently been the unhappy lot of his widow, — a lady highly respected, and to whose "rectitude of conduct" a number of condoning friends bear eager to testimony. They appeal to the public on her behalf; they ask from sympathy and benevolence the relief they are themselves unable to bestow - for nearly all of them are men of genius, less unhappily circumstanced indeed than her husband, but like him, dependent mainly upon health of mind and body for the high positions they occupy now. Among our readers there are many who can easily make the small sacrifice which may help to give the necessaries of life to this bereaved widow. We respectfully but earnestly hope they will honour us by making as the medium of communicating to her the fact that her appeal has not been made through our columns in vain.'

The APPEAL in the advertising columns read as follows:

'A CASE OF DISTRESS — the following gentlemen make an appeal to a benevolent and generous public, on behalf of the destitute widow of a late distinguished Artist. Since the death of her husband, she has endeavoured to exist, and has been kindly assisted by the contributions of private friends, as well as by the Profession of which her late lamented husband was a member.

Her state of health and advanced age preclude the hope of her being able to provide the common necessaries, and it has occurred to those gentlemen who have known her, and can personally vouch for the rectitude of her conduct and the merits of her case; that an appeal to the public would not be made in vain.

His Royal Highness the Prince Albert has been graciously pleased to give twenty guineas. It is proposed with this sum to open a Subscription for the purchase of a small annuity for this poor widow.

Sir Martin Archer Shee, President of the Royal Academy.
Thomas Wyse, Esq., M.P., 17 Wilton Place, Belgrave Square.
W. Collins, Esq., R.A., 2 Devenport Street, Hyde-park-gardens.
John Doyle, Esq., 17 Cambridge-terrace, Hyde-park.
R. Rothwell, Esq., 31 Devenshire-street, Portland-square.
Robert Bell, Esq., F.S.A., The Rosary, Old Brompton.

Contributions will be received by any of the above-named gentlemen, also by Messrs. C. Hopkinson and Co., Bankers, 3 Regent St., or by Thomas Baker, Esq., 20 Spring Gardens, who will be happy to answer every inquiry that may be made as to this distressing case.'

The artist did not leave a will, but his estate, £200, was granted to his wife, Anastatia Agnes O'Connor.[38] Presumably she also received the money realized by the sale of the paintings left by O'Connor after his death (about fifty landscapes), which were auctioned by Christie's on February 12th, 1842. According to an annotated copy of the sale catalogue,[39] none of the pictures sold for more than a few pounds a piece, so Mrs. O'Connor did not receive a sizeable sum to add to her meagre resources.

It would be all too easy to become sentimental about the pathetic end to O'Connor's career, but it is indisputable that the story of his life is both appealing and sad, particularly as O'Connor appears to have been a kind and humble individual. As 'M' wrote in the *Dublin Monthly Magazine*, 'Thus passed away a spirit of exceeding mildness; manly, ardent, unobtrusive, and sincere; generous in proclaiming contemporary merit, and unskilled and reluctant to put forth his own. Such was the man of whom we have written, whose death we deplore, whose memory his numerous friends will with affection cherish. Such was our warm-hearted early friend, James O'Connor.'

An equally sympathetic description of O'Connor was given by Francis Danby:[40] '... If I have one sincere friend in the world beside yourself, it is poor O'Connor, with affection and respect I write his name, though he was never intended by nature for a conspicuous character — he is simple honest and unchanging; a painter from the first who never loved to strain his imagination, and who never changed in his manner from his first picture, nor from the first impression he had received from the Friend who he once took to his heart; he has always been indefatigably industrious yet poor, as he disdains to follow any fashion of the day: it was not from a similarity of feeling for the art that we became Friends, but we fell together when we were boys and though unlike in disposition our friendship must remain while we live for when it has passed the storms of 30 years, it is not to be entirely dissolved by poverty, error follies or even crime, I am not surprised that the generous poor O'Connor should take in my son in distress to share his last morsel of bread'[41]

1. Letter from O'Connor to John Gibbons, August 28th, 1830.

2. In a letter to John Gibbons, December, 19th, 1830, O'Connor mentions this fact.

3. According to Mr. Hugh Maude, a previous owner, the painting was commissioned by one of his ancestors, and very accurately depicts the *Eagle's Rock* in Killarney.

4. *Morning Chronicle*, April 16th, 1829. Quoted in E. Adams' *Francis Danby* (Ph. D. Thesis).

5. Eric Adams, *Francis Danby*, (1973), no. 168. Present location unknown.

6. Letter from O'Connor to John Gibbons, July 2nd, 1830.

7. Letter from O'Connor to John Gibbons, February 17th, 1831.

8. Letter from O'Connor to John Gibbons, March 5th, 1831.

9. Letter from O'Connor to John Gibbons, April 20th, 1831.

10. Letter from O'Connor to John Gibbons, May 17th, 1831.

11. His open admiration for Turner notwithstanding, O'Connor's style has much more in common with Constable's.

12. *Dublin Monthly Magazine*, April, 1842.

13. *Royal Academy Exhibition Catalogue*, 1812. However, when O'Connor exhibited at the British Institution, his address was '67 Clarendon Street, Somerstown'; and a letter of March 15th was also sent from that address.

14. *Dublin Monthly Magazine*, April 1842.

15. Bodkin, op.cit., pp. 20-21.

16. *The Gentleman's Magazine*, March 1841.

17. My thanks are due to Prof. Barbara Wright, who very kindly examined the Catalogues of the Bibliotheque Nationale, and who made inquiries there on my behalf.

18. 'M', in the *Dublin Monthly Magazine*, states that many of the smaller sketches made on the Saar and Moselle came into the possession of Captain Chidley Coote, 'of Huntington, in the Queen's County'.

19. 'M' specifies November 1st. Bodkin and Strickland both give the month.

20. *Royal Academy Exhibition Catalogue*, 1834.

21. *W. Cremin Collection Catalogue*, Dublin, 1948.

22. *James Arthur O'Connor Centenary Exhibition*, Hugh Lane Municipal Gallery of Modern Art, Dublin, 1941, no. 42,

23. *Royal Academy Exhibition Catalogue*, 1835.

24. *Royal Academy Exhibition Catalogue*, 1836.

25. Letter from P. H. Rogers to John Gibbons, February 9th, 1836.

26. Letter from the Rev. T. J. Judkin to John Gibbons, 1836, (but otherwise undated).

27. Letter from O'Connor to his sister Mary, October 20th, 1836.

28. It is interesting to see that O'Connor was hoping for commissions from his old patron, the Marquis of Sligo. One might deduce from the artist's comments that he had been in communication with Lord Sligo since his move to England.

29. I am grateful to Miss Alma Brooke Tyrrell for this information. The notebook belonged to her grandfather, who also recorded the fact that he once had Holy Mass offered for J. A. O'Connor, 'a good old Papist'.

30. Adams, *Francis Danby — Varieties of Poetic Experience*, p. 159, note 33.

31. Adams, op. cit., p. 99.

32. Quoted by Col. M. H. Grant, in *The Old English Landscape Painters*, (1957-1961) Vol. 8, p. 639, from Solomon Hart's *Reminiscences*.

33. *Royal Academy Exhibition Catalogue*, 1840. There is a possibility that O'Connor visited Scotland in 1839. *A View near Kilmarnock* was sold at Christie's on April 29th, 1882, and was dated that year. In the National Library of Ireland, there is a most pathetic letter from a 'J. O'Connor' to George Petrie, dated 1840,

which describes the writer's abject poverty. Although similar, the handwriting is not identical to James Arthur O'Connor's, so I have not assumed that the letter is by him. (MSS.789.24,NLI).

34. All sources agree that O'Connor died on this date. According to the catalogue of the *Centenary Exhibition*, Hugh Lane Municipal Gallery of Modern Art, Dublin, 1941, (no. 48), *A Rocky Landscape with Figures* was also painted for Colonel Chidley Coote.

35. Obituary, *Gentleman's Magazine*, March 1841.

36. Only Ottley, in his *Dictionary*, offered another reason for O'Connor's death, and attributed it to 'intemperate habits'.

37. A letter from O'Connor to a Mr. H.P. Parker of Newcastle-on-Tyne, (presumably a dealer), reveals the artist as more than anxious to please: '... by all means keep the pictures. I feel confident that you will sell it (sic) for me if you can'. When one also recalls ths swindling incident in Belgium, it appears that O'Connor was overly trustful of his dealers.

38. The Grant of Administration of O'Connor's estate is in the Public Record Office, London.

39. Christie's, London. See also Appendices.

40. Letter to John Gibbons, February 29th, 1836.

41. E. V. Rippingille related the following story to John Gibbons, in a letter of December 16th, 1830. It describes another occasion when O'Connor took care of Danby's children:

'I have never told you but I went to the house in which [Danby] lived with Sir W. Beechey; we found it shut, an Irish man next door a friend of Danby called us in and told us, that after Danby went off with some young man and the aunt who was left in the care of the children after pawning and selling every thing she could get rid of, turn [sic] one of the children into the street and took herself off after putting the key under the door. At Eleven o'clock at night this poor little thing had to seek shelter with a neighbour a Mr. O'Connor, who was at the time giving shelter to a little boy who had come home from school expecting to find a home but his parents had fled and the house was a void. This Mr. O'Connor was going the next morning to send the little fellow off to Ostend by the packet.'

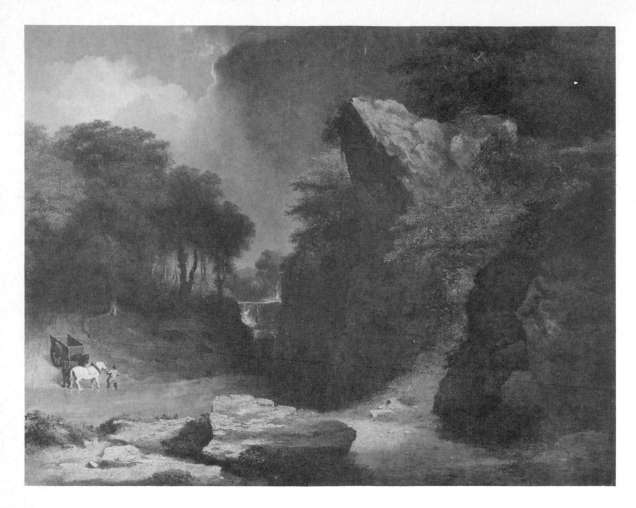

67. The Ford — A Landscape with Wagon, three Horses, and Figure, *c.1830*

Oil on canvas,
67.3 x 88.3 cm.,
(26½ x 34¾ ins.).

PROVENANCE:
Authur Larkin; Hibernian
Antiques Ltd.

EXHIBITED:
Possibly British Institution,
1831.

It is tempting to interpret paintings like *The Ford* symbolically, or at least to view them in the light of the artist's unhappy life. The wagon is here dominated by the forces of nature, whose objectivity is beyond his control, and it is as if O'Connor were trying to represent the daunting and apparently insurmountable difficulties in his own life. A preparatory drawing for this painting (cat. no. 69) is dated 1830, so one can assume that the picture was completed in the same year. If so, it predated *A Thunderstorm; The Frightened Wagoner*, (cat. no. 73) which takes the same motif of a wagon, driver, and horses, and presents it in a much more dramatic and romantic way. Even here, though, the craggy ridge is disproportionately large in relation to the figure and horses, which helps to suggest the wagoner's insignificance when faced with natural obstacles.

Lent by Francis D. Murnaghan, Jr.

68. The Mountain River, *1829*

Pencil and ink wash on paper 9.8 x 13.0 cm., (3⅞ x 5⅛ ins.). Inscribed: The Mountain River/Mr Chinnery/Mr P.B. Duncan/size 25 x 30. Inscribed on mount: Painted for me in 1829 J.F.C.

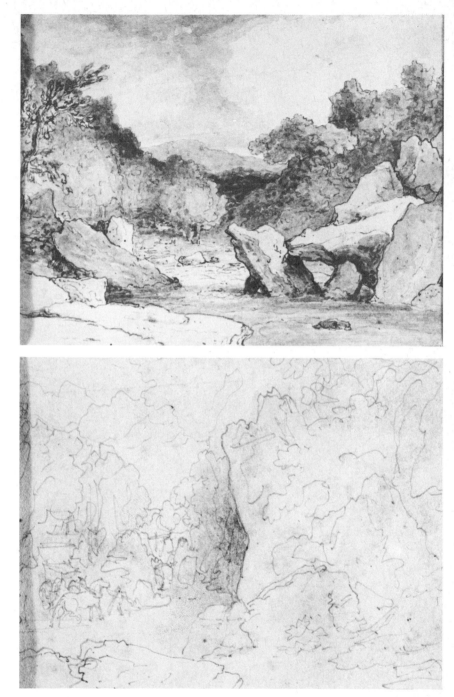

69. The Ford, *1830*

Pencil and chalk on paper, 10.7 x 13.0 cm., (4¼ x 5⅛ ins.). Inscribed: The Ford 3/Mr Chinnery/O'Connor. Inscribed on mount: Painted for me in 1830/ size Kit Cat

PROVENANCE:
Hibernian Antiques Ltd., 1973; where purchased by present owner.

These two drawings, although unimportant in themselves, are significant because they document specific commissions.

Lent by Pat and Antoinette Murphy

165

70. A View of the Devil's Glen, *c.1830*

Oil on canvas,
63.0 x 76.0 cm.,
(24¾ x 30 ins.).

PROVENANCE:
Captain Shedden; Captain
R. Langton Douglas, by
whom presented 1919;
N.G.I. Cat. No. 825.

EXHIBITED:
*Exhibition of Arts, Industries
and Manufactureurs*,
Dublin, 1872 (214); *Lerse
Schilders der 19e en 20e
cenur*, Stedelijk,
Amsterdam, 1951; *National
Gallery of Ireland Centenary
Exhibition*, 1964, (173).

LITERATURE:
J. White, 'O'Connor at
Westport House', *Apollo*,
(July, 1964).

This is one of the most impenetrable of O'Connor's romantic landscapes: the high horizon, and gloomy clouds, offer the viewer no easy escape from the painting's melancholy mood. *A View of the Devil's Glen* is close in composition to *The Eagle's Rock, Killarney*, (cat. no. 72), except for the absence of a figure.

Lent by the National Gallery of Ireland

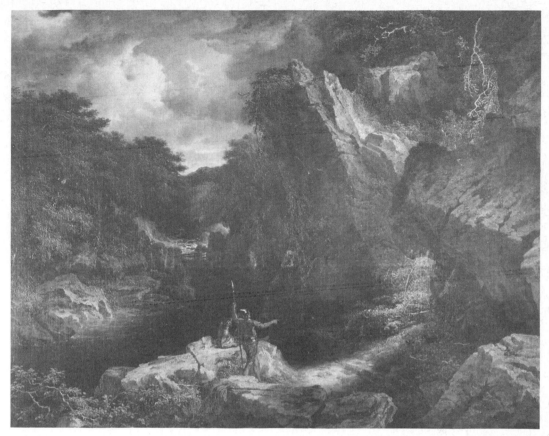

71. The Glen of the Rocks, *1830*

Oil on canvas,
101.5 x 127.0 cm.,
(40 x 50 ins.).
Signed and dated:
J.A.O'Connor, 1830.

PROVENANCE:
Patrick O'Connor; Lord
Brocket at Carton.

EXHIBITED:
Possibly Royal Academy,
1830, (445); *Centenary
Exhibition*, Hugh Lane
Municipal Gallery of
Modern Art, Dublin,
1941, (51); *Irish Art in the
19th Century*, Cork, 1971,
(98).

LITERATURE:
Anne Crookshank and The
Knight of Glin, *The
Painters of Ireland*, (1978),
p. 212, illus., 208.

The Glen of the Rocks, with figures that are reminiscent of Salvator Rosa, was almost certainly conceived as an important Academy picture: it was probably exhibited at the Royal Academy in 1830. The motif of the figures being struck by supernatural light was used by O'Connor in one of his early drawings, *The Vision* (illus. no. 6); the picture also bears some resemblance to *Banditti at the Mouth of a Cave* which was painted by George Hayter in 1817 (collection Brinsley Ford). The latter was described as follows in the catalogue of the Hayward Gallery 'It is a straightforward pastiche of Rosa ... in conception, Hayter's painting scarcely differs from 18th century examples, though he perhaps introduces more of a hint of the legend of Rosa's youthful stay among the brigands of the Abruzzi. This legend was given renewed currency by Lady Morgan (1824) and, in consequence, there were a number of pictures on this subject at the R.A. exhibitions in the 1830s and 1840s ...'[1]

It is possible, therefore, that O'Connor painted this after reading Lady Morgan's *The Life and Times of Salvator Rosa*, (1824).

1. Hayward Gallery, *Salvator Rosa*, by Michael Kitson, (1973), p. 38.

Lent by The Hon. David Nall-Cain

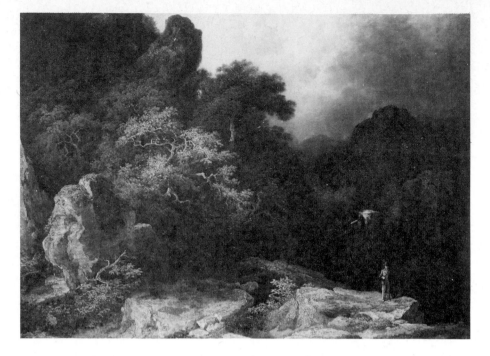

72. The Eagle's Rock, Killarney, *1831*

Oil on canvas,
69.7 x 90.2 cm.,
(27½ x 35½ ins.).
Signed and dated:
J.A. O'Connor 1831.

PROVENANCE:
Possibly sold Christie's,
October 15th, 1854, (61);
Lord de Montall, Hugh
Maud (bought by his
father from a Dublin
dealer, who had purchased
it at the Charleville sale),
Adams, Dublin, December
3rd, 1975 (328),
Godolphin Gallery.

EXHIBITED:
*Paintings from Irish
Collections*, Dublin, 1957,
(168); *Irish Houses and
Landscapes*, Belfast and
Dublin, 1963, (33).

LITERATURE:
Anne Crookshank and The
Knight of Glin, *The
Painters of Ireland*, (1978),
p.212; Col. M. H. Grant,
*The Old English Landscape
Painters*, (1957-1961) Vol.
VIII, p. 638, illus. 670.

The Eagle's Rock, Killarney is certainly one of O'Connor's finest paintings, and it is a powerful image of romantic solitude. Like most of O'Connor's better landscapes of the 1830s, its drama is based on skilful use of 'chiaroscuro': the single figure (possibly a self-portrait) is accentuated by the light, which enables him to dominate the composition, even though he is small in scale. Isolated in the right-hand corner, with a gun under one arm and a dead bird in his left hand, the man faces the viewer with an unflinching gaze. He stands on a cliff, contrasted with the dark ravine, and above him stormy clouds billow in a deep blue sky. The rocks in the foreground, defined by ochre impasto, extend across the painting, and rise again on the left, in the form of a boulder, which acts as a compositional balance to the hunter. Behind the rock in the middle-distance, also highlighted with impasto, is a huge, gnarled tree.

Col. Grant, in *The Old English Landscape Painters*, (1957-61) wrote of this painting: 'It is to be feared that the illustration shows little of the very excellence which constitutes the superiority of this painting to the general run. That superiority is entirely in the handling, which is here that of a Master inspired by a scene of singular savagery and beauty, of the ravines behind *The Eagle's Nest* Killarney. It is no exaggeration to declare that Constable might have painted the sky and Crome the remainder of this fine piece, not that there is an imitation of either, but merely a rivalry with the power of both. It is the true O'Connor, the manifestation of a genius 'by poverty depressed', of a trafficker in small change glorified momentarily by the handling of gold'.

In fact, it is not easy to find any close parallels to *The Eagle's Rock, Killarney* in contemporary English painting — although, as Grant suggests, the rich lively texture of the paint brings to mind Constable's technique.

Lent by Richard Wood

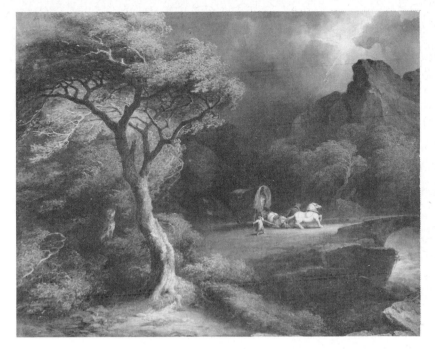

73. A Thunderstorm: The Frightened Wagoner, *1832*

Oil on canvas:
65.0 x 76.0 cm.,
(25⅝ x 30 ins.).
Signed and dated:
J. A. O'Connor 1832.

PROVENANCE:
W.C. Cremin; Mr. F. B.
McCormick, by whom
presented, 1972; N.G.I.
Cat. No. 4041.

EXHIBITED:
Centenary Exhibition, Hugh
Lane Municipal Gallery of
Modern Art, Dublin,
1941, (41); *Irish Art in the
19th Century*, Cork, 1971,
(99).

LITERATURE:
Anne Crookshank and The
Knight of Glin, *The
Painters of Ireland*, (1978),
p. 212, illus. no. 207.

A Thunderstorm: The Frightened Wagoner
is one of O'Connor's masterpieces.
Whether the eye turns first to the
windswept tree in the foreground, to the
cascading waterfall, or even to the bolt of
lightning that bursts into the picture, our
attention is inevitably drawn to the centre
of the picture — to the wagon-driver,
alone and afraid. The wagoner is the focus
of the painting in every sense; he stands,
perhaps, as a symbol of the artist.

Although there is nothing to prove that
O'Connor was directly influenced by
literary Romanticism, there is sometimes
an uncanny affinity between his paintings
and contemporary poetry. This quotation
is from *The Wagoner*, which Wordsworth
published in 1819:

'The rain rushed down — the road was
 battered,
As with the force of billows shattered;
The horses are dismayed, nor know
Whether they should stand or go;
And Benjamin is groping near them.
Sees nothing, and can scarcely hear them.
He is astounded, — wonder not-
With such a charge in such a spot;

Astounded in the mountain gap
With thunder-peals, clap after clap,
Close-treading on the silent flashes —
And somewhere, as he thinks, by crashes
Among the rocks; with weight of rain,
And sullen motions long and slow,
That to a dreary distance go —
Till, breaking in upon the dying strain,
Amending o'er his head begins the fray
 again'.

The Thunderstorm: A Frightened Wagoner
is reminiscent of the work of many earlier
painters. For example: Poussin (*L'Orage*,
Musée des Beaux-Arts, Rouen), Stubbs
(the *Frightened Horse* paintings of
c.1770),[1] Vernet (engraving of *Storm
Scene with Travellers*), and Loutherbourg
(*Stormy Scene with Wagon, Frightened
Horses, and Fallen Wagoner,* present
location unknown). Its similarity to
Ashford's *The Thunderstorm* (cat. no. 9)
has already been noted.

1. See Basil Taylor 'George Stubbs "The Lion
 and Horse" theme'. *Burlington Magazine*,
 CVII, 1965, pp. 81-86.

Lent by the National Gallery of Ireland

JAMES ARTHUR O'CONNOR, *The Field of Waterloo*, photograph courtesy of Anglesea Abbey Collection, England.

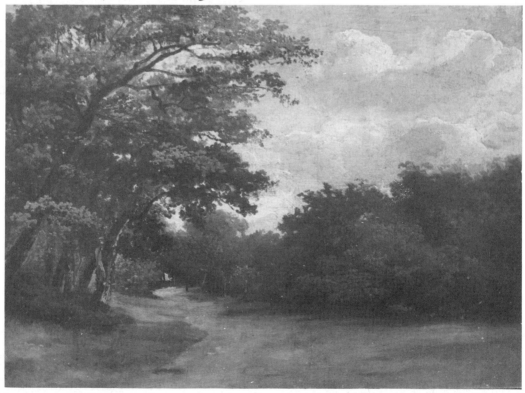

JAMES ARTHUR O'CONNOR, *In the Bois de Boulogne*, photo collection of the National Gallery of Ireland.

WE KNOW COMPARATIVELY little about O'Connor's continental pictures —
especially those he painted during his stay in Belgium in 1826. Apart from
the topographical view of *The Field of Waterloo* (illus. no. 13), which can be
attributed to him, no other Belgian views have been discovered. There are
two known paintings that were certainly painted in France: a very attractive
View in the Bois de Boulogne (illus. no. 14) and cat. no. 78, which is probably
an avenue in Paris. The German paintings include two mountain views (illus.

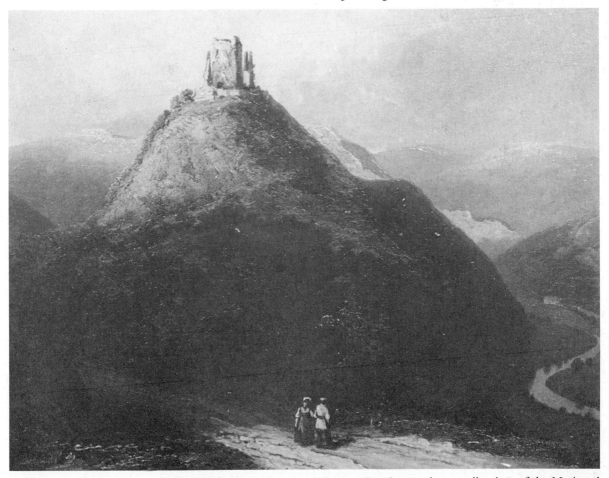

Illustration 15 JAMES ARTHUR O'CONNOR, *A German Landscape,* photo collection of the National
Gallery of Ireland.

nos. 15 and 16), *A Rhine Landscape* (cat. no. 75), and a free sketch of *The Valley of Rocks, near Metlach* (illus. no. 17). Judging from the available pictorial evidence, O'Connor's continental paintings appear to have spanned the extremes of his technique, from the familiar tight style of the drawings (cat. no. 74) to the unusually naturalistic *Bois de Boulogne* scene, which is not dissimilar to contemporary Barbizon painting.

It would be interesting to know if O'Connor saw the work of Georges Michel, Corot, or the Swiss artist Calame when he was abroad, for all three artists painted in a way that might have appealed to him.

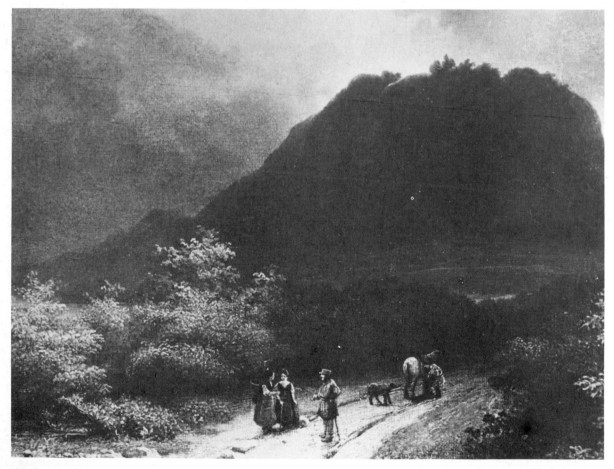

Illustration 16 JAMES ARTHUR O'CONNOR, *A German Landscape*, photo collection of the National Gallery of Ireland.

Illustration 17 JAMES ARTHUR O'CONNOR, *A View of the Valley of Rocks, near Metlach*, photograph
courtesy of Paul Mellon Collection, Yale Centre for British Art.

74. German Drawings — Rudesheim, Bingen, Rheinstein

a. Rudesheim: View looking up the Rhine from the bank near Bingen, *1833*
Pencil on paper,
11.0 x 29.5 cm.,
(4⅜ x 11⅝ ins.).
Signed, dated and inscribed: At Bingen on the Rhine. The tower of Rudesheim to the left. July 1833. J. A. O'Connor

b. Bingen: View on the Rhine looking up the river to Bingen, *1833*
Pencil on paper,
10.0 x 13.3 cm.,
(4 x 5¼ ins.).
Signed, dated and inscribed: The town of Bingen on the Rhine with the ruins of the castle of Klopp and Mansthurm. July, 1883 (sic) J.A. O'Connor

c. Rheinstein, *1833*
Pencil on paper,
10.0 x 13.3 cm.,
(4 x 5¼ ins.).
Signed, dated and inscribed: The Castle of Rheinstein on the Rhine, the property of Prince Frederick of Prussia, July 1883 (sic) J. A. O'Connor

PROVENANCE:
Purchased, 1872; British Museum.

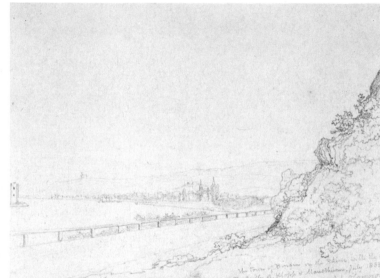

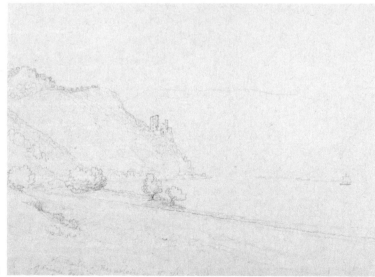

Lent by the Trustees of the British Museum

174

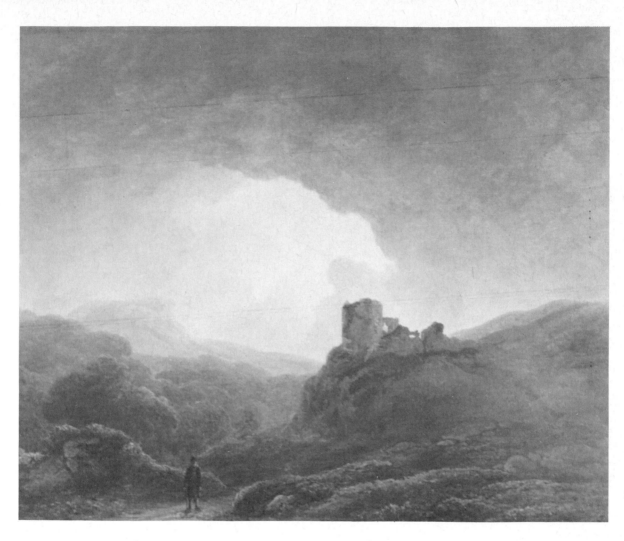

75. Rhine Landscape, c.1833

Oil on millboard,
22.9 x 28.0 cm.,
(9 x 11 ins.).
Inscribed: J.A. O'C.
Label: Part of the Plateau
Klopp near Alps, Rhinish
Prussia.

PROVENANCE:
John Kelly, Huntingdon,
from whom purchased,
1956; Ulster Museum
Belfast.

Rhine Landscape is a romantic mountain view which does little to corroborate Strickland's and Bodkin's statements that O'Connor painted some of his best pictures in Germany. Weakly composed, the painting has neither the pastoral calm of his more ordinary works, nor the heightened gloom of his major romantic paintings. The ruin has been identified as Castle Arras, which is near Alf, and south of Bullay on the Moselle.[1] O'Connor exhibited another view of Chateau d'Arras in 1839.

1. Information supplied by Eileen Black of the Ulster Museum.

Lent by the Ulster Museum, Belfast

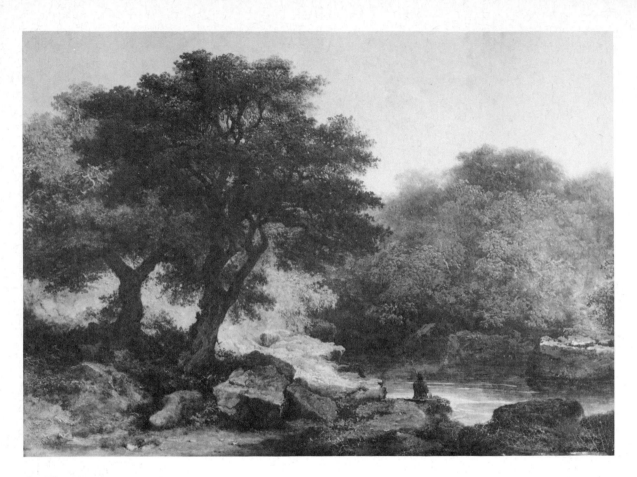

76. A View in the Glen of the Dargle, *1834*

Oil on canvas,
36.0 x 50.0 cm.,
(14⅛ x 19¾ ins.).
Signed and dated:
J. A. O'Connor 1834.

PROVENANCE:
Purchased, London,
Christie's, 1873; N.G.I.
Cat. No. 163.

Unlike *A View of the Devil's Glen* (cat. no. 70) which was painted some years earlier, *A View in the Glen of the Dargle* is not unremittingly gloomy; the mood of the picture is lifted by the pool of light in the centre of the composition, and the scene is comparatively tranquil.

Lent by the National Gallery of Ireland

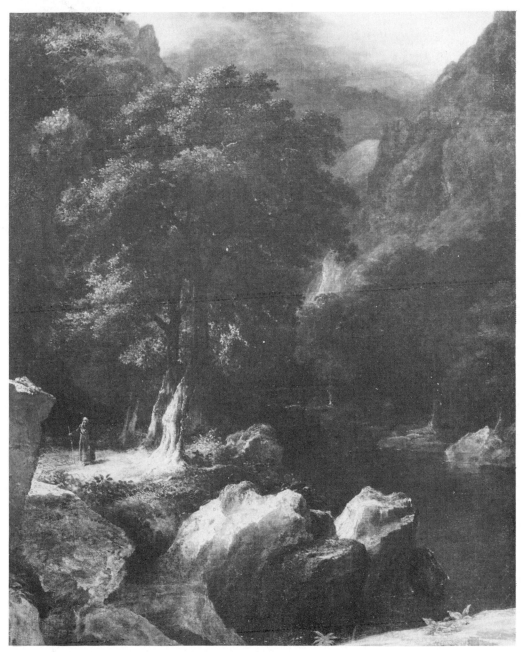

77. Monk in a Landscape, *c.1834*

Oil on canvas,
125.7 x 101.6 cm.,
(49½ x 40 ins.).

PROVENANCE:
Unknown.

The theme of a lonely monk or hermit in a landscape is an old one, and can be traced from Salvator Rosa, through George Mullins, the 18th century Irish landscape painter, to Richard Wilson's *Solitude* (illus. no. 18) and Caspar David Friedrich, whose *Monk by the Sea* of 1810 (Schloss Charlottenburg, Berlin) is probably the most powerful visualization of the idea. Like so many romantic motifs, it was formalized in the late 18th century, as the following quotation

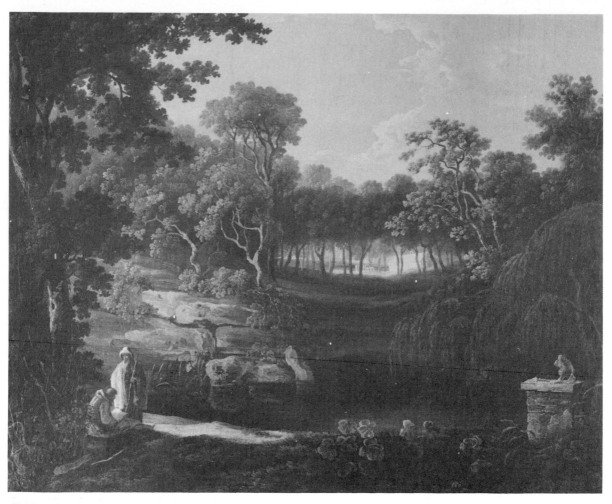

Illustration 18 RICHARD WILSON, *Solitude*, National Gallery of Ireland. Dated 1762.

illustrates. It is taken from a popular novel by M. G. Lewis, *The Monk*, which was published in 1796:

'The disorder of his imagination was increased by the influence of the surrounding scenery; ... the gloomy caverns and steep rocks, rising above each other, and dividing the passing clouds; solitary clusters of trees scattered here and there, among whose thick twined branches the wind of night sighed hoarsely and mournfully; ... the stunning roar of torrents, as swelled by late ruins they rushed violently down tremendous principles; and the dark waters of a silent sluggish stream, which faintly reflected the moonbeams and bathed the rock's base on which Ambrose stood'.

David Solkin, in the introduction to the Tate Gallery *Richard Wilson* exhibition (1982) makes some interesting observations about 'Solitude', one of the forbears of cat. no. 77; '(It) gives emblematic form to the notion of rural retirement, as a moral activity which allows man the opportunity to study and to became aware of the greatness of God ... such a message was designed to appeal

178

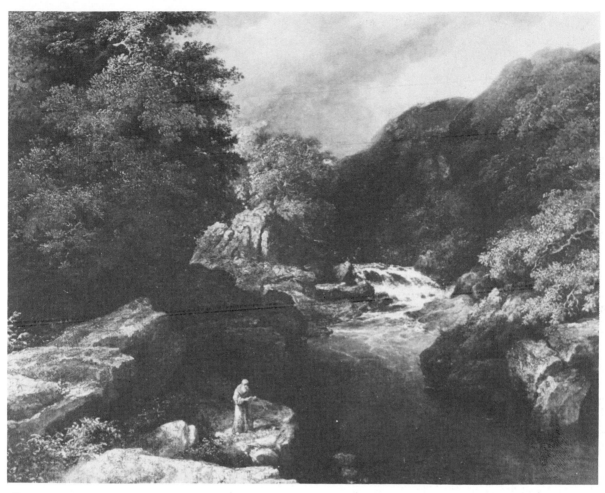

Illustration 19 JAMES ARTHUR O'CONNOR, *Monk in a Landscape, photo collection of the National Gallery of Ireland*.

to contemporary patrician landowners, who liked to think of themselves as virtuous hermits in the private confines of their country estates. Wilson's picture also supports another important aspect of aristocratic mythology, in suggesting that rural leisure is a necessary prerequisite for the acquisition of wisdom'.

O'Connor's paintings of monks in a landscape (he painted at least one other, a rather better picture, whose present whereabouts is unknown; illus. no. 19) fall somewhere between the romanticism of Lewis' Ambrose, and Wilson's moralism.

Lent by Fota House, Collection of Richard Wood

78. A View of an Avenue, 1835

Oil on canvas,
35.5 x 45.0 cm.,
(14 x 17¾ ins.).
Signed and dated:
J.A. O'Connor 1835.

PROVENANCE:
Michael Harvard; Paul
Rich.

LITERATURE:
Anne Crookshank and The
Knight of Glin, *The
Painters of Ireland*, (1978),
illus. 205.

This is a curiously topographical picture for O'Connor to have painted in the 1830s. The avenue, probably in Paris, has not been identified. Unless O'Connor went abroad again in 1835, he must have worked up this painting from an earlier drawing or canvas. It is also possible that the avenue may be in Brussels — there were two O'Connor watercolours of a Brussels park in the 1842 Royal Hibernian Academy exhibition.

Lent by Mr and Mrs S. Abbott

180

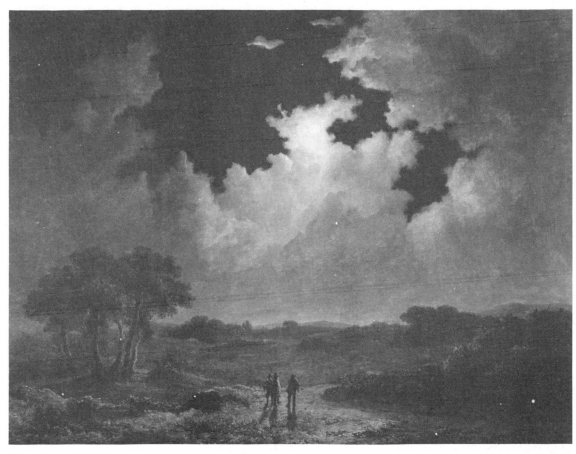

79. The Poachers, *1835*

Oil on canvas,
55.5 x 70.5 cm.,
(21⅞ x 27¾ ins.).
Signed and dated,
J.A. O'Connor 1835.

PROVENANCE:
Lord Powerscourt, from
whom purchased, 1879;
N.G.I. Cat. No. 18.

EXHIBITED:
*Exhibition of Works by Irish
Painters*, Guildhall, 1904,
(98).

LITERATURE:
Bodkin, (1920), pl. VII
and opp.page; J. White;
'Irish Romantic Painting',
Apollo, (October 1966),
p.272; Anne Crookshank
and The Knight of Glin,
The Painters of Ireland,
(1978) p. 212, illus. 209.

The Poachers is the finest of all O'Connor's moonlight landscapes, and is unquestionably one of his best paintings; it is a subtle blend of greens and blues that creates a clear image of rolling hills under a moonlit sky. The three poachers, shadows cast behind them, are in the centre of the picture, framed on the left by a clump of trees, and on the right by a bank of bushes. Directly above them is the bright moon, encircled by clouds. It is a clever composition, but even more masterly is the way O'Connor leads the eye into the picture by his use of tonal gradations: every element is distinct, yet unified by the light.

The romanticism of *The Poachers* distinguishes it from moonlight scenes by artists such as Aert van der Neer and John Crome; O'Connor accentuates the relationship between the individual and the universal — in other words, between the poachers and the lonely expanses of countryside in which they stand. The figures' isolation is emphasised both by the dramatic illumination of the poachers, and by the emotional tension that is created by the contrast of their stillness with the implied movement of the clouds. It should be remembered, too, that the penalties for poaching were severe in the 19th century — a fact of which contemporary viewer would certainly have been aware and which would have heightened the image's impact.

There is a literary parallel to O'Connor's

moonlight paintings in Wordsworth's *A Night-Piece* (1815):

The sky is overcast
With a continuous cloud of texture close,
Heavy and wan, all whitened by the Moon,
Which through that veil is indistinctly
 seen
A dull, contracted circle, yielding light
So feebly spread that not a shadow falls,
Chequering the ground — from rock,
plant, tree, or tower.
At length a pleasant instantaneous gleam
Startles the pensive traveller while he
treads
His lonesome path, with unobserving eye
Bent earthwards, he looks up — the
 clouds
are split
Asunder, — and above his head he sees
The clear Moon, and the glory of the
 heavens ...

Lent by the National Gallery of Ireland

182

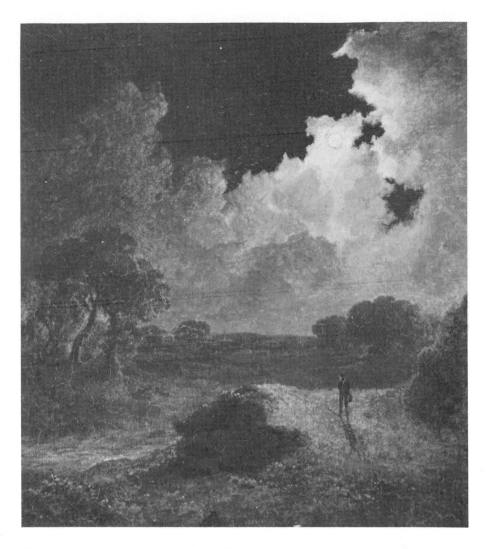

80. Moonlight, *c.1835*

Oil on panel,
18.0 x 17.0 cm.,
(7⅛ x 6⅝ ins.).

PROVENANCE:
Purchased, London,
Christie's, 1872; N.G.I.
Cat. No. 158.

This panel obviously relates to *The Poachers*, (cat. no. 79). It may be either a preliminary sketch, or, which is more likely, a later, derivative composition.

Lent by the National Gallery of Ireland

183

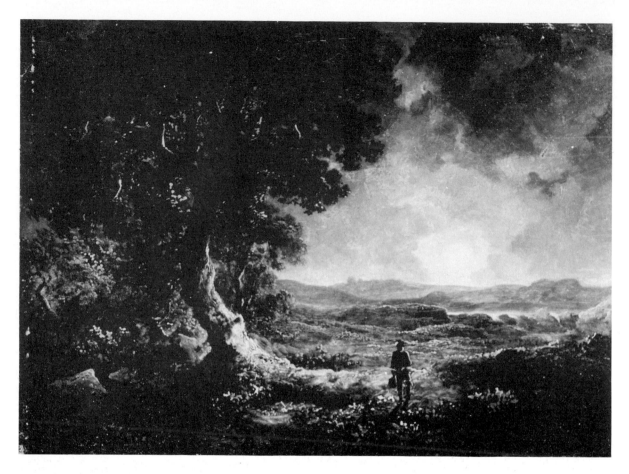

81. A Moonlight Scene, *c.1835*

Oil on millboard, 22.0 x 30.0 cm., (8⅝ x 11¾ ins.). Inscribed: Sold to Capt Sheddan, RDS, 183..?

PROVENANCE: Captain Sheddan; John Maher Collection 1964; from whom purchased by present owner.

EXHIBITED: *Centenary Exhibition*, Hugh Lane Municipal Gallery of Modern Art, Dublin, 1941, (51); *Exhibition of Arts, Industries, and Manufacturers*, Dublin, 1872, (264).

O'Connor must have liked his moonlight views (or they must have sold well), because he painted many of them. Several are hurried, rather unimpressive pictures, but they all have a strong, almost tangible, atmosphere.

Lent by Pat and Antoinette Murphy

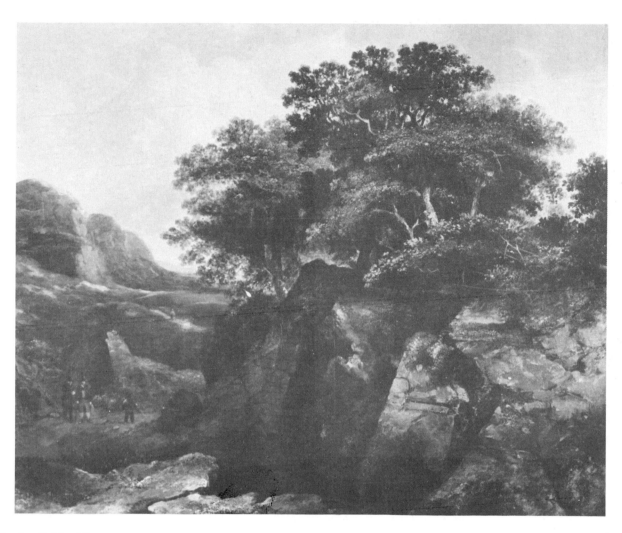

82. An Irish Glen, *1836*

Oil on canvas,
61.0 x 76.2 cm.,
(24 x 30 ins.).
Signed and dated:
J.A. O'Connor 1836.

PROVENANCE:
Unknown.

EXHIBITED:
Royal Academy, 1837,
(316).

By 1836 O'Connor's romanticism had passed its peak, and although he continued to use romantic, formal 'vocabulary', the artist's later pictures were not generally infused with his earlier melancholy spirit. In a letter of that year, (see biography), O'Connor wrote: 'I am literally speaking doing nothing, not selling a single picture indeed they are all in limbo but things must alter for the better, as with me they cannot be worse', and in the few remaining years of O'Connor's life, the quality of his work varied enormously. *An Irish Glen* is one of the more successful paintings of this period.

Private Collection

185

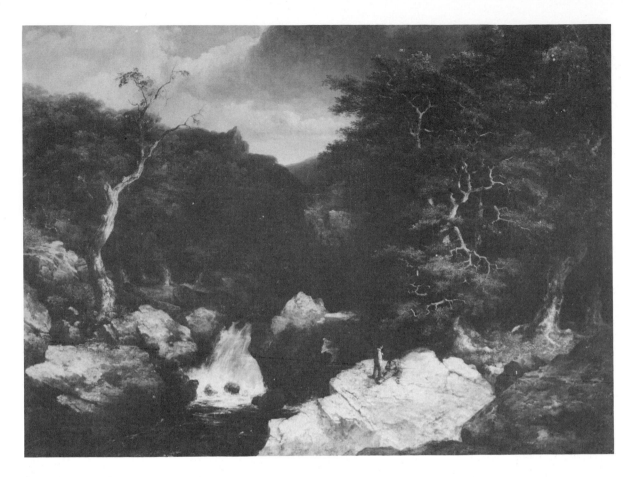

83. A View of the Dargle — Lovers Leap, *1837*

Oil on canvas,
119.5 x 168.0 cm.,
(47 x 66 ins.).
Signed and dated:
J.A. O'Connor 1837.

PROVENANCE:
Charleville House, Christies
Sale, 23-24 Jan. 1978,
from where purchased by
present owner.

This may be the painting that O'Connor mentioned in a letter of October 20th, 1836, to his sister Mary: '[I] have commenced a large picture (indeed the largest I have every attempted) for the exhibition at the Royal Academy next season — my brother artists flatter me very highly as to its merits — but after [all?] the Public are the persons to be pleas'd as they are the purchasers ...'. Indeed, O'Connor appears to have had little trouble in working on this scale.

Private Collection

84. A Sea Piece, *1839*

Oil on canvas,
19.0 x 24.0 cm.,
(7½ x 9½ ins.).
Signed and dated:
J.A.O'C 1839.

PROVENANCE:
Unknown.

This is a most unusual work by O'Connor; were it not for the inpasto in the foreground, and the comparatively free treatment of the waves, it would appear to be of a much earlier date.

Suspended from the staff on the rock is a beacon of some sort.

A Sea Piece is an unaffected, simple picture, probably painted for the artist's own pleasure.

Lent by Richard Wood

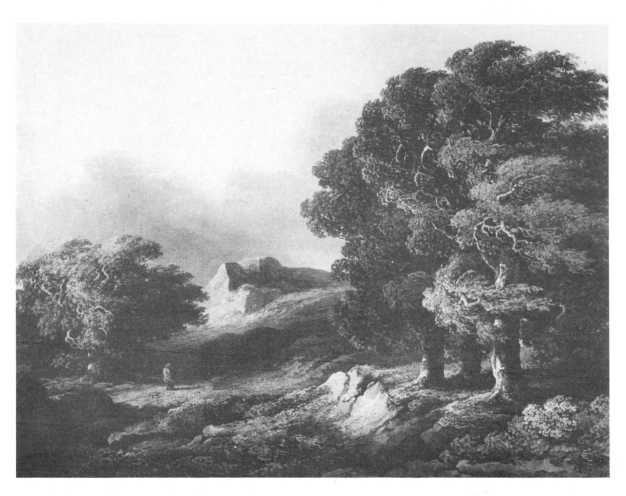

85. An Oncoming Storm: Windswept Trees, *1839*

Oil on canvas,
35.5 x 45.7 cm.,
(14 x 18 ins.).
Signed and dated:
J.A.O'C. 1839.

PROVENANCE:
A. E. Gillingham; Senator
Brennan.

EXHIBITED:
Centenary Exhibition, Hugh
Lane Municipal Gallery of
Modern Art, Dublin,
1941, (49).

In 1839 O'Connor's health began to decline, and his eyesight became weaker. He was still capable, however, of good painting, as this picture and cat. no. 84 attest. *An Oncoming Storm: Windswept Trees*, is much lighter in tone than his romantic landscapes of the early 1830s.

Private Collection

188

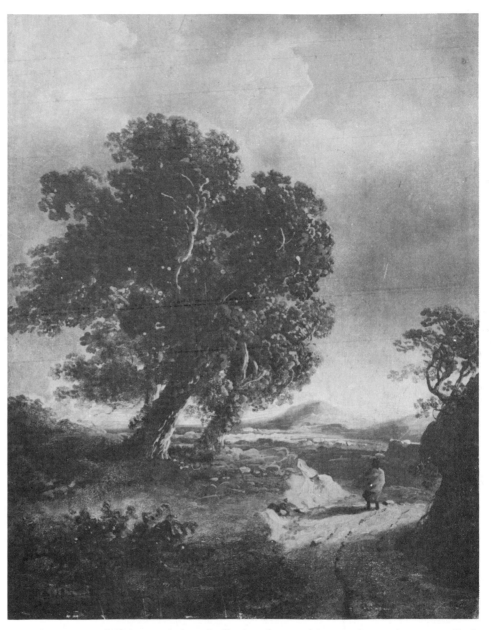

86. Windy Landscape with Figures, *c.1839*

Oil on Millboard:
23.0 x 17.8 cm.,
(9 x 7 ins.).
Signed: J.A.O'C.

PROVENANCE:
Cynthia O'Connor Gallery.

This is one of O'Connor's 'pot-boilers' — speedily executed, money-spinning pictures — that achieves more than it set out to. It is a delightful, unpretentious little painting that appears to have been done with genuine enjoyment. It is tentatively ascribed to this period on the basis of its similarity to the preceding picture (cat. no. 85).

Private Collection

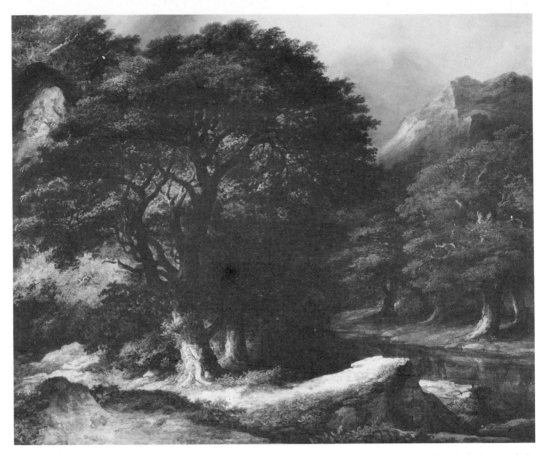

87. Castle Coote Demesne, *1840*

Oil on canvas,
62.2 x 76.2 cm.,
(24½ x 30 ins.).
Signed and dated:
J.A. O'Connor 1840.

PROVENANCE:
Probably commissioned by
Captain Chidley Coote
from the artist; Charles
Bennett; Lord Justice
O'Connor; E. O'Brien.

EXHIBITED:
*Dutch Exhibition of Arts and
Industries*, 1872, (213);
Centenary Exhibition, Hugh
Lane Municipal Gallery of
Modern Art, Dublin,
1941, (47).

LITERATURE:
Bodkin, op.cit., pl. VI,
and opp. page.

Castle Coote Demesne, probably
commissioned by Captain Childley Coote
(see biography) may be the last major
picture O'Connor painted. It is certainly
accomplished, and has both feeling and
intensity of his earlier dark landscapes.

Private Collection

APPENDIX I

Paintings by O'Connor Exhibited during his Life-time

Reprinted from Thomas Bodkin: *Four Irish Landscape Painters*, Dublin and London, 1920.

EXHIBITION HELD AT THE DUBLIN
SOCIETY'S HOUSE IN HAWKINS STREET.

J. O'Connor, 15 Aston's Quay

1809
164 Card-Players, A Sketch

EXHIBITION OF THE SOCIETY OF THE ARTISTS
OF IRELAND
J. O'Connor, an Associate Exhibitor

1810
 52 Sea View and Martello Tower

J.A. O'Connor, Aston's Quay, an Associate Exhibitor

1811
 11 A Rustic Figure Sketched with a Pen
 82 Companion
 98 Sunset Composition

1812
 4 Landscape Composition
 5 Landscape Composition
 7 Landscape Composition
 11 Landscape Composition
186 Landscape Composition

J.A. O'Connor, Aston's Quay, Member of the Society

1813
 44 Italian Seaport — Moonlight
 45 Landscape Composition
 54 Smith's Forge — Moonlight
 59 Moonlight — Composition
 86 View of the Salmon Leap, Leixlip
 92 Landscape and Figures — Composition
109 Historical Landscape Aeneas and Dido — Land Storm, *Note* — With quotation from Virgil
122 Landscape Composition
137 Moonlight and Smith's Forge

HIBERNIAN SOCIETY OF ARTISTS
J.A. O'Connor, Aston's Quay

1814
 11 A Travelling Mendicant
 16 Landscape and Figures
 17 Landscape and Figures
 30 Landscape and Figures
 35 Landscape
 46 Landscape Composition
163 Gipsy and Child
172 Back View of a Cottage
217 Sun-Rise, Composition

1815
 18 View of Bristol Channel
 46 Landscape Composition
 47 Landscape and Figure Composition

1816
Catalogue missing

1817
Catalogue missing

1818
No exhibition.

EXHIBITION OF THE ARTISTS OF IRELAND
AT THE DUBLIN SOCIETY'S HOUSE
J.A. O'Connor, 18 Dawson Street

1819
 24 Old Court Castle, Co. Wicklow
 29 Landscape Composition
 33 View from Killiney looking to Bray
 36 Landscape Composition
 38 View in the Dargle, Co. Wicklow
 46 View of the Salmon Leap, Leixlip
 51 View of Rockingham House and Demesne, Co. Roscommon, the Seat of the Right Hon. Lord Viscount Lorton
 61 Landscape Composition (J.A. O'Connor and J. Peacock)
 63 Landscape Composition (J.A. O'Connor and J. Peacock)

THE ROYAL ACADEMY
32 Upper Marylebone Street

1822
368 View in the Dargle, Co. Wicklow

1823
203 Landscape and Figures a Scene in the County of Dublin
324 The Lovers' Leap in the Dargle, Co. Wicklow

1824
265 Water-mill at Arundel, Sussex
348 Landscape

29 Fredrick Street, Hampstead Road

1825
178 Landscape and Figures

14 Mornington Crescent

1826
369 Landscape
884 Landscape — Evening

8 Soho Square
1828
333 The Trout Stream

67 Clarendon Street
1829
476 The Sequestered Glen

1830
445 The Glen of the Rocks

1831
290 Scene in the Dargle, Co. Wicklow

39 Charing Cross

1832
118 A Landscape

61 Seymour Street, Euston Square

1834
 77 Landscape — Evening
115 Landscape

1835
230 Landscape Sunset

67 Clarendon Street, Somer's Town

1836
436 Landscape

13 Rathbone Place

1837
316 An Irish Glen

1838
527 A Landscape — Moonlight

1839
547 On the Lynn, North Devon — Moonlight

1840
294 Landscape

THE BRITISH INSTITUTION
33 Upper Marlebone (sic) Streeet

1823
213 Landscape and Figures, Evening; A scene in Wicklow
301 Landscape, with a mill: A View at Miltown, Dublin

1824
 29 Landscape and Figures
291 A Scene in an Oak Wood at Offington Sussex
300 Morning, A View of part of the Town and Castle of Arundel
351 Landscape and Figures

1825
 39 Landscape and Figures
 63 West Port Bay, from the New-Port Road, Mayo
148 Landscape and Figures, Hampstead Heath
384 Sandy Mount Beach, Dublin

26 Frederick Street

1826
104 Landscape and Figures, Evening
175 Landscape
245 Landscape, Evening
305 Landscape

Mornington Crescent

1827
261 Landscape

8 Soho Square

1828
253 A View in the Devils Glen, Wicklow

67 Clarendon Street, Somer's Town

1829
226 River Scene, Moonlight
395 The Mountain Glen
461 The Mountain Torrent

1830
124 The Tired Fisherman
386 Landscape
454 The Devils Gap
499 The Glen of Oaks

1831
224 Landscape
325 The Ford

1832
65 Landscape
66 The Woodcutter
477 Scene in the Dargle, Wicklow
495 Moonlight

5 Polygon, Somer's Town

1833
60 The Eagle's Crag

1834
523 A View in the Valley of Tieferbach on the Moselle

67 Clarendon Square

1835
427 Landscape, Storm Coming On
453 Landscape, Moonlight
525 Scene on the River Avonmore, Co. Wicklow

1836
375 A Landscape, Twilight

1837
325 A Landscape

1838
119 An Irish Glen

1839
139 The Chateau D'Arras, Rhenish Prussia

THE SOCIETY OF BRITISH ARTISTS
O'Connor T. (sic) 167 (sic) Clarendon Street, Somer's-Town

1829
171 The Broken Bridge

67 Clarendon Street, Somer's-Town

1830
384 The Water Fall
466 Scene in the Devil's Glen, County of Wicklow

1831
347 Solitude
498 A Scene in the Mountains

1832
67 Landscape, A Shower Coming On
85 Moonlight
209 Coast Scene — Morning

5 Polygon, Somer's-Town

1833
269 Mountainous Scenery: Windy Day
376 The Precipice: Moonlight

61 Seymour Street, Euston-Square

1834
330 Landscape — Moonlight
384 Saarbourg, on the Saar, Rhenish Prussia
489 The Mountain Pass

67 Clarendon Street, Somer's-Town

1835
172 Landscape

1836
527 Landscape; The Bathing-place

13 Rathbone Place

1838
417 The Fisherman's Cave

ROYAL HIBERNIAN ACADEMY
67 Clarendon Street, Somer's-Town, London
1830
The Glen of Oaks — A Storm Coming On

31 (sic) Rathbone Place, London
1840
9 Landscape
78 Landscape, Moonlight
91 Landscape, The Mountain Pass

Paintings by James Arthur O'Connor Exhibited after his Death

THE ROYAL HIBERNIAN ACADEMY

1842

32 A River Scene (oil)

Watercolours
340 The Park at Brussells (sic)
341 The Park at Brussells (sic)
342 At Tervueren (sic) near Brussells (sic)
343 La Place du Sablon near Brussells (sic)
346 In the Market at Brussells (sic)
347 Sunset on the coast of Holland
348 Hampton Court
349 Rochester Cathedral and Castle
Note — All described as 'by the late J.A. O'Connor'

1843

68 Sunset
102 Seapiece
164 Hampstead
454 Composition
523 A Waterfall
578 Composition
Note — All described as 'by the late James Arthur O'Connor, 41 Lisle Street, Leicester Square London'

INDUSTRIAL EXHIBITION, DUBLIN

1853

9 Landscape — *Lent by the Right Hon More O'Ferrall*
24 View in the County Wicklow — *Lent by the Rev. J.A. Mallet, F.T.C.D.*

MANCHESTER ART TREASURES

1857

512 River Scene in Ireland — *Lent by John Fernley, Esq.,*

ROYAL DUBLIN SOCIETY ART EXHIBITION

1858

45 View in the County of Wicklow: Meeting of the Waters — *Lent by J. A. Journeaux*
88 Rocky Landscape — *Lent by Capt. Shedden*

207 Salmon Leap — *Lent by Miss Fitzgerald*
219 Landscape — *Lent by Miss Fitzgerald*
220 Landscape: River Scene — *Lent by Miss Fitzgerald*
228 Landscape — *Lent by Miss Fitzgerald*
246 View in the Park — *Lent by Miss Fitzgerald*

IRISH INSTITUTION

1859

69 River Scene — *Lent by the Earl of Charlemont*
75 View in Connemara — *Lent by Wm. Jenkins, Esq.*
134 Woody Landscape — River Scene — *Lent by Col. Chidley Coote*

ROYAL DUBLIN SOCIETY EXHIBITION OF FINE ARTS

1861

5 Powerscourt Waterfall — *Lent by Captain Shedden*
19 A Glen Scene — *Lent by Captaqin Shedden*
88 Landscape, Co. Wicklow — *Lent by B. Watkins, Esq.*
227 Landscape — *Lent by J.H. Read, Esq.*
229 A Land Storm — *Lent by Captain Shedden*
264 A Sea View — *Lent by ... Tayler, Esq.*
291 Landscape — *Lent by J. A. Journeaux*
297 Landscape — *Lent by George Austin, Esq.*
301 Landscape — *Lent by J.A. Journeaux*

ROYAL DUBLIN SOCIETY EXHIBITION OF FINE ARTS

1864

241 Landscape — *Lent by E. H. Madden, Esq.*
256 Moonlight — *Lent by Captain Shedden*
270 View of Castle Priory — *Lent by T. Geoghegan, Esq.*

DUBLIN INTERNATIONAL EXHIBITION

1865

30 The Cadi's Court

79 Landscape — *Lent by Mrs. Atkinson*

Note — both these pictures are described in the Catalogue simply as by 'O'Connor'

62 Landscape — *Lent by Henry Devit*

DUBLIN EXHIBITION OF ARTS AND INDUSTRIES

1872

198 Landscape — *Lent by the Right Hon. More O'Ferrall*

207 Landscape — *Lent by the Right Hon. More O'Ferrall*

213 View in Castle Coote Demesne — *Lent by C. Bennett, Esq.*

214 The Devil's Glen — *Lent by Captain Shedden*

Note — Now in the National Gallery of Ireland.

218 Landscape — *Lent by the Right Hon. More O'Ferrall*

256 Landscape — *Lent by Captain Shedden*

259 Powerscourt Waterfall — *Lent by Captain Shedden*

260 Frost Piece — *Lent by C. Bennett, Esq.*

261 Stormy Evening in the Wood — *Lent by Captain Shedden*

262 Thunderstorm — *Lent by Captain Shedden*

263 In the Vale of Glenmalure — *Lent by Captain Shedden*

264 Moonlight — *Lent by Captain Shedden*

265 View in County Wicklow — *Lent by Captain Shedden*

266 View in County Wicklow — *Lent by Captain Shedden*

268 Landscape — *Lent by Col. Chidley Coote*

DUBLIN LOAN MUSEUM OF ART TREASURES

1874

486 Landscape — *Lent by Col. Chidley Coote*

WREXHAM

1876

496 Waterfall — *Lent by Mr. Potts*

808 Trees (drawing) — *Lent by J.W. Safe*

CORK EXHIBITION

1883

389 The Gap of Barnaghee, Co. Mayo — *Lent by Sir Thornley Stoker*

400 Castle Carrow, Co. Mayo — *Lent by Sir Thornley Stoker*

LOAN EXHIBITION AT CLYDE ROAD VICARAGE, DUBLIN

1884

47 Landscape — *Lent by Canon Smith*

56 Landscape — *Lent by Canon Smith*

CENTURY OF BRITISH ART, GROSVENOR GALLERY

1887-88

55 Landscape with a Figure in a Red Cloak — *Lent by Richard Gibbs, Esq.*

270 A Mountain Scene — *Lent by Richard Gibbs, Esq.*

MANCHESTER (JUBILEE EXHIBITION)

1887

1 Pentonville by Sunset — *Lent by Isaac Holden*

224 Market Place, Vincenza — *Lent by Isaac Holden*

Note — O'Connor was never in Italy. These pictures are attributed in the catalogue of the exhibition of J. O'Connor. Though Mr. Algernon Graves in his *A Century of Loan Exhibitions* assigns them to James H. (sic) O'Connor, I think they must have been painted by John O'Connor, A.R.H.A. (1830-1889).

IRISH EXHIBITION IN LONDON

1888

178 Lake Scene: Sunset — *Lent by W.M. King, Esq.*

179 Twilight — *Lent by George Andrews, Esq.*

180 Landscape — *Lent by M.H. Colnaghi, Esq.*

181 Wood Road Scene — *Lent by M.H. Colnaghi, Esq.*

182 Landscape with Figures and Sheep — *Lent by M.H. Colnaghi, Esq.*

183 Coast View: Sunset — *Lent by M.H. Colnaghi, Esq.*

184 Moonlight — *Lent by George Andrews, Esq.*

185 Landscape with Figures — *Lent by M.H. Colnaghi, Esq.*

186 Landscape with Waterfall: A Picnic Party — *Lent by W.M. King, Esq.*

187 Landscape: Bay of Naples in Distance — *Lent by Stephenson Clarke, Esq.*

188 Landscape: Moonlight Scene — *Lent by M.H. Colnaghi, Esq.*

189 Landscape and Waterfall with Highlander — *Lent by W.M. King, Esq.*

190 Woody Landscape with Figure in Foreground — *Lent by M.H. Colnaghi, Esq.*

191 Mountain and Lake Scene: Waggonhorse and Figure, on Road — *Lent by M.H. Colnaghi, Esq.*

192 Moonlight Scene — *Lent by M.H. Colnaghi, Esq.*

193 Norwood Gipsies: A Sketch on the Site of the Chrystal Palace — *Lent by W.M. King, Esq.*

195 Sunset — *Lent by George Andrews, Esq.*

196 Shore Scene: Sunset — *Lent by M.H. Colnaghi, Esq.*

197 Morning: Ireland's Eye in the distance — *Lent by George Andrews, Esq.*

210 Landscape — *Lent by M.H. Colnaghi, Esq.*

211 Near Templeogue, Co. Dublin — *Lent by George Andrews, Esq.*

EARLSCOURT EXHIBITION

1897

4 Peasant and Dog — *Lent by the Countess of Normanton*

WORKS BY IRISH PAINTERS AT THE GUILDHALL, LONDON

1904

98 The Poachers — *Lent by the National Gallery of Ireland*

103 Landscape — *Lent by the Right Hon. Jonathan Hogg, P.C., D.L.*

MUNSTER-CONNACHT EXHIBITION, LIMERICK

1906

18 Landscape — *Lent by the Right Hon. Jonathan Hogg*

26 Landscape — *Lent by the Right Hon. Jonathan Hogg*

TAISBEANTAS AN OIREACHTAIS, DUBLIN

1911

1 Moonlit Landscape — *Lent by Miss Mansfield*

2 Landscape — *Lent by Prof. J.M. O'Sullivan*

3 Landscape — *Lent by Prof. J.M. O'Sullivan*

WHITECHAPEL ART GALLERY

1913

22 Landscape — *Lent by the Maharajah Gaekwar of Baroda, G.C.S.I.*

23 Lake Scene — *Lent by Col. J.L. Rutley, V.O.*

26 Landscape — *Lent by the Right Hon. Jonathan Hogg*

138 Frame Containing four Sketches — *Lent by the National Gallery of Ireland*

155 Frame Containing four Sketches — *Lent by the National Gallery of Ireland*

THE NATIONAL GALLERY OF IRELAND

1918

Powerscourt Waterfall — *Lent by Captain R. Langton Douglas*

The Storm — *Lent by Captain R. Langton Douglas*

The Devil's Glen — *Lent by Captain R. Langton Douglas*

Note — now in the permanent collection of the National Gallery of Ireland.

A Scene in Wicklow — *Lent by Captain R. Langton Douglas*

APPENDIX II

Paintings from the Artist's Studio, sold at auction by Christie's after O'Connor's Death, in 1842

On Saturday, February 12, 1842 at one o'clock precisely

1 A Landscape, with a corn field; *a very clever sketch from nature*
2 A small landscape
3 A Rocky scene; and a sketch
4 An open landscape — moonlight
5 A Woody scene, with sheep
6 A road-Scene, with a group of trees
7 A hilly view, with a ruin near a river — warm evening scene
8 A woody river-scene, with a waterfall
9 A woody landscape — evening
10 AN OPEN LANDSCAPE, WITH TREES — land-storm
11 A RIVER SCENE, WITH A WATER-FALL AND RUINED CASTLE — moonlight
12 An open view, with trees — sunset
13 A sea-shore, with a rock — very true to nature
14 A small river-scene — moonlight
15 A landscape, land-storm; and an evening scene — a pair
16 A landscape, and a small sketch
17 A WOODY LANDSCAPE, WITH FIGURES ON A ROAD
18 A small landscape and a river falling among rocks
19 An open landscape, with a group of trees
20 A landscape — sunset; and a heath-scene
21 A SCENE IN A WOOD; *admirably coloured*
22 A river-scene, with boats
23 A woody scene, and a landscape — moonlight
24 A pair of woody landscapes
25 A landscape with a river
26 A mountainous landscape
27 A rocky dell, with a ruined castle — moonlight
28 A river-scene with trees
29 A pair of landscapes — morning and evening
30 A landscape — moonlight; and the companion
31 A landscape — sunset
32 A landscape with a river, and a cascade — *unfinished*
33 A romantic landscape, with a broken bridge; and another sketch
34 A small sketch, with figures under a bank
35 A rocky dell, with a cascade
36 A RIVER SCENE — glowing effect of evening
37 A Woody scene near a river, with figures; and an open landscape — a pair *brilliantly coloured*
38 AN OPEN ROAD SCENE, WITH FIGURES
39 An upright mountainous landscape, with figures near a group of trees
40 A view in Wales — evening scene
41 A rocky road-scene, with trees
42 An open landscape with trees; and a road-scene in Wales — effect of storm
43 A romantic view in Ireland, with rocks and water, and a cascade — a pair — *unfinished*
44 A ROMANTIC MOUNTAINOUS VIEW with a waterfall near a group of trees — moonlight
45 Polyphemus

APPENDIX III

Paintings Exhibited at the O'Connor Centenary Exhibition in 1941

Municipal Gallery of Modern Art, Dublin

1 The Library, T.C.D. Exterior with figures
J.A. O'Connor
15½" x 21½"

2 The Dargle. Landscape with three figures
J.A. O'Connor, 1818
Panel 9¼" x 12"

3 A Woody Landscape with Peasants
J.A. O'Connor, 1828
Panel 13" x 17"

4 River Scene with fisherman
O'Connor, 1823
Millboard cut into signature, 6" x 8¼"

5 View in Phoenix Park
J.A. O'Connor, 1817
On copper, 7¼" x 10¾" R.D.S. Ex. 1858
Bodkin: Four Irish Landscape Painters, p. 103

6 Self Portrait of James Arthur O'Connor
Millboard 4½" x 3½" ill. Bodkin

7 Landscape Composition. Cart and team with three figures, probably by Joseph Peacock
J.A.O'C 1819
Panel 6¼" x 8¼"
Artists of Ireland Ex. 1819. Bodkin, p. 97

8 Landscape
7" x 6" Bodkin, p. 107

9 View north from Howth
J.A. O'Connor, 1823 or 1825
14" x 11"

9a Seapoint Bathing Place
J.A. O'Connor, 1820
14¼" x 17½"

10 Landscape, Co. Mayo
14" x 11"
Bodkin, p. 107

11 Roche's Castle, Ballyhooly, near Macroom
J.A. O'Connor, 1821
18" x 24"
Formerly in possession of Barry Redmond

12 River Landscape and figures
J.A. O'Connor, 182-
20" x 24"

13 View near Monasterevan
Panel 9½" x 13½"

14 Spring Landscape with castle and Martello tower
J.A. O'Connor, 1819
13" x 18½"

15 Clew Bay with figures
J.A. O'Connor, 1825
21" x 32"

16 Autumn Landscape
13" x 18½"

17 Landscape with figures
J.A. O'Connor, 1824
Millboard 9¾" x 7¾"

18 Forest Path with figures
18" x 24"

19 Landscape
J.A.O'C.
Panel 9" x 11"

20 Powerscourt, Co. Wicklow. Park scene with figures and sheep
J.A. O'Connor, 1825
20" x 24"

21 Lough Corrib
J.A. O'Connor, 1828
18" x 24"
Formerly in the collection of Dr. Treves

22 River Landscape with boats and figures
J.A. O'Connor, 1825
Panel 14½" x 18½"

23 Mountainous Landscape with figure
J.A.O'C.
Panel 10" x 12"
From Sir John Olphert's collection. Bodkin, p. 110

24 Barnaghee, Co. Mayo
Millboard 11" x 16" Cork Ex. 1833. Bodkin, p.109

25 Forest scene with figures
J.A. O'Connor, 1827
25" x 30"
Hill's sale, 1875. Bodkin, p. 108

26 Hastings
Millboard 7" x 9"

27 Castle Carrow, Co. Mayo
J.A. O'Connor
Millboard 11" x 16"
Cork Ex. 1883. Bodkin, p. 109

28 Glenmalure, Co. Wicklow
J.A. O'Connor, 1828
12¼" x 15"

29 Landscape with water and two figures
J.A. O'Connor, 1827
14" x 17½"

30 River Landscape with small figure
J.A. O'Connor, 1826
25" x 30"

31 Homeward Bound
24½" x 30"

32 View on the Shannon with boats and figures
J.A. O'Connor, 1828
16" x 18"

33 A Woodland Landscape with figures
J.A. O'Connor, 1828
Panel 15" x 11¼"
Formerly in the possession of Sampson Burleigh

34 Moonlight
J.A. O'Connor
Panel 7½" x 10"

35 Wooded Defile with figures and cattle
J.A. O'Connor, 1827
25" x 31"

36 Landscape with figures; hills and sea in background
Panel 14" x 21"

37 Landscape with two figures
J.A.O'C., 1830
10¼" x 12¼"

38 View on the Liffey, Co. Dublin
J.A. O'Connor, 1828
Millboard 8¾" x 11"

39 Wooded Landscape
J.A. O'Connor, 1828
12" x 15"

40 Wooded River Scene with figures
J.A. O'Connor, 1830
16½" x 23"
W.B. White's sale, 1879. Bodkin, p. 108

41 Thunderstorm: the Startled Waggoner
J.A. O'Connor, 1832
25" x 30"

42 On the Saar or Moselle
J.A. O'Connor, 1834
12½" x 18"

43 Moonlight
J.A. O'Connor, 1838
Millboard 9" x 12"
Lent by M.H. Colnaghi to Irish Ex., London, 1888. Bodkin, p. 106

44 On the Saar or Moselle
J.A. O'Connor, 1834
28" x 36"

45 Forest Glade with three figures
J.A. O'Connor, 1836
Panel 12¼" x 14"

46 The Dargle. Moonlight and ruin
J.A. O'Connor, 1837
14" x 17½"

47 View in Castle Coote Demesne
J.A. O'Connor, 1840
24½" x 30"
Painted for Colonel Chidley Coote. Dublin Ex. Arts and Industries, 1872. Ill. Bodkin.

48 Rocky Landscape with figure
J.A. O'C., 1840
14" x 18"
Painted for Colonel Chidley Coote. Dublin Ex. Arts and Industries, 1872.

49 Oncoming Storm wind-swept trees
J.A.O'C., 1839
13¾" x 18"

50 River View, Co. Wicklow
J.A. O'Connor, 1828
Millboard 8¾" x 12"

51 The Glen of the Rocks with classical figures
J.A. O'Connor, 1830
40" x 50"

52 Moonlight
J.A. O'Connor,
Millboard 8½" x 11½"
Lent by Captain Shedden to Dublin Ex. Arts and Industries, 1872. Bodkin, p. 104

53 Evening Landscape with figure
J.A. O'C., 1838
10" x 12"

54 On the Lynn, North Devon. Moonlight
J.A. O'Connor
14" x 17½"

PRIMARY SOURCES

MANUSCRIPTS, ETC.: Precise dates of the letters referred to are mentioned in the notes following both chapters.

Letters from J.A. O'Connor and Francis Danby to John Gibbons, and those from the Rev. T.J. Judkin and P.H. Rogers to John Gibbons in the possession of Mrs. Edward Gibbons.

Letter from J.A. O'Connor to his sister Mary, in the posession of G. Kenyon, Esq., Dublin.

Letter from J.A. O'Connor to H.P. Parker, in *Jupp's Interleaved Royal Academy Catalogues*, Royal Academy, London.

Letter from 'J. O'Connor' to George Petrie, in the National Library of Ireland, Dublin. (Petrie Letters, MSS. 789-94).

Grant of the Administration of the Estate of J.A. O'Connor, Public Record Office, London.

Address from the Hibernian Society of Artists to the Dublin Society, 1815, in the National Library of Ireland, Dublin.

Petition from the Hibernian Society of Artists to the Dublin Society, 1818, Royal Dublin Society Records, Dublin.

Thom's Dublin Directories, 1790-1807.

ARTICLES, ETC.: *The Art Journal*, February 13th, 1861. (Obituary of Francis Danby).

Art Union Magazine, April 1845. (Appeal for J.A. O'Connor's widow).

Dublin Monthly Magazine, April 1842. (Article on O'Connor signed by 'M', probably George Mulvany).

The Gentleman's Magazine, March and June 1841. (Obituaries of J.A. O'Connor).

Hibernia, May 1810. (Review of early etchings by J.A. O'Connor).

EXHIBITION CATALOGUES, ETC.: Royal Academy Exhibitions, 1821-1841

British Institution Exhibitions, 1823-1842

Society of British Artists Exhibitions, 1829-1838

Sale of paintings by J.A. O'Connor, Christie's, 1842.

SECONDARY SOURCES

BOOKS AND ARTICLES:
ADAMS, Eric: *Francis Danby*, Ph.D. thesis, London University, 1969.
ADAMS, Eric: *Francis Danby — Varieties of Poetic Landscape*, Yale 1973.
BARRELL, John: *The Dark Side of the Landscape*, Cambridge, 1980
BATE, W.J.: *From Classic to Romantic, Premises of Taste in 18th Century England*, New York, 1961.
BERGER, John: *Ways of Seeing*, London, 1972.
BOASE, T.S.R.: *English Art 1800-1870*, Oxford, 1959
BODKIN, Thomas: *Four Irish Landscape Painters*, Dublin and London, 1920.
BOURET, Jean: *The Barbizon School and 19th Century French Landscape Painting*, London, 1973.
BREEZE, George: *The Society of Artists in Ireland Index of Exhibits, 1760-80*, Dublin, 1985.
BURKE, Joseph: *English Art 1714-1800*, Oxford, 1976.
CAREY, William: *Some Memoirs of the Patronage and Progress of the Fine Arts in England and Ireland*, London, 1826.
CLIFFORD, D. & T.: *John Crome*, London, 1968.
CONSTABLE, W.G.: *Richard Wilson*, London, 1953.
CROOKSHANK, Anne: 'Early Irish Painters', *Country Life*, London, August 24th, 1972.
CROOKSHANK, Anne and GLIN, The Knight of: *The Painters of Ireland*, London, 1978.
CULLEN, L.M.: *Life in Ireland*, London, 1976.
FISCHER, Ernst: *The Necessity of Art: A Marxist Approach*, Harmondsworth, 1978.
GRANT, Col. M.H.: *A Chronological History of the Old English Landscape Painters*, 8 vols., Leigh-on-Sea, 1957-61.
GRIGSON, G.: *The Harp of Aeolus*, London, 1948.
HARDIE, Martin: *Watercolour Painting in Britain*, 3 vols., London, 1968.
HERRMAN, Luke: *British Landscape Painting of the 18th Century*, London, 1973.
HONOUR, Hugh: *Romanticism*, London, 1979.
HUSSEY, Christopher: *The Picturesque*, London, 1927.
HUTCHINSON, B.A.: 'On the Study of Non-Economic Factors in Irish Economic Development', *Economic and Social Review*, Vol. 1., No. 4., Dublin, 1970.
KLINGENDER, Francis D.: *Art and the Industrial Revolution*, St. Albans, 1972.
LISTER, Raymond: *British Romantic Art*, London, 1973.
MAAS, Jeremy: *Victorian Painters*, London, 1969.
MALINS, E. and GLIN, The Knight of: *Lost Demesnes*, London, 1976.
MANWARING, E.W.: *Italian Landscape in 18th Century England: A study chiefly of the Influence of Claude Lorrain and Salvator Rosa on English Taste*, New York, 1925.
MAXWELL, C.: *Country and Town in Ireland under the Georges*, London, 1940.
McHUGH, Roger and
HARMON, Maurice: *A Short History of Anglo-Irish Literature*, Dublin, 1982.
MONK, Samuel H.: *The Sublime*, Michigan, 1960 (reprint).
MURRAY, Peter: *George Petrie*, unpublished M.Litt. Thesis, Trinity College Dublin, 1980.
NICOLSON, Marjorie: *Mountain Gloom and Mountain Glory*, Ithaca, 1959.
NOVOTNY, Fritz: *Painting and Sculpture in Europe 1780-1880*, Pelican History of Art Series, Harmondsworth, 1970.
O'DRISCOLL, W.J.: *A Memoir of Daniel Maclise*, London, 1871.
PASQUIN, Anthony: *An Authentic History, etc.*, London, 1796.
(pseud. of John Williams)

PAULSON, Ronald: *Literary Landscape: Turner and Constable*, Yale, 1982.
RAFROIDI, Patrick: *Irish Literature in English — The Romantic Period*, Gerard's Cross, 1980.
REYNOLDS, Graham, ed.: *Constable's Sketchbooks of 1813 and 1814*, London, 1973.
ROSENBLUM, Robert: *Transformations in Late 18th Century Art*, Princeton, 1969.
ROSENTHAL, Michael: *Constable: The Painter and his Landscape*, Yale, 1983.
ROSENTHAL, Michael: *British Landscape Painting*, Oxford, 1982.
STECHOW, Wolfgang: *Dutch Landscape Painting of the 17th Century*, London, 1966.
STOKES, William: *The Life and Labours in Art and Archaeology of George Petrie*, London, 1868.
TAYLOR, Basil: *Constable*, London, 1973.
TRITCHELL, James B.: *Romantic Horizons — Aspects of the Sublime in English Poetry and Painting 1770-1850*, Columbia, 1983.
VAUGHAN, William: *German Romanticism and English Art*, Yale, 1979.
WATERHOUSE, Ellis: *Painting in Britain 1530-1790*, Pelican History of Art Series, Harmondsworth, 1962.
WHITE, James: 'Irish Romantic Painting', *Apollo*, Vol. 84, no. 56, London, October, 1966.
WHITE, James: 'O'Connor at Westport House', *Apollo*, Vol. 80, no. 29, London, July 1964.
WHITLEY, W.J.: *Art in England, 1800-1837*, 2 vols., reprint, New York, 1973.

WORKS OF REFERENCE

BENEZIT, E.: *Dictionnaire des Peintres*, 2nd ed., 8 vols., Paris, 1966.
BRYAN'S: *Dictionary of Painters and Engravers*, 4th ed., 5 vols., London 1903-4.
GARNETT, Sir Richard: *Dictionary of National Biography*, Oxford 1917- (entry on O'Connor by Sir Richard Garnett).
GRAVES, A.: *A Dictionary of Artists*, London, 1895.
GRAVES, A.: *Royal Academy Exhibitors, 1769-1904*, 8 vols., London, 1905.
GRAVES, A.: *The British Institution 1806-1867*, London, 1908.
LUGT, F.: *Repertoire des Catalogues des Ventes 1826-1860*, The Hague, 1953.
NATIONAL GALLERY OF IRELAND: *Illustrated Summary Catalogue of Paintings*, Dublin, 1981.
NATIONAL GALLERY OF IRELAND: *Illustrated Summary Catalogue of Drawings, Watercolours and Miniatures*, Dublin, 1983.
OTTLEY, H.: *A Biographical and Critical Dictionary of Recent and Living Painters and Engravers*, London, 1876.
PILKINGTON, Rev. M.: *A Dictionary of Painters*, London, 1805.
REDGRAVE, Samuel: *A Dictionary of Artists of the English School*, London, 1878.
STRICKLAND, W.B.: *A Dictionary of Irish Artists*, 2 vols., Dublin and London, 1913.
THIEME, U., and BECKER, F.: *Allgemeines Lexicon der Bildenden Kunstler*, Leipzig, 1907-.

EXHIBITION CATALOGUES

James Arthur O'Connor Centenary Exhibition, Municipal Gallery, Dublin, 1941.
The Romantic Movement, Arts Council, London, 1959.
Irish Houses and Landscapes, Ulster Museum, Belfast; Municipal Gallery, Dublin, 1963; catalogue by A. Crookshank, D. Guinness, J. White and D. FitzGerald.
The Art of Claude Lorraine, Hayward Gallery, London, 1969; catalogue by M. Kitson.
Shock of Recognition — Landscape of English Romanticism and the Dutch 17th Century School, Mauritshuis, The Hague; Tate Gallery, London, 1971; catalogue by R. Campbell and A.G.H. Brackrach.
Irish Art in the 19th century, Cork, 1971; catalogue by C. Barrett.
Caspar David Friedrich, Tate Gallery, London, 1972; catalogue by W. Vaughan, H. Borsch-Supan and H.J. Neidhardt.
Salvator Rosa, Hayward Gallery, London, 1973; catalogue by M. Kitson.
The Bristol School of Artists, City Art Gallery, Bristol, 1973; catalogue by F. Greenacre.
Landscape in Britain c.1750-1850, Tate Gallery, London, 1973; catalogue by L. Parris.

National Gallery of Ireland Acquisitions 1982-83, 1984; catalogue by A. Le Harivel and M. Wynne.

Turner 1775-1851, Tate Gallery and Royal Academy, London, 1974; catalogue by M. Butlin, A. Wilton and J. Gage.

Constable, Tate Gallery, London, 1976; catalogue by L. Parris, I. Fleming-Williams and C. Shields.

Presences of Nature: British Landscape 1780-1830, Yale Center for British Art, 1982; catalogue by D.H. Solkin.

Wilson, Tate Gallery, 1982; catalogue by D.H. Solkin.

INDEX TO LENDERS AND EXHIBITION CATALOGUE NUMBERS